the

Spiritual

in

Art

SUNY series in
Aesthetics and the Philosophy of Art

Mary C. Rawlinson, editor

RECLAIMING THE SPIRITUAL IN ART

Contemporary Cross-Cultural Perspectives

Edited by

DAWN PERLMUTTER and DEBRA KOPPMAN

STATE UNIVERSITY OF NEW YORK PRESS

Published by
State University of New York Press, Albany

© 1999 State University of New York

For information, address State University of New York Press,
State University Plaza, Albany, NY 12246

Production by Laurie Searl
Marketing by Dana E. Yanulavich

Library of Congress Cataloging-in-Publication Data

Reclaiming the spiritual in art : contemporary cross-cultural
 perspectives / edited by Dawn Perlmutter, Debra Koppman.
 p. cm. — (SUNY series in aesthetics and the philosophy of
 art)
 Includes bibliographical references and index.
 ISBN 0–7914–4161–X (hardcover : alk. paper). — ISBN 0–7914–4162–8
 (pbk. : alk. paper)
 1. Spirituality in art. 2. Spirituality in literature. 3. Arts—
 Religious aspects. 4. Arts, Modern—20th century. I. Perlmutter,
 Dawn, 1959– . II. Koppman, Debra, 1958– . III. Series.
 NX661.R43 1999
 700'.1—dc21 98–30050
 CIP

10 9 8 7 6 5 4 3 2 1

For helping us to reclaim the spiritual

Bradford K. Varney

Andy Norton and Julia Koppman Norton

CONTENTS

ACKNOWLEDGMENTS

This project grew out of the session entitled *The Subjugation of the Spiritual in Art*, held at the 1995 College Art Association annual meeting in San Antonio, Texas, and was expanded to include other papers submitted to and presented at the same conference. We would like to extend our appreciation to the College Art Association for giving us the opportunity to present our work, and specifically to the organizers of that conference, John R. Clarke, Marie Carmen Ramirez, Kathy Vargas, and Liliana Wilson.

We would also like to acknowledge the Department of Art and Art Professions at New York University where we met, went through the doctoral program together, and initiated the research which we have continued from each side of the continent. Specifically we would like to thank the following professors at New York University: David W. Ecker, Baruch A. Levine, Marilyn G. P. Karp, Angiola R. Churchill, Maria Harris, and Rose Slivka. Other friends and colleagues have contributed directly or indirectly to this work. At John F. Kennedy University, Orinda, California, Debra Koppman would like to thank Mike Grady of the Department of Arts and Consciousness for creating a program that makes this project plausible. At Cheyney University of Pennsylvania, Cheyney, Pennsylvania, Dawn Perlmutter would like to thank W. Clinton Pettus, William Hegamin, Sebronette Barnes, Lisa Schoenberg, and my students for their unwavering support.

Heartfelt thanks for various kinds of support go to Eva Pariser, Martin Kotler, Lance Perlmutter, Brad Varney, Andy Norton, and Julia Koppman Norton. Profound appreciation to our parents Abraham Perlmutter, Joan Sutton, and Mae and Lion Koppman.

Reclaiming the Spiritual in Art is the result of a collective conversation among its contributors. We would like to reiterate our thanks to all of the contributors to this volume and to James Peltz and Laurie Searl at State University of New York Press for their support in bringing this work to fruition.

INTRODUCTION

DAWN PERLMUTTER and DEBRA KOPPMAN

From Walt Disney World to *Natural Born Killers* this book explores uncommon indicators of the spiritual in contemporary art and culture. In this volume, we draw on a diversity of perspectives in philosophy and aesthetics to highlight conscious and unconscious manifestations of the sacred in art, and to make a compelling case for its continued contemporary relevance. Our investigations grew out of our mutual fascination with what appeared to us to be a significant and growing trend in contemporary art, and a curious and concomitant dearth of discussion on the subject among artists, critics, philosophers, and historians. We began by looking at the wealth of historical and cross-cultural models of the intimate relationship between art and the sacred, and attempted to understand the apparent non-existence of this relationship in the present. We came to the conclusion that in spite of the fact that a large part of the world's art and artlike production has been integrally intertwined with either specific religious practices or more generalized beliefs connected with numinous, non-visible, non-rational experiences many would ascribe to a difficult-to-define realm of the sacred, the majority of contemporary Western practitioners of art, criticism, and philosophy appear to be involved in what is perceived as a completely secular activity.

This is not to say that we were alone in noticing this trend. The fact that contemporary art is replete with references to a variously defined "sacred" has been noted and discussed from a variety of viewpoints, most interestingly to us by Lucy R. Lippard and Suzi Gablik. In *Overlay:*

1

Contemporary Art and the Art of Prehistory, Lippard looked at various manifestations in contemporary art of what she identified as the tendency to "primitivize art." She interpreted this trend as arising from a need of artists to reenvision the integration of art and society in an age of dehumanized technology. In this context, she described artists as the "keepers of racial memory," "natural archeologists" who by reinterpreting images of the past in the present evoke memories of lost symbols and myth which can provide insights into contemporary life. In a similar vein, Suzi Gablik, in *The Reenchantment of Art*, analyzed the work of contemporary artists who are trying to expand the social and environmental contexts of art in what she interpreted as a collective process of connectivity, reenchantment, and spiritual healing. According to Gablik, artists are attempting to regain a sense of the divine side of life and an ability to perceive the world as magical through the powers of imagination and vision.

Through our collaboration, we hope to contribute to the ongoing work of artists and theoreticians exploring contemporary connections between art and the sacred. Multiple perspectives are included to articulate dimensions of the spiritual which continue to be largely overlooked in mainstream philosophy and criticism. Western theories in philosophy and aesthetics are interwoven with examples of Native American, Latin American, and African American aesthetic and spiritual precepts and practices to provide a sense of the myriad cultural influences at play. Connections are made between art and issues of cultural, ethnic, and gender identity to suggest the possibility of both affirmative and subversive relationships between art, artists, and spiritual traditions.

Through this volume, readers will become familiar with a wide variety of contemporary ideas, artists, and art forms flourishing outside of the framework of the "official" artworld. They will also become aware of the ways traditional spiritual practices and sacred ideas are potentially influential in an apparently secular American context. Wide-ranging discussions include references to the work of both well-known and unknown artists working in sculpture, painting, performance, and film.

Sources such as the Old Testament are used to illuminate the meaning of the work of contemporary earthwork and performance artists in chapter 1, "The Subjugation of the Spiritual in Art." In this chapter it is suggested that the subjugation of the spiritual in art grew out of, and continues to be, a political battle for control over what is deemed sacred from Biblical prohibitions of images to the National Endowment for the Arts. Censorship is demonstrated to be a manifestation of a conflict over religious ideology. Earthworks, ritual art, and postmodern spiritual objects are used to illustrate the struggle between monotheistic and polytheistic doctrines.

A spiritual perspective on the human body in Western art is considered in chapter 2, "Venus/Intra-Venus: Art against and as the Body." It is claimed throughout the chapter that the spiritualization of the sensuous body can only be achieved by the denigration of the physical body and its subsequent violent idealization. This is exemplified in Grünewald's *Isenheim Altarpiece*, Chris Burden's violent performance art, and Orlan's reconstructive surgeries. The affirmation of the body and the recovery of the animal body is depicted in Rembrandt's paintings, Piero Manzoni's use of excrement in his work, and the performances of Hannah Wilke.

Walt Disney World is considered an American, twentieth-century secular pilgrimage site in chapter 3, "Mickey, Minnie, and Mecca: Destination Disney World, Pilgrimage in the Twentieth Century." The concept, definitions, and theories of pilgrimage rituals are applied to travelers' experiences of the Magic Kingdom. An analogy made between Disney World and the medieval pilgrimage center of Santiago de Compostela provides compelling insights into the phenomenology of sacred worship.

Chapter 4, "Feminist Revisions," offers feminist redefinitions of the sacred as a basis for a reexamination of contemporary manifestations of the sacred in art. It is demonstrated that both feminist visions of the sacred and contemporary artists' concepts of the sacred are influenced by cross-cultural traditions. Feminist approaches to art criticism and spirituality are introduced citing major theories in their respective disciplines. Finally, it is suggested that feminist reconstructions of the meaning of the sacred in language will effect interpretations of the sacred in art.

A personal account of artmaking as a form of aesthetic prayer in a apophatic spiritual quest is narrated in chapter 5, "(Dis)integration as Theory and Method in an Artmaking Practice." The author, an artist educated in religious studies seeking a path to the spiritual through her art, describes how words became an inadequate language for religious expression. She discovers that nonliturgical enactments, such as the sewing of a quilt or the rhythmic breaking of twigs, become nonrational, nonverbal practices of experiencing the spiritual through art.

Contemporary altars created by European artists Niki de Saint Phalle and Jean Tinguely are the subject of chapter 6, "Between the Sacred and the Profane: The Altars of Niki de Saint Phalle and Jean Tinguely." Their works are described as addressing issues of personal and national identity with many references to the technology-based consumer cultures of France and the United States during the postwar years. It is suggested that even though their altars are made of found objects and scrap metal, they continue to represent the altar in the traditional manner as a site that stands at the crossroads of mortality and transcendence.

A proposed multicultural aesthetic framework derived from overlapping and recurring cross-cultural sacred themes is described in chapter 7, "Multiple Visions: Revisioning Aesthetics in a Pluralistic America." Six aesthetic categories are outlined, including an aesthetics of invocation, transformation, process, energy, improvisation, and magic. It is demonstrated that the contemporary Western separation of art from life, from the sacred, and from meaning is not shared cross-culturally and that a multicultural vision can be achieved by an awareness of various cultural perspectives.

The conceptual works of Cuban artist Jose Bedia, Cuban American artist Ana Mendieta, African American artist David Hammons, and German artist Joseph Beuys are the subject of chapter 8, "Blood Relations: Jose Bedia, Joseph Beuys, David Hammons, and Ana Mendieta." It is proposed that the work of these artists, produced outside of the Western mainstream and within the context of cultures more infused with religious activity, has the common objective of giving voice to the artists' experiences as "other" and of revealing a politics of exclusion and negation. Descriptions of their work reveal common characteristics inclusive of the use of nonart materials, a preference for site-specific or temporary installations that involve performance, and the reenactment of ritual practice and symbolism based on ancient cultures. Most significantly, it is illustrated that spirituality is the central, unifying force in every aspect of these artists' lives and that their artmaking echoes shamanistic practices.

The shrine of a Detroit martyr named Malice Green, an unemployed African American steel worker bludgeoned to death by two white Detroit police officers, is the subject of chapter 9, "Malice Green Did Like Jesus: A Detroit Miracle Story." The author describes how the site of Green's murder evolved into a memorial that sanctified the space, inspired pilgrimage, and harnessed the anguish of the community. It began with visitors leaving written messages, flowers, candles, shells, and other objects associated with veneration in African and Christian traditions, and culminated with the addition of a Christlike portrait mural of Malice Green by Bennie White. This chapter is an account of a saint's suffering, death, and odyssey from ordinary human being to potent cultural symbol.

The religious and violent content of the 1994 films *Pulp Fiction* by film maker Quentin Tarantino and *Natural Born Killers* by director Oliver Stone are examined in chapter 10, "Postmodern Idolatry: The Media and Violent Acts of Participation." Building on the theories of Aristotle, René Girard, Edward Whitmont, and Konrad Lorenz, it is demonstrated that historically there is a direct correlation between violence and the sacred, that participation in either actual or signified acts of violence are a significant part of religious ritual, that violence in art and

the media serves as a catharsis for human aggressive drives, and that religious ritual formerly realized this function. It is argued that violence in the media reflects a theological problem of idolatry and that censoring representations of violence is actually serving to perpetuate rather than diminish crime in our society.

The survival of patriarchal myths, which have an essentially religious origin, is described in chapter 11, "Thou Art: The Continuity of Religious Ideology in Modern and Postmodern Theory and Practice." The author refers to these myths as "Intelligent Life," "The Protestant Work Ethic," "The Death of the Author," "The Appropriation Strategy," and the "Myth of the Apocalypse." According to this view, these myths (1) uphold such characteristics of contemporary art as unreadable theory and deliberately incomprehensible art, (2) maintain the ideological separation between high and low art, and (3) validate recent influential theoretical treaties on the deconstruction of authority, the impossibility of originality and creativity, and the philosophical notion of the end of art. The author suggests the possibility of a reintegration of the spiritual in art through the use of multivocal models offering alternative interpretations of the myths of postmodernism.

By addressing the role of the spiritual in art, an issue which has been for the most part ignored or underexamined in contemporary discourse, greater understanding is potentially gained of otherwise obscure contemporary practices. Through the use of specific examples to discuss variously defined terms such as "postmodernism," "religion," and "spirituality," and an expansion of cross-cultural aesthetics and feminist analysis, we hope to create a wider range of interpretative possibility than currently exists. The interdisciplinary and cross-cultural perspectives in this volume reflect the current nature of the reemergence of the sacred in our culture. It is hoped that these voices will provide useful tools to investigate more profoundly the work of both specific artists and contemporary art as a whole.

1

THE SUBJUGATION OF THE
SPIRITUAL IN ART

DAWN PERLMUTTER

Considering that an extremely large portion of the foundation of Western art is comprised of religious images, it is a fairly recent phenomenon that art relating to the spiritual goes virtually unrecognized by the critics, authorities, and patrons of the art world. This is a reflection of the subjugation and denial of unconventional forms of the sacred in Western culture. Manifestations of the sacred in art have been ignored because forms of postmodern "spiritual art" represent heretical thinking that poses an ideological threat to the current political-religious structure. Contemporary artists are trying to reclaim the sacred by reuniting spirituality with the aesthetic and integrating both into society in a manner that existed in the prebiblical, prepatriarchal, premonotheistic era. Hence, twentieth-century censorship can be likened to a revival of the biblical prohibition of images, which originated to protect the tenets of monotheism that deliberately separated the aesthetic from the spiritual. In brief, the subjugation of the spiritual in art grew out of and continues to be a political battle for control over this very influential form of the aesthetic.

The most effectual suppression of art occurred when the prohibition of images appeared in biblical literature in the form of the second commandment. "Thou shalt have no other gods before Me. Thou shalt not make unto thee a graven image. . . . Thou shalt not bow down unto them, nor serve them."[1] The phrase "graven image" is synonymous with the

term idol and refers to the Judaic-Christian concept of idolatry. An idol is defined as a physical representation of a deity used as an object of worship. In scriptural language, idol is applied to objects worshipped by so-called pagans and referred to as false gods. Etymologically, idolatry means adoration of images and is defined as the worship of idols or images and of the powers they represent. From a late twentieth-century, multicultural, or feminist point of view, the phrase "graven image" can be considered pejorative, as specifically referring to the censorship and eradication of objects that are held sacred by others.

It has been argued by scholars from various disciplines that the original context of the prohibition of images in the Judaic-Christian tradition had an unequivocal political-religious agenda. Feminist theologian Merlin Stone asserts that Exodus 34:11–16 describes the intention of the Hebrews not only to inhabit the already inhabited land of Canaan, but also purposely and violently to destroy the existing religion and replace it with their own.[2] Stone's hypothesis is relevant because it was essential for the prohibition of image worship to be introduced and strictly enforced for the one-god ideal to flourish.

According to biblical literature, when the Hebrews entered the land of Canaan they found the inhabitants worshipping statues, altars, and pillars. The inhabitants acquired their identity through the statues they worshipped. For example, if a community worshipped Baal they were then designated the cult of Baal. In order to introduce the ideal of one god, the existing beliefs of the inhabitants had to be diminished. This was accomplished by the systematic denigration of what the so-called cults held sacred. Their statues, altars, and pillars were proclaimed to be objects of mere wood and stone (idols), and the people were called pagans, heathens, and idol worshippers. The primary motivation for labeling religions cults was to identify the god with its idol (object of worship). By denouncing the idol/object, one could denounce the entire belief system of the people. Objects and places that were held sacred were deliberately stigmatized in order to discredit them in the eyes of their believers. The so-called cults in ancient Israel were empowered by their idols; whoever controlled the idol also controlled the god. Therefore abolishing all other gods eventually led to complete religious and political control over the inhabitants of that land. The people had no recourse because Israelite monotheism was an entirely new concept that portrayed God as a transcendent and omnipotent sovereign, with no mythological history, and significantly, with no form. Monotheism eventually displaced the surrounding polytheistic cultures by demythologizing their objects of veneration. Polytheistic cultures were subordinated; their beliefs and practices denigrated as merely magical and

superstitious. From this perspective the prohibition of images had a decided political agenda that not only involved the subjugation of other peoples' religious ideologies, but also inadvertently initiated the subjugation of the spiritual in art in Western culture.

Subsequently, prohibitions on viewing and making art founded on interpretations of the second commandment and the polemics of idolatry carried over into Christianity and Islam. Western culture has reinforced the suppression of the spiritual in art by the deliberate secularization of religious objects from other cultures. This has been achieved by either designating sacred objects as dead artifacts, destined to reside in anthropological museums, or by the faddish exhibition of supposedly magical objects. Sacred objects are neutralized of their spiritual quality once they are placed in a gallery for exhibition. Without an individual or a community to pay homage to, consecrate, or endow a statue/image with spiritual attributes, none exist. Unconsciously our culture still perpetuates the dogma of the second commandment by seeing statues from other cultures as mere wood and stone. The only difference is that our ancestors were still enough in awe of these objects to vow to destroy them. Our century has so severely suppressed any power attributed to images that we are secure enough to sit them on our fireplace mantels and display them as interesting objects.

This does not mean that current American culture is devoid of sacred objects. It is a commonly held illusion that a scientific rational society can successfully separate the sacred and the secular. In actuality, the conception of what is held sacred simply changes. In the industrial age, science became the new god, and society placed its faith in technological advances. With the advance of capitalism, the preoccupation with money, property, and commodities takes the form of contemporary idol worship. Many examples of this can be cited: a contemporary version of an ancient fertility goddess is a Barbie doll whose accessories among other things include a Porsche 911 Cabriolet and a health club complete with weights, bike, and treadmill. Fertility rituals involving the tilling of the earth for cultivation have been replaced with exercise routines that enable a person to obtain the latest ideal body form. The washing and waxing of a new car can be likened to the consecration ceremony of an Egyptian deity. Even advertisements for new cars have taken on a religious quality; the car becomes the idol in the sacred grove, and owning one can be likened to having one's own mobile sanctuary.

The twentieth century is marked by artists who, rejecting materialistic values, have attempted various methods of integrating the spiritual and the aesthetic. Modern artists embraced an "art for art's sake" ideology by

which aesthetic experience developed into an individualistic and secularized religion. As art theorist Suzi Gablik states:

> The attitude of art for art's sake was essentially the artist's forced response to a social reality he could no longer affirm. This inward turn . . . inspired, in the early period of modernism, almost a theodicy of individual being; for many artists at that time abstraction was no less than an aesthetic theology.[3]

Abstract Expressionist artists such as Mark Rothko and Barnett Newman published statements that reflected both their transcendental and their "art for art's sake" ideologies; along with Clyfford Still, Adolph Gottlieb, and Ad Reinhardt, these artists were referred to as the theological sector of abstract expressionism. Art critic Harold Rosenberg stated, "The new movement is, with the majority of painters, essentially a religious movement."[4] The exploration of formal artistic problems served as the focal point for artists concerned with an intensely personal spiritual quest, centered on the individual self rather than on a community of believers.

Postmodern art is a reaction against modern formalist aesthetics and the separation of the individual from his or her community. By questioning the meaning, purpose, and function of art in relation to society, postmodern artists are attempting to reintegrate art into the life of the community. One of the identifying characteristics of postmodern art is questioning the relationship of art to a commodity-producing, capitalist society. Some postmodern artists are mocking capitalist culture by creating, *ad absurdum*, artworks that are meaningless objects. For example, artists Haim Steinbach and Jeff Koons create what has been referred to as "object/commodity sculpture" and "product art"; what is displayed as their art are literally everyday consumer objects recently bought at stores.

Modern artists deliberately tried to avoid partaking in the established political-religious system; postmodern artists are parodying the same system. Both groups seem to be lacking a genuine social identity, resulting in a sense of alienation. These artists are exhibiting the frustration that is the consequence of not only the suppression of the spiritual in art, but the lack of any interrelation between sacred objects and community. This isolation generates a situation in which the ego frantically strives to create its own meanings and has led to some contemporary nontraditional forms of art. This work is categorized under terms such as performance, ritual, earthwork, and environmental art.

Ritual art—sometimes referred to as Performance Art, Body Art, and in the sixties as "Happenings"—consists of various artistic activities. Many of these directly evoke ancient ceremonies by the use of magical dance and costumes, sometimes during solstices and equinoxes.

In 1985 R. Murray Schafer presented a dawn ritual entitled *The Princess of the Stars,* for which the audience had to arrive at a lake in the middle of the night. The event, which began at 5:00 A.M., included costumed performers in canoes, musicians, and a mythological story that ended with the actual rising sun as the Sun God. Gablik describes the intent of Schafer's rituals:

> the intention is to cultivate a sense of merging with a vast ecology, with a scenery that can't be controlled, in order to understand that working with nature means working on nature's terms. By responsive and careful listening to the natural world, Schafer hopes to make this understanding a practice through his art, which is paced by the rhythms of nature and linked with the greater movements of the cosmos.[5]

Chicago artist Fern Shaffer performed an empowerment ritual in the waters of Lake Michigan at the winter solstice. She dressed for the occasion in a shamanic outfit of her own making and then proceeded to cleanse crystals. Shaffer's rituals mark the passage of the seasonal equinoxes and solstices with special ceremonies. According to Gablik, "For Shaffer, the process of creating a shamanic outfit to wear can be likened to creating a cocoon, or alchemical vessel, a contained place within which magical transformations can take place."[6] During the spring equinox in 1986, Shaffer performed *Spiral Dance* in Cahokia Mounds, Illinois, at a site referred to as Wood Henge. Wood Henge is an ancient Native American site where archeologists have discovered a series of pits thought to be the ruins of a solar clock similar to Stonehenge.[7] Shaffer describes the significance of her rituals:

> If I am able to rediscover my own first experience of the basic spiritual existence with nature, it might help others rediscover and honor the same things in themselves. . . . What the world lacks today is not so much knowledge of these things of the spirit as experience of them. Experiencing the spirit is all. To believe is Okay, but a personal experience is better, a direct feeling with something. You can call it a shamanic state if you like.[8]

Austrian artist Hermann Nitsch performed a ritual entitled *48th Action* at the Munich Modernes Theater in 1974 that involved the disembowelment of a slaughtered lamb whose entrails and blood were poured over a nude man while the drained animal was strung up over his head. Art historian RoseLee Goldberg describes the meaning of Nitsch's ritual:

> Such activities sprang from Nitsch's belief that humankind's aggressive instincts had been repressed and muted through the media. Even the ritual of killing animals, so natural to primitive

man, had been removed from modern day experience. These rit-
ualized acts were a means of releasing that repressed energy as
well as an act of purification and redemption through suffering.[9]

Miriam Sharon presented an art ritual entitled *The Desert People* at
Ashoda Harbor, Tel Aviv in 1978. She performed a participatory ritual
with workers from the Tel Aviv waterfront wearing desert costumes in
which the head and body were covered in long pieces of cloth similar to
wearing the loose skins of animals. Art critic Lucy Lippard describes
Sharon's intentions as

> a ritual process intended to reestablish bonds between people
> and nature, the relationships of nomadic tents and dwellings to
> the land, and the political struggle of the Bedoins in the Israeli
> desert to maintain a way of life that is under attack by mod-
> ern bureaucracy.[10]

Carolee Schneemann appeared nude with live snakes crawling on
her body and breasts in a 1963 performance called *Eye Body*. This ritual
represented "a graphic reflection of the goddess' dominion over the ser-
pent—a universal symbol of rebirth and fertility connected with woman,
water and healing."[11]

Ritual artist Vijali performed *Western Gateway* in Malibu, Califor-
nia in August 1987. This ritual is part of a five-year project entitled *World
Wheel: Theater of the Earth* in which she instills a sense of community in
the people with whom she lives and works while creating the event.

> Her projects transform attitudes and build community by en-
> gaging local residents in all stages of the art process. She begins
> by asking them three questions: What were our beginnings?
> What has created our imbalances? What can bring us back
> into harmony? From the answers grows the art event.[12]

In *Western Gateway* the first part of the ritual portrayed humans, origi-
nally unified, splitting into male and female identities. The second seg-
ment depicted the disorder that occurred when American society justified
killing people in other countries. In the final stage of the performance, Vi-
jali appeared as Gaia personified to achieve balance by reuniting man
with woman and both with earth.[13] Art historian Patricia Sanders de-
scribes the significance of Vijali's rituals:

> Her concern . . . is generally to convey the idea that 'we
> (plants, animals, people, earth and universe) are one breathing
> organism.' This transpersonal vision and her insistence on in-
> dividual responsibility are her ways of recalling art to its lost
> shamanic role of nourishing and directing the community.[14]

Ritual art is not only similar to ancient pagan ceremonies but is exactly what the patriarchs had so much difficulty eradicating in the early history of monotheism. The actions performed in art rituals are similar to actions described in commentaries on idol worship and witchcraft in biblical literature. Ritual art suggests a return to pagan ideology, and exemplifies the severe disenchantment contemporary artists are experiencing with current political and religious systems.

Earthwork art, also referred to as "Environmental," "Land," and "Ecological" art, has been defined as "art that encompasses our relationship with plants and animals, the geologic history of the earth, the symbolic meaning of shelter, and changing socioeconomic relationships."[15] From a spiritual perspective, earthwork artists can be viewed as contemporary shamans, whose work involves sanctifying places and creating sacred grounds and mystical monuments, as opposed to the creation of ritual ceremonies or objects to be worshipped.

Artist Andy Goldsworthy went to the Arctic island of Ellesmere at the North Pole in 1989, apprenticed to an Inuit, Looty Pitjamini, and created *Touching North*, which is made of packed snow bricks. Gablik described *Touching North* as:

> a kind of ice-henge at the very top of the world: circles made of packed snow bricks at the four points of the compass; arches and spires; a group of ten-foot-high stacked cones that echoed shapes of distant mountains;[16]

Goldsworthy's works are part of a transient process and some of them don't even last a day. He works with nature on nature's terms, stating: "I cannot stop the rain falling or a stream running. . . . When I work with a leaf, rock, stick, it is not just the material in itself, it is an opening into the processes of life in and around it. When I leave it, these processes continue."[17]

In 1970 Robert Smithson created *Spiral Jetty*, at Rozel Point, Great Salt Lake, Utah. Made of earth, black basalt, and limestone, *Spiral Jetty* extended fifteen hundred feet into the lake but has been submerged in water for several years now. A thirty-five-minute, sixteen millimeter film on *Spiral Jetty* provides insights into the earthwork:

> Smithson compared the earth-moving machinery to dinosaurs, the red salt lake to blood. . . . He saw *Spiral Jetty* as "an image of contracted time: the far distant past (the beginning of life in saline solutions symbolized by the lake) is absorbed in the remote past (symbolized by the destructive forces of the legendary whirlpools in the lake) and the no longer valid optimism of the recent past. . . . All these pasts collide with the

futility of the near present (vacated oil rigging nearby). All appear to be canceled, made useless: all are results of the essential universal forces of entropy."[18]

Beginning in 1970 and continuing over a dozen years, on seventeen acres of meadow and woodland at Pratt Farm on the Kennebec River in central Maine, earth artist James Pierce created a work he describes as a "garden of history," "a landscaped park containing numerous individual but interdependent elements rich with historical associations."[19] Pierce's garden contains a pair of forts, *Triangular and Circular Redoubts* influenced by eighteenth-century British and French redoubts, a *Burial Mound* modeled on Native American prototypes, a *Turf Maze* based on the plan of a seventeenth-century topiary maze, a small *Observatory* to view the maze, and a spiral hill or *Motte* similar to medieval defensive structures. Other burial monuments are the *Stone Ship*, alluding to Viking burial practices, *Tree Burial*, a log that is large enough to contain a corpse that sits atop glacial boulders inspired by Scandinavian bronze age tombs, and *Shaman's Tomb*, a wooden coffin raised on four posts alluding to the belief among certain Siberian peoples that the soul of the deceased shaman was a bird that would return only if the body was left unburied.[20] From 1976 to 1978, Pierce proceeded to make a series of procreative works.

> *Earthwoman*, which was inspired by the dorsal view of the prehistoric *Venus of Willendorf* in Vienna, is thirty feet long, half as wide, five feet high and she lies face down, spread-eagled. She is aligned to the sunrise on the summer solstice, in such a way that the sun rises through the cleft in her buttocks in a symbolic fertilization. Nearby lies, face up, the similarly spread-eagled *Suntreeman*. . . . His arms suggest tree branches, and his round head, which doubles as a fire pit, alludes to the sun.[21]

The Lightning Field was created by artist Walter De Maria in 1977 in a flat, semiarid basin in west-central New Mexico. It is composed of four hundred stainless steel poles that were placed to attract lightning and thereby to celebrate its power and visual splendor. John Beardsley, art historian and expert on earthworks, describes De Maria and *The Lightning Field*:

> He wanted a place where one could be alone with a trackless earth and an overarching sky to witness their potent interchange through apparently wanton electrical discharge. The work is neither of the earth nor of the sky but is of both; it is the means to an epiphany for those viewers susceptible to an awesome natural phenomenon.[22]

A piece entitled *Totem* by Chris Millon done in 1975 stands in the center of the woods. It is approximately seven and a half feet high, con-

structed on wood, and covered in animal skin that appears to be the robe of a Native American. At the top of this structure is an elaborate head-dress that sits on an empty, faceless head. This work fits into the environment in such a superb manner that it virtually acquires mystical attributes. *Totem* exemplifies a quote by Owen Barfield, "Participating cults naturally cluster about man-made images; artificial representations evoke and focus the experience of nature as representation; the grove is rendered more numinous by the idol in the grove."[23]

Goldsworthy built ice-henge on top of the world, Smithson's *Spiral Jetty* wove together geological time and entropy, Pierce created burial and fertility grounds, De Maria celebrates the power and visual splendor of lightning, and Millon sanctified a piece of land by placing a totem in it. All of these earthworks exemplify sacred spaces that are qualitatively different from profane space. Earthworks on a large scale, produced in nature, are reminiscent of temple, fertility, burial, and sacrificial sites.

Ritual and earthwork artists are demonstrating a need for meaningful rituals in their art and in their lives. These nontraditional forms of art are disturbing to our society because they emerge from pluralistic ideologies that threaten the ethical foundations of monotheistic religions. These art forms can be considered postmodern idols because in the authentic sense of the term, they constitute graven images.

The substantive issue behind the subjugation of the spiritual in art is the conflict between monotheistic and polytheistic ideologies and the political exploitation of people who embrace ideals other than one's own. This same conflict is exhibited in the artwork and ideologies of postmodern artists, hence the proliferation of censorship in the last decade. For example, photographer Robert Mapplethorpe's homoerotic and sado-masochistic images provoke the same moral indignation and censorship as statues of fertility gods and goddesses did in the biblical era. Mapplethorpe's images themselves were not originally shocking. What was profoundly disturbing was the fact that they rose above the status of pornography and were displayed in respectable institutions, giving them the sign of social approval. This came too close to threatening American moral beliefs. Artist Karen Finley's performance art dealing with the oppression of women also breached the social gap. In her performances she talks about rape, alcoholism, and suicide while sometimes stripping down to her waist and smearing food on her body. In return for this outrageous behavior, the National Endowment for the Arts, under pressure from Congress, in 1990 withdrew its $8,000 grant to Finley. Again what is so fascinating is that it is perfectly acceptable for women to strip to nothing and dance at bars in every major city in the U.S. as long as they are referred to as Girlie Shows, XXX-Rated, or my personal favorite, "Titty

Bars." But performing nude on stage with a political agenda and the NEA stamp of approval means we are no longer in the realm of pornography. As soon as what has traditionally been labeled as indecent is validated as a legitimate art form, the ideological war begins. Finley's performances were threatening to the patriarchal structure because in that system women should only strip to please men, not to promote feminist activism. If art did not pose a threat to the current political-religious structure, it would not have received the amount of attention it has been getting from politicians.

Even the most permissive observers, who are not offended by sexually explicit art, are disturbed by religious images such as Andres Serrano's *Piss Christ*. When a photograph of a crucifix immersed in a container of the artist's urine appears, then we are in the realm of blasphemy. This photograph is much more offensive than any of Mapplethorpe's because rather than being designated simply pornographic, it is a direct attack on the most respected and powerful symbol of Christianity. This photograph is a postmodern way of smashing the Ten Commandments. The desecration one feels when looking at it is probably similar to how the Druids felt when their groves were cut down and how the Canaanites felt when their statues were broken.

A photographic montage by Carolee Schneemann, entitled *Unexpectedly Research*, is comprised of stills from Schneemann's performances, artworks, and films and is composed of eight segments, each containing two images with text above each segment. On the left side of each section is a still of one of Schneemann's works next to images of various goddesses, lions mating, and two of her other works. The text over the images reads: "unexpectedly her research—into the archaic goddess figurations—revealed striking precedents for—images of her lived actions—each equivalence is discovered—after months or after years—the energy which drove—concept to occupy her own body."[24] *Unexpectedly Research* clearly demonstrates that the current secular debate of censorship in art is a revival of the original theological prohibition of images. This time contemporary artists, who previously would have been called pagans, heathens, and idol worshippers, are reintroducing pluralistic ideologies. Throughout her career Schneemann has had to deal with her images and performances being censored, including an incident where a man from the audience came on stage, pushed her against a wall, and tried to strangle her. In an article entitled *The Obscene Body/Politic*, Schneemann posed specific questions regarding why her work was constantly censored. An answer to those questions: Yes, her work is judged obscene because she uses the body in its actuality. Her photographic works are self shot without a controlling eye, and she posits the female

body as a locus of autonomy. But more specifically, Schneemann's images and performances represent a spirituality that is in direct conflict with patriarchal, monotheistic beliefs. In a society of Goddess worshippers, her work would probably be placed in a similar sacred context and be accorded as high a level of respect as a crucifix receives in a community of devout Christians.

It is not just a coincidence that prohibitions on images coincide with political or religious upheaval. There is a direct correlation between the veneration of objects, and political-religious power. To challenge the theological prohibition of images is to confront the ethical and moral tenets of the three monotheistic religions, and the political structures of the societies they represent. The current issue of censorship in art is not just another First Amendment rights debate. Rather, the debate over censorship is a struggle between those who wish to retain the ethics and morality of a monotheistic society, and artists who are attempting to introduce an entirely new, pluralistic paradigm.

A sure method of maintaining a male-dominated, monotheistic society is to have a moral commandment that prohibits not simply images but the creative process of art. According to biblical ideology, the concept of creativity is sacrilegious when the human drive towards creation leads to ideals that are different from those proscribed. Ritual Art, Earthwork Art and postmodern spiritual objects represent those "different" ideals and, biblically speaking, are the material representation of "other gods," thus they may be seen as postmodern idols. Contemporary artists have simply rekindled the confrontation that transpired in ancient Israel: monotheistic versus polytheistic ideologies. Artists are reclaiming the sacred by uniting unconventional forms of spirituality with the aesthetic and integrating the result into society. The following chapters examine the various and unexpected aesthetic manifestations of the spiritual in contemporary society.

NOTES

A version of this chapter was presented at the 1995 annual meeting of the College Art Association as part of the panel entitled *The Subjugation of the Spiritual in Art*, cochaired by myself and Debra Koppman. Other versions were presented at Mercer County Community College Distinguished Lecture Series in Trenton, New Jersey, The School of Visual Arts Eighth Annual National Conference on Liberal Arts and the Education of Artists in New York City, and the Thirteenth International Congress of Aesthetics in Lahti, Finland.

1. J. H. Hertz, ed., *Pentateuch and Haftorahs* (London: Soncino Press, 1989) 295. This phrase also appears in various Hebrew and Christian Bibles in Exodus 20:3.

2. Merlin Stone, *When God Was a Woman* (New York: Harcourt Brace Jovanovich, 1976) 168.

3. Suzi Gablik, *Has Modernism Failed?* (London: Thames and Hudson, 1984) 21.

4. Henry Geldzahler, *New York Painting and Sculpture: 1940–1970* (New York: Dutton, 1969) 345.

5. Suzi Gablik, *The Reenchantment of Art* (London: Thames and Hudson, 1991) 87–88.

6. Gablik, *Reenchantment* 42–43.

7. Gablik, *Reenchantment* 44.

8. Gablik, *Reenchantment* 45.

9. RoseLee Goldberg, *Performance Art From Futurism to the Present* (New York: Harry N. Abrams, 1988) 164.

10. Lucy R. Lippard, *Overlay: Contemporary Art and the Art of Prehistory* (New York: Pantheon Books, 1983) 195.

11. Lippard 66.

12. Patricia B. Sanders, "Eco-Art," *Art Journal* 51.2 (1992): 80–81.

13. Sanders 81.

14. Sanders 81.

15. Howard Smagula, *Currents: Contemporary Directions in the Visual Arts* (Englewood Cliffs, NJ: Prentice-Hall, 1983) 262.

16. Gablik, *Reenchantment* 92–93.

17. Gablik, *Reenchantment* 92.

18. Lippard 225.

19. John Beardsley, *Earthworks and Beyond: Contemporary Art in the Landscape* (New York: Abbeville Press, 1989) 65.

20. Beardsley 65, 67.

21. Beardsley 67.

22. Beardsley 62.

23. Owen Barfield, *Saving the Appearances: A Study in Idolatry* (Middletown, CT: Wesleyan University Press, 1988) 110.

24. Carolee Schneemann, "The Obscene Body/Politic" *Art Journal* 50.4 (1991): 30.

2

VENUS/INTRA-VENUS

ART AGAINST AND AS THE BODY

CRISPIN SARTWELL

Hegel, describing and endorsing the dominant tradition in Western representation, held that "the sensuous is spiritualized in art." He said that works of art were the "primary bond of mediation between that which is exclusively external, sensuous, and transitory, and the medium of pure thought, between Nature in its finite reality and the infinite freedom of a reason that comprehends."[1] Now Hegel, like the Renaissance neo-Platonists, for example, thought of this as an exaltation of the physical and the sensuous. What, for Hegel, was physical and sensuous—in short, the body—was *qua* body, base. Its "spiritualization"—which, for Hegel, was also an attempt to bring the body to reason, to master it by reason—was, hence, its ascension. But the spiritualization of a body is also that body's death, so that to exalt the body in this way is to kill it.

I am interested in exploring the extent to which the spiritualization of the sensuous, the ontological apotheosis of the body in Western art, is also a violence to the body. The connection of these facts is, of course, no accident. To see the body as something which ought to be spiritualized is always also to denigrate it as it is. In fact, this is a denigration of the body in its essence, a denigration of the body precisely insofar as it is body, insofar as it is particular and physical. The spiritualization of the body in Western art is an expression of fear and hatred of the body, and in particular of the human body. This expresses itself as the idealization of the

19

body in depiction. Always this idealization is first, an abstraction away from particularity, so that the depicted body cannot be any actual person's body in particular. And always, second, it is a negation of or an assault upon the animality of the human body, denying its functions, for example, of reproduction and excretion.

1

The murderous idealization of the human body that constitutes, in many ways, the history of Western representation expresses itself in two intertwined subject matters: the spiritual and the erotic. Consider, for example, Grünewald's *Isenheim Altarpiece*. When closed, it displays with hideous exaggeration the brutalization of Christ's body. The depiction goes well beyond realism into a total immersion in suffering. The crucified Christ is horribly discolored and distorted, with particular emphasis placed on the hands. The body is covered with sores and wounds in a manner that surpasses even the most gruesome previous treatments of the subject. But the degradation of the body is treated in the overall composition as preparatory. The intensity of this degradation corresponds to and is necessary for an appreciation of the ideal beauty of the resurrection as depicted on the right-hand panel of the open altarpiece.

Through the work, violence to the body is directly connected with its idealization. Christ's body appears in *The Resurrection* etherealized, as an ideal human body that now expresses spiritual overcoming of the world, that is, of the physical. The viewer of the *Isenheim Altarpiece* is invited to identify with this process, to see suffering as a purification of the physical that is capable, finally, of volatilizing the body in an ecstatic moment into the realm of pure spirit. The body of the crucified Christ is utterly and intolerably particular; each wound is applied precisely. The body of the resurrected Christ is purged of all particularity. It is whitened to the point where specific features of physiognomy cannot be discerned, and it floats free of the earth in a balloonlike ascent. In the *Isenheim Altarpiece*, Grünewald tortures the body to death in order to transcend it.

I turn now to the erotic. Plato, in *The Symposium*, connects erotic love with idealization and abstraction in a way that became exemplary in the West. In the following passage, Diotima tells Socrates how to get from appreciation of boys to appreciation of nothing in particular.

> [W]hen his prescribed devotion to boyish beauties has carried
> our candidate so far that the universal beauty dawns upon his
> inward sight, he is almost within reach of the final revelation.
> And this is the way, the only way, he must approach, or be led
> toward, the sanctuary of Love. Starting from individual beau-

ties, the quest for the universal beauty must find him ever
mounting the heavenly ladder, stepping from rung to rung—
that is, from one to two, and from two to *every* lovely body,
from bodily beauty to the beauty of institutions, from institu-
tions to learning, and from learning in general to the special
lore that pertains to nothing but the beautiful itself—until at
last he comes to know what beauty is.

And if, my dear Socrates, Diotima went on, man's life is
ever worth the living, it is when he has attained this vision of
the very soul of beauty.[2]

Erotic love is, for Socrates, base, except insofar as it can be used as a
propaedeutic to abstraction, as a way to ascend toward the ideal. Thus,
erotic love, which in itself always particularizes, always seeks immersion
of a particular body in a particular body, is turned against itself. Ludi-
crously, we "ascend" in this passage from erotic love of boys to erotic
love of government agencies to erotic love of nothing in particular, that
is of general ideas. This process is a serial disembodiment; its goal is to al-
low one to use even sexual desire as a means of forgetting that one is an
animal body.

It is too familiar a point to need emphasis that this program is cen-
tral to the arts of the West. The paradigmatic erotic image of the Western
tradition is perhaps Botticelli's *Birth of Venus*. It is an embodiment, and
also a disembodiment, of male heterosexual desire. But in many ways it is
strikingly similar to Grünewald's resurrected Christ. The first step in ide-
alization is bleaching the skin; both skins are depicted as absolutely with-
out pigment. It goes without saying that there are no blemishes or
imperfections that would indicate particularity. The surface of Venus's
body is smoothed; there are no lines at all beyond what is minimally re-
quired to articulate a female body. Venus's face, like the resurrected
Christ's, is a cipher, systematically purged of any expression, blank with
the emptiness of the abstract.

Idealization is always violent; the process of idealization is always a
dismembering of the actual. But the structure of violation in Grünewald
is different from that in Botticelli. The Grünewald is essentially masochis-
tic; it emerges from an identification of the artist with the suffering
Christ. The structure of the Botticelli, however, is sadistic; it is the impo-
sition of an idealizing male will that compromises the particularity of the
female body. The actual female body—the particular female body with its
massed particularities—is never sufficiently beautiful. To be made beauti-
ful, the female body must be transformed: bleached, smoothed, emptied
of expression and of interiority. It must be pared down here and plumped
up there, its hair pulled out to impossible lengths, and so forth. All of

these acts are designed to create a worthy object of sexual desire, and to also construct the subject of desire as a person who is engaged spiritually, and not merely erotically, with the erotic.

In this picture and in thousands of others, beauty is identified with a rejection of particularity, and hence of embodiment, since all embodiment is particular. Beauty in this sense is sadism: the torturing of the actual for its intolerable actuality. Arousal can only be achieved here by forcibly transforming the object; finally, we can only be aroused by what we ourselves make. That fact turns us toward the actual with violence, makes us find sexual satisfaction in the transformation of the body of the partner. And it should be remarked briefly that it is not only the human body that gets treated this way. Everything that reminds one of the earth, everything physical, must be denigrated, dominated, and transformed before it can be accepted and utilized. In this sense, both the depiction of the earth in the landscapes of, say, Claude Lorraine, and the actual transformation of the earth by technology respond to the same displaced erotic desire. Technology, as Heidegger observed, is bound up with the modes of representation of the West. What these modes had in common, for Heidegger, was "enframing," the attempt to isolate something and render it wholly visible, so that it could be controlled and made available for use. And both enframing representation and technology are created out of an erotics of idealization.

2

But the West is not univocal. An affirmation of the body runs throughout that history in fitful oscillation with its damnation in Western spirituality and eroticism. One figure who spent his life in this affirmation was Rembrandt. For example, in his various paintings of Hendrickje Stoffels, Rembrandt's erotic desire is palpable. But Rembrandt's desire was never displaced from Stoffels's body to an idealized pseudo-object; Rembrandt always preserves the tokens of her total particularity. The *Bathsheba* of 1654 is as close as Rembrandt ever came to Botticelli's Venus. But even here, one detects the rolls of fat on Stoffels's belly and the musculature of her legs. She cocks her eyebrow in slight amusement. In *Woman Bathing* of the same year, Stoffels is absolutely particularized even in the midst of facture that is loose even by Rembrandt's standards. Her body is thick with reality and presence. She hikes her skirt up to keep it out of the water in a gesture that is both sexy and clumsy. And whereas Venus is a blank, Stoffels is, obviously, enjoying her bath, and perhaps enjoying being painted as well. There is in these paintings, as in everything Rem-

brandt ever painted, an allowance of things to be, and a respect for their externality to the painter and their particularity.

And if Grünewald's project is masochism for the sake of transcendence (and in some sense all masochism is for the sake of transcendence), then Rembrandt's self-construction as an alternative to masochism is no less dramatic. He painted himself with accuracy and honesty, with psychological insight that emerged essentially from physiognomic truth. He had a great respect for his own particularity, and refused every opportunity to transfigure himself—of all temptations the most tempting. That is, one can kill oneself in the attempt to transcend or idealize oneself. One can come to regard oneself as abstraction, and then every reminder of one's concreteness becomes intolerable. But Rembrandt holds his concreteness dear. And of course, these same features are found in his religious works, where he interprets the humanity of Christ, for example, not as the temporary, unaccountable lodgement of the spirit of God in the actual, where it must suffer from and for its actuality, but as God made real by being made physical, God enabled to be by becoming particular.

The negation and affirmation of the body in the West—where it is always negation that predominates—has continued into contemporary art. Indeed manifestations of this negation have intensified to fever pitch, with artists examining the issue through multiple layers of self-awareness. I turn now to contemporary examples.

3

The characteristic postmodern representations of the body actually use the body as a medium, breaking the issue out of the picture and into reality, thereby collapsing the distinction between the two. Now there have always been forms of art produced in or on the human body. Dance, for instance, uses the body as a medium, as does vocal music. In fact, it is just here that the Western loathing for the body is most evident. Ballet is a torture, especially of women. It is a constant attempt to locate the limits on the capacity of particular bodies to be made over into ideals and to transcend those limits. It is, thus, profoundly "unnatural"; it continually tries to make the body do what it cannot do, or can barely do. It is, like Botticelli's *Venus*, an exaltation of the body that is also, and here quite literally, an act of torture. Or again, consider the "trained" voices of the operatic tradition. This must be what the choiring cherubim sound like, or perhaps the torments of the damned, but it has as little as possible to do with the human voice. Opera is the human voice twisted, distorted, turned against itself. If you want to hear what the human voice sounds like when it is

lifted in song, listen to Tammy Wynette or Billie Holiday; the "trained" voices of the Western choral tradition seek an idealized uniformity, a total loss of particularity that is, of course, identified with beauty.

But the radical recent move has been to turn the body into a picture, or to turn pictures into the body, so that the distinction between representation and reality—for example, between represented violence and actual violence—breaks down. Chris Burden's early works consisted of a relentless attack on his own body. The notion of the suffering artist has been thematized since romanticism. The suffering of the lonely artist is represented by *his* Christlikeness, and the voluntary pain he endures which signals transcendence of the physical. Burden enacted this role in his early performances. For example, in *Trans-Fixed* (1974), he had himself crucified on the back of a Volkswagen, and driven around a bit. Nails were literally driven through his hands. Here, he sought to become Grünewald's Christ. Now in one sense this is solidly, or rather hyper-intensely and hyper-consciously, in the tradition of Western religious art, where, again, a key moment is the identification of the artist with the sufferings of Christ. But additionally, the act of crucifying oneself on a car is so deranged that it demonstrates the insanity of the tradition it enacts. Burden's act is both postmodern Christian art and a *reductio ad absurdum* of the entire idea of a Christian art.

Burden accomplishes this reduction simply by moving the act out of the realm of depiction and into the realm of the actual, where even a mild version of Christ's suffering is revealed as a great violation. Or rather, what happens in *Trans-Fixed* is that the artist becomes the picture. As soon as representation collapses into reality, the violence in the representation comes home. In fact, the Western philosophical concept of "aesthetic distance" is an invention for the insulation of the actual from the pictorial. In the identification with Christ that is suggested by Grünewald, there is present the medieval festival of suffering. Rationalization of this concept which occurred during the Renaissance consisted largely in the creation of a meticulous distinction between image and reality, in a mitigation of the magical or religious power of the image (and this is a predominant theme in Hegel). By the time of Burden's work, this mitigation had been so thoroughly produced that the only way to retrieve the power of the image was to make the image actual.

Burden had himself shot. What was supposed to be a flesh wound turned out to be more serious. He had himself electrocuted. He spent five days in a locker, and twenty-two days on a platform above a gallery, without eating. This carnival of masochism would be playful if it were not for the seriousness which had to be mustered in order to accomplish

these works. Burden's work is a violence performed on himself, but it becomes truly equivocal or perhaps criminal in its enlistment of others to perform the violent acts. Burden had to be *nailed* to the car. Someone had to *shoot* him. And Burden has even elicited the assistance or assault of the average "art-lover." In one performance, he lay on a table next to a pin cushion, with a sign above him that said "please push pins into my body." Here, the art viewer is identified not with Christ, but with Christ's tormentors. The viewer is invited to *participate* in the violence that is represented in the Western tradition. Indeed, in his later works, which deal with weapons such as warplanes and submarines, he connects the assault on the body in Western depiction with the technology of killing produced in the masterpieces of defense technology. Burden has been particularly fascinated with the neutron bomb, a weapon that attacks bodies and leaves buildings intact.

Many of these themes are taken up and intensified in the work of the French artist Orlan, in whose work the erotic and spiritual run together in disturbing ways. Orlan's early performances included acts of measurement in which she assessed the scale of her body in relation to a cathedral and an art museum. She also did a series of *tableaux vivants* in which she photographed herself as "Saint Orlan" in a variety of artistic styles. These works were (perhaps parodically) religious, with a charged erotic overtone. For example, she would expose one breast from beneath her vestments. But the work for which Orlan has become notorious is her own body. She began in 1990 a series of seven plastic surgery operations designed to turn her into a sort of compendium of Western idealizations of the female body. By the end of the process, she is to have the chin of Botticelli's *Venus*, the forehead of the *Mona Lisa*, the mouth of Boucher's *Europa*, and so forth. She thus becomes an anthology of heterosexual male fetishes; she is self-constructing and self-destructing into a pure object. The process by which this is accomplished, however, becomes a series of works in its own right, as surgery becomes videotaped performance complete with costumes, music, and props. She has even used her own flesh—removed by liposuction and placed in vials—as relics of the performances, and of the woman, now transformed, who performed them.

Orlan practices a technique of idealization that is as old as the Greeks: taking the best parts of several bodies and combining them. As Leone Battista Alberti puts it: "it will help to take from all beautiful bodies each praiseworthy part . . . for perfect beauty is not in one body alone, but [beautiful parts] are dispersed . . . in many bodies."[3] This displays both the dependence on the actual that is inescapable even for the most abstracted pursuers of the ideal (even Socrates needed his boys), and the

imaginative violence that must be performed in the transcendence of the actual through the technique of dismemberment.

Orlan takes this violence out of the realm of imagination and into reality: she has herself dismembered. She makes her own body the medium of representation of the female body in Western art; like Burden, but with more persistence and more permanence, she violates the rationalist distance between representation and reality, collapsing them both into her own body. She is both artist and work, object and subject of desire, idealized sexual image and masturbatory fantasist. Above all, she makes of herself the violation that is both a cause and effect of the representation of the body in Western art. Like Grünewald's Christ, she martyrs herself to transfigure herself; she is the *Isenheim Altarpiece* simultaneously closed and open. Her work shows the connection—obvious but necessarily repressed—between the ideal of "self-improvement" that motivates plastic surgery, and the self-loathing that motivates the self-improvement.

In one way, she has seized control of herself, which, when you think about it, is a rather odd notion. When one seizes control of oneself, what, exactly, has seized control of what? To seize control of oneself presupposes one's fragmentation, and Orlan the artist here seizes control of Orlan the representation. In another way, however, she has allowed herself to be made use of by those who assault the female body with their ideals. In this way, she embodies the seductive power of images. The image doesn't, like the word, seek to browbeat you into obedience; it doesn't actually *tell* you anything. It invites you to *mimesis* by its own mimetic structure and its glamorous surface, its pushing outward of all interiority. Thus, Orlan has both been seduced and become a seductress; she is, finally, the seductress of herself. She says: "Being a narcissist isn't easy when the question is not of loving your own image, but of re-creating the self through deliberate acts of alienation."[4]

Orlan, hence, is the last picture, the final representation of the female body in the West. She transfigures herself into a picture and seeks entrance into the flattened, stilled, ontological dimension of images. But she remains a particular body: flesh and blood and bone. An appropriate conclusion for her work (which will, in any case, be its actual conclusion, since her body is her work) is death: the final degradation and destruction of the body. Here, as everywhere, to idealize something is to destroy it; the impulse to love, displaced from the actual to the ideal, is the impulse to destroy the actual. Orlan displays this connection with absolute precision: every act by which she transforms herself toward beauty is an act by which she destroys herself.

4

If Burden and Orlan are heirs of Grünewald, Piero Manzoni is an heir of Rembrandt. Whereas Rembrandt celebrated in images the particular physical actuality of the things of this world, Manzoni uses the actual things. This again, is the characteristic postmodern collapse of representation and reality, which can be used, just as can images, to destroy or to affirm the world. For example, Manzoni in 1961 made *Base magica*, a stone pedestal that transformed anyone who stood upon it into a "living sculpture." Manzoni would then "sign" his work, including himself, with a marker. Here, one becomes one's own portrait. Now a portrait (think of Hals, for example) can allow its subject to be what he is, or it can seek to make her over into a great hero, beauty, or whatever. To repeat, the latter case is both celebration and imaginative assault. But there is no question of a living sculpture losing its particularity; whatever particularity is possessed by the motif is possessed by the picture of it because these are now numerically identical. Manzoni's *Base of the World*, which rests inverted on the ground, turns the earth as a whole into a living sculpture. This could be seen as precious aestheticism; turning the world into art. But I think of it in Manzoni's case more as an attack on aestheticism, as an attempt to turn art into the earth. Now art has always been earth in permutation; we have nothing to make things out of but what we find here. But the ontological ladder of Plato and the idealizing impulses of artists have tried to deny or evade this fact, have tried to open a gap between art and reality. Manzoni's *Base of the World* is a reminder that this gap is an illusion. Thus, Manzoni seeks to efface two ontological distinctions simultaneously: the distinction between the materials out of which the work is made and those materials as transfigured into art, and the distinction between the representation and reality. The whole project, then, seeks to bring art back to earth, and thus to reinvest it with magic.

Manzoni's most notorious work is *Merda d'artista* (*Artist's Shit*). Manzoni canned ninety samples of his excrement, labeling, numbering, and signing each can. These works were then to be sold for the price of gold at the time of the sale. This is a wonderfully playful attempt to recover the body for art. Try, for instance, to imagine the resurrected Christ or Botticelli's Venus taking a dump. The denial of excretion in these images is entailed by their denial of mammality, of animality. What is purged in idealization is any very vivid sign that the idealized object is a beast, though it is this very bestiality—the humanity of Christ, the sexuality of Venus—that makes these objects appropriate in the first place for idealization, that motivates that idealization. Making shit into art is at

once an outrageous attack on the Western tradition and a trivial play on such notions as production, creation, and expression (what is expressed is what is *pushed out*).

It would be possible to represent shit in an idealized form, as the Western tradition is perfectly capable of depicting what it despises. But the loathing for the depicted shit would be obvious; possibly, whatever in shit is visibly disgusting would be emphasized, as whatever is visibly disgusting in Christ's physical suffering was emphasized in the *Isenheim Altarpiece*. What marks Manzoni's work as an affirmation is its great playfulness. This playfulness is present in Rembrandt's bathing Hendrickje, but is conspicuously absent even in the flimsiest pretty Botticellis. Manzoni plays with his shit, and simultaneously, plays with his art and with the Western art tradition. Such play is more deadly to that tradition than any refutation; humor is always fatal to pretension. There is a wonderful photograph of Manzoni in a bathroom, holding one of his cans. He has on his face what can only be termed a "shit-eating grin." His smile seems appropriate, first, to the satisfaction that derives from successful defecation, and second, to the satisfaction that derives from pulling off a good joke. In short, Manzoni's work playfully recovers the body in its entirety, and in particular in its obviously animal aspects, for Western art. It is doubtful, however, that Western art can survive many such recoveries for it is deeply invested in the strange loathing of an animal for itself as animal.

The work which, I think, most fully enacts the recovery of the animal body is that of Hannah Wilke. Through her work, Wilke obsessively focused on her own body. Wilke focuses on herself as an analogue of the "male gaze," as does Orlan. But unlike Orlan, Wilke's depictions of herself invest her, as she is at the time the work was made, with power. Wilke used her body erotically, refusing idealization, except in certain ironic respects. For example, in her 1985 performance *So Help Me Hannah*, she lolled around nude, (except for high heels) through a building as she was videotaped and photographed from all possible angles. It was a parody of the making of a porn movie. But Wilke choreographed the whole production herself; she made herself the object. In fact, Wilke says that her art is dedicated to "respecting the objecthood of the body."[5] Notice that though in one sense, Venus is a "sex object," in another sense she suffers a problematic loss of objecthood. Every object is physical, particular, actual. But Venus is abstracted, generalized, impossible. Wilke maintains her body as a sex object in order to relentlessly emphasize its realness, the realness of herself.

In *So Help Me Hannah*, Wilke was also toting a pistol. So here was this sexy woman, rolling around the floor in high heels, but with a

weapon. The pistol was at once her own phallic appreciation of herself as an object, her own deadly gaze focused on herself, and her response to the sexual desire she aroused in the people who saw the performance, especially in photographs or videotapes, where her physical presence would be, in the familiar fashion, attenuated. Wilke's objectification of herself is a recovery of herself as real. It is, hence, a response both to the appropriation and dismemberment of the female form in Western art, and a response to the shift in some feminist theories toward trying to forget the sexual altogether. Wilke's critique of feminism, which became explicit in such works as her poster *Marxism and Art: Beware of Fascist Feminism*, is devastating, though she was herself a feminist. She criticizes feminism for de-eroticizing the female body, for making it "spiritual" rather than animal, for creating a new asceticism, a mortification of the flesh.

The still photographs from *So Help Me Hannah* are a systematic recovery of animal functions. For example, in one still she appears with legs spread in what is an almost pornographic pose among toy Mickey Mice and guns. The image includes a quotation from Ad Reinhardt: "WHAT DOES THIS REPRESENT? WHAT DO YOU REPRESENT?" It thus immediately confronts you with the fact that you are looking at a sex object, and asks you how you are responding. Another still shows Wilke standing over a toilet peeing, holding her pistol. Her expression looks strikingly like Manzoni's in his bathroom. Her imitation book jacket of 1977–1978, *I Object: Memoirs of a Sugargiver*, again shows her spread out for sexual delectation, and again plays with this notion. Does she object to being used in this way, or to feeling compelled to use herself this way? Or is she writing her own autobiography: *I, Object*?

In *Hannah Wilke Super-T-Art* of 1974, she records in photographs her own striptease. One shot, in which Wilke is stripped down to a loin cloth that Joanna Frueh rightly describes as "Christlike," has her toying with her breast. She used this image again wrapped around a series of cans. These cans were in turn used in a 1978 performance: *Give: Hannah Wilke Can—a Living Sculpture Needs to Make a Living*, in which Wilke posed sexily, soliciting contributions to be inserted by the viewer into the cuntlike slots of the "Hannah Wilke Cans." Here, she brings together the erotic and the spiritual, sexuality and charity; she identifies Christ with Venus (and many of her works, for example *Venus Envy*, make explicit use of the Venus archetype), the sufferings of crucifixion with the idealization of depiction. Indeed, in the neo-Platonic tradition, the erotic is consistently called into the service of the spiritual, as it is in the quotation from Plato above. Part of the attraction of Christianity has always been Christ as sex object, and a sexy Christ appears in the conventionalized images found in Christian homes and churches. This is the Christ that, for

example, pierces St. Theresa with his golden arrows. The penetration of
Christ's own body by nails and spears also surely holds a certain erotic
power. Ultimately, Christ and Venus participate in the same structure of
depiction and desire.

It would be easy to accuse Wilke of wanting to have it both ways, of
wanting to be both a male-articulated Venus and a feminist. The fact that
a beautiful woman is purveying herself as a sex object while simultane-
ously laying claim to a feminist criticism of Western depiction is surely
problematic. Yet the end of her project makes it impossible to deny its
sincerity and power. Wilke died in 1993 of lymphoma. As she underwent
the long series of degradations that led to death—the chemotherapy, the
radiation, the hairloss, the bone marrow transplants—she continued to
make her own body the center of her work. Her final series, titled *Intra-
Venus*, displays the body in decline and violation with shattering truth.
She constructed sculptures from the lead guards of her radiation therapy,
the tubes and the bloody bandages produced by the harvesting of her
bone marrow, the hair that fell off her head. Additionally, she pho-
tographed herself as she turned from the conventionally beautiful woman
of her earlier work to the conventionally horrifying body of her decline
toward death. These images are as close as contemporary art gets to
Grünewald's crucified Christ. But here there is no disembodied redemp-
tion, only totally embodied death. She had, in fact, recorded her mother's
death from cancer in the early eighties with the same unflinching gaze, ex-
hibiting juxtaposed images of her own nubile nudity in *So Help Me Han-
nah* with pictures of her mother's mastectomy scar at the New Museum
in New York.

Death is as much a reminder of embodiment, of objecthood, as is
sex or excretion. Death, in fact, is something we absolutely require for the
truth of our particularity; death is our temporal bound. Wilke devoted
herself to displaying every reminder of particularity. She did not flinch
from the total implication of her identification of herself with her body.
In one image from *Intra-Venus*, she sticks out her tongue, much as she
might have in her earlier work. But now her tongue is split by the effects
of chemotherapy. As she said in 1980, ten years before her final illness:

> To get even is to diffuse the dangerous power of male separatist
> religious ideals; the virgin as superior being, the nun, the celi-
> bate priest, the bleeding Christ—a female fertility figure in dis-
> guise . . . recognizing the marks, the wounds, the suffering, the
> pain, the guilt, the confusion, the ambiguity of emotions; to
> touch, to cry, to smile, to flirt, to state, to insist on the feelings
> of the flesh, its inspiration, its advice, its warning, its mystery,
> its necessity for the survival and regeneration of the universe.[6]

NOTES

A version of this paper was presented at the 1995 meeting of the College Art Association as part of the panel entitled *The Subjugation of the Spiritual in Art*.

1. G. W. F. Hegel, *Aesthetics*, trans. T. M. Knox (Oxford. Clarendon Press, 1975) 2.

2. Plato, *Symposium*, trans. Michael Joyce, in *Plato: Collected Dialogues* (Princeton: Princeton University Press, 1961) 562–63.

3. Alberti, *Della pittura*, quoted and translated in Erwin Panofsky, *Idea: a Concept in Art History*, trans. Joseph J. S. Peake (New York: Harper and Row, 1968) 49.

4. Quoted in Barbara Rose, "Is it Art? Orlan and the Transgressive Act," *Art in America*, 81.2 (1993): 83.

5. Quoted in *Hannah Wilke: a Retrospective* (exhibition catalog), text by Joanna Frueh (Columbia, MO: University of Missouri Press, 1989) 41.

6. Quoted in *Hannah Wilke* 141.

3

MICKEY, MINNIE, AND MECCA

DESTINATION DISNEY WORLD, PILGRIMAGE IN THE TWENTIETH CENTURY

CHER KRAUSE KNIGHT

All pilgrimages, whether ecclesiastical or secular, share the basic component of a journey—always spiritual and usually physical—to achieve a specified goal. Most pilgrimages are linear, centripetal journeys to a common center, conforming to Arnold van Gennap's tripartite model of the rites of passage: separation from the home community, transition or liminality, and reincorporation into society.[1] Among the secular pilgrimages of the twentieth century should be included Walt Disney World in Florida, where time and space are collapsed in eternal, freeze-dried (much like Walt Disney is reputed to be himself) images of American culture.[2] The Magic Kingdom's Fantasyland, Adventureland, Frontierland, Liberty Square, Tomorrowland, and Main Street, U.S.A., allow pilgrims to live out their fantasies of the past, present, and future at will.[3] Furthermore, the ritualistic procession of visitors through liminally organized space, and reverence for architecture and monuments as though they were shrines, enhance our experience of Disney World as a place for contemporary forms of worship in a consumer culture.[4] The question remains as to whether or not the simulacra of Disney can satisfy our cravings for a supernatural "Other," and rival the relics and shrines of the past.

The goals of pilgrims may vary and overlap greatly; certainly Disney's visitors seek entertainment and celebration, but in our culture the Disney World pilgrimage is nearly obligatory for middle-class parents and children.[4] Like a haijj returned from Mecca, a child back from Disney World is the envy of all his or her friends. A trip to Disney World also marks a plateau of achievement; consider those television commercials which picture American sports heroes proclaiming "I'm going to Disney World!" as their reward.

Although the decision to undertake a pilgrimage may be individual, once on the journey the pilgrim engages in a *communitas* formed of peoples of different cultures who temporarily share a common set of norms and values. This temporal, homogeneous community enhances our excitement, comforts us, and strengthens our ideals with the knowledge that others share them. This bonding of "humankindness" may seem classless but is actually rooted in an exclusivity, the conviction that "our" belief system and pilgrimage center are supreme to all others. Social interaction is crucial for Disney pilgrims who travel in groups, stand in line and brave the attractions together, and congregate to dine and lodge.

Scholars have often categorized pilgrimage as a structural process, citing its ritualistic qualities such as scheduled activities and specific rules of conduct. Pilgrims do not congregate spontaneously but group in an organized manner at a supervised site. According to anthropologist Alan Morinis, "because pilgrimage places tend to enshrine collective ideals, pilgrimage is usually a conservative force that reinforces the existing social order."[5] From the start, Walt Disney World was planned as a highly institutionalized entity, where the mass movement of visitors is tightly regulated and synchronized to achieve the optimal pilgrimage experience. There is an intellectual and moral uniformity of conduct and thought among the pilgrims, whose goals and moral ideals are higher than in the everyday world.[6] At Disney, these goals and ideals are nothing short of universal niceness and total world peace, in a Disneyfied context, of course.

Victor Turner, a pioneer of pilgrimage study, maintains that pilgrimage is "ordered anti-structure" which temporarily disrupts the social fabric.[7] Thus, pilgrimage may either emerge from the serious purposes of obligation and initiation, or from a choice to engage in essentially voluntary play.[8] Pilgrimage was, from the beginning, a combination of "devotion with pastime and mirth."[9] The ease of travel in the modern age makes pilgrimage seem an act of "curiositas," (that is, curiosity-seeking)[10] rather than devotion, but pilgrimage has never been beyond criticism as Turner reminds us:

> The apparent capriciousness with which people make up their
> minds to visit a shrine, the rich symbolism and communitas
> quality of pilgrimage systems, the peripheral character of pil-
> grimage vis-à-vis the ritual or liturgical system as a whole, all
> make it suspect.[11]

Free from the social constraints of his or her home community, the pilgrim
was open to corruption and temptation. The pilgrim would often visit sec-
ular sites while en route to the center, get drunk and be gluttonous, and en-
gage in casual sex, among other "sinful" behaviors. Although Disney
World is not a place of vice, it is the grandest of playgrounds. Play, how-
ever, is as ritually charged as worship, especially when it is as organized
and routinized as it is at Disney World.[12] The talking animals are congenial
and even rowdy kids are coaxed into good behavior, and thus play func-
tions as a socializing agent.

Yet Walt Disney World is more than a playground. Those who visit
the site display behavior akin to devotional pilgrims. The anticipation
with which pilgrims await and prepare for a visit to Disney World, the ex-
hilaration they experience while there, and the vivid memories they bring
home with them are like those experienced by other pilgrims at more tra-
ditional pilgrimage centers.[13] As devotional pilgrims, Disney visitors pay
homage to Walt Disney's utopian vision, seeking encounters with him
through his intervening agents, Mickey, Minnie, and Goofy. The restora-
tive powers of Walt Disney World and Disney's role as a curative oracle
should not be underestimated. Mourning Walt Disney, Eric Sevargid, a
longtime Disney employee, eulogized:

> He probably did more to heal or at least soothe troubled hu-
> man spirits than all the psychiatrists in the world. There can't
> be many adults in the allegedly civilized parts of the globe who
> did not inhabit Disney's mind and imagination at least for a
> few hours and feel better for the visitation.[14]

According to anthropologist Alexander Moore's criteria, Walt Dis-
ney World is a traditional pilgrimage center of formally bounded ritual
space.[15] Its pilgrims engage, often en masse, in shared activities and par-
ticipate in Van Gennap's tripartite rites of passage. The center also con-
structs cultural myths through Disney fairy tales, cartoons, and lore, and
displays universally recognized figures (the most pervasive of these being
that rodent ambassador of good will, Mickey Mouse, whose likeness
plasters Disney World like the Barberini bees of baroque Rome).

Soon after Disneyland opened in 1955, Anaheim grew into a jungle
of hotels, restaurants, and parking lots catering to the pilgrims. Shortly

thereafter, Walt Disney secured 27,400 acres (twice the size of Manhattan) of what was essentially swampland in Florida, to buffer his new park against the evils of un-Disneyfied society.[16] The Florida facility, which opened in 1971, is the larger and more venerated one, offering not just the Magic Kingdom found in California, but also Epcot Center (an acronym for the Experimental Prototype Community of Tomorrow, a World's Fair–type theme park), MGM Studios (a Hollywood film theme park), several water parks, a shopping village, and Pleasure Island (a nightlife theme park for the adults who comprise eighty percent of Disney World's annual thirty million visitors).[17] Disneyism also has major outposts in Japan and France, and minor shrines—The Disney Stores—in nearly every American shopping mall.[18]

It is essential to acknowledge the conscious development of Disney World as a sacred place for an increasingly secularized culture. From its inception Disney was designed for ritualistic procession through space, with shrinelike structures and pathways emphasizing the visitor's participation in a rite of passage. The pilgrim to Disney World crosses through numerous clearly marked thresholds—a series of symbolic and commercial barriers including Disney-owned and operated highways, parking lots designated by Disney characters and symbols, the human-made Seven Seas Lagoon, the Contemporary Resort—before entering the Magic Kingdom proper. Everyone then passes through an admission gate and directly into one of two entrances to the park, which bring them to Main Street, U.S.A. Once inside the park, the controlled experience of space continues as the path past the uniform Main Street buildings leads the pilgrims directly to the circular plaza fronting Cinderella's Castle, the spiritual and physical heart of Disney World. From this plaza radiate wide pedestrian walkways to the various themed "lands" laid out in a roughly oval plan. The similarity to Baroque capitol planning is marked as Disney World takes on the Baroque symbol of the solar system in the form of a sundial with avenues encircling the seat of sovereign power to which a grand boulevard gives access.[19] As noted by Moore, "this baroque ground plan, the expression of a world order thought to run mechanistically by divine clockwork, was also the staging for royal, secular rituals to glorify that baroque order."[20] Disney World operates on the same kind of self-reinforced images of power set within a metaphorical system.

Queuing up and winding around roped-off lines, the Disney pilgrim experiences a heightened thrill, perhaps akin to the spiritual awakening of a Buddhist or Hindu pilgrim circumambulating at a shrine. The rides and attractions unique to Disney emphasize liminal passage in "the form of mini-phases of separation, transition, and reincorporation as the

passenger journeys past electronically manipulated symbols evoking well known myths."[21]

The medieval pilgrimage center of Santiago de Compostela on the Iberian peninsula (an interesting comparison to Disney World's Floridian peninsula), offers a strong analogy to Disney. During the height of its popularity in the eleventh and twelfth centuries,[22] the difficult site was made accessible with new bridges and roads, and its prestigious cathedral was rebuilt in the latest Romanesque style. Compostela is nationalistically significant for Spaniards, as Walt Disney World is for Americans, or those receptive to American culture (contrast the success of Tokyo Disneyland as opposed to the problematic French Euro Disney, dubbed "Euro Disaster" by David Letterman). The martyred apostle St. James became the patron saint of Spain during its reclamation from Moorish domination.[23] St. James, whether his relics are really there or not, endures at Compostela and affirms the power of Christianity, similar to the way the eternally youthful Mickey functions as a living testimony to Walt Disney's legacy.

Pilgrimage to Compostela was heavily promoted.[24] Guides, like contemporary travel agents, arranged lodging and instructed pilgrims in the correct behavior and performance of rituals. The Cluny monks were the most ardent promoters of Compostela. Since their monasteries were on the pilgrimage route, travelers could stay at their establishments, and like Disney-owned and operated resorts, towns grew up around these establishments.[25] Once there, describes medievalist Marilyn Stokstad, "the city must have seemed more like a commercial than a religious center. The streets were lined with shops, taverns, and hospices catering to the pilgrims' needs."[26] The layout of Disney World is clearly akin to Compostela, a city whose oval-planned space is bounded by city walls with a magnificent cathedral at its heart. In the square adjacent to the church was the *Paraiso*, a commercial center where one could find money-changers, make arrangements with innkeepers, and buy all types of goods, including souvenirs which functioned as sacred traces, visibly tracking the former presence or passage of people, ideas, symbols, and experiences. Souvenirs provided physical proof of a deity's existence, completion of the pilgrimage, and advertising for the site.[27] The most popular souvenirs at Compostela were cockle shells, symbols of St. James and good works. By the twelfth century, lead badges that replicated the shells became Compostela's official emblem, and church authorities controlled their sale in much the way Disney World licenses and merchandises its own products.

Disney World's sacred traces are numerous; everywhere we see T-shirts, toys, postcards, television shows, movies, and comic books.

Anthropologist Stephen Fjellman cautions that one should not under-estimate the potency of Disney commercialism:

> We must remember that the business of the Walt Disney
> Company is business. . . . The Company—especially at its
> theme parks—produces, packages, and sells experiences and
> memories as commodities.[28]

While this commercialism may perpetuate the success of Disney World, it does not account for nor negate the pilgrim's devotion.[29] Fjellman himself recognizes this when he acknowledges Disney World's healing capacities:

> Our sense of powerlessness is fed by the institutions of modern
> life and by the uncontrollable behavior of others. What we buy
> at WDW is not just fun and souvenirs but is also a welcome ci-
> vility on a human scale.[30]

The development of travel literature was fostered at Santiago de Compostela as well. Practical travel data, initially passed by word of mouth, was eventually codified in guide books for pilgrims.[31] The most renowned guide to Compostela is the *Codex of Calixtus*, bearing the name of the Spanish pope Calixtus II, although neither written nor com-piled by him.[32] The Codex's fifth book, *The Pilgrim's Guide*, was the most popular.[33] This provided a Basque vocabulary guide and sightsee-ing itineraries, outlined travel routes, priced tolls, and explicated local conditions and lodging at Compostela and the towns along the pilgrim-age route. The author highlighted the best relics and shrines, which feast days to celebrate, and advised who and what to avoid, concluding with a detailed description of the city and cathedral of Compostela.[34] No differ-ent from Birnbaum's *Guide to Walt Disney World*, such comprehensive literature conditions our expectations and selectively directs our visit,[35] just as preplanned, contrived experiences like the package tour weed all of the real risks and surprises out of travel.[36]

Both Disney and Compostela have a constant influx of pilgrimage traffic, yet each has peak seasons which coincide with the climate and school holidays.[37] In order to accommodate more commercial pilgrimage, Compostela now celebrates St. James's festival day (a public holiday orig-inally in late December) on July 25. On that day high mass is televised and fireworks are set off in the church square, much like the daily parades and laser shows at Disney World. If Disney World is structured analo-gously to a medieval site of ecclesiastical devotion, then one must also acknowledge Compostela's increasing and ironic kinship with the cele-bratory, secularized nature of a contemporary vacation destination. Pil-grims to Compostela come to enjoy the good weather and good times,

just as Disney pilgrims come not to worship a martyred saint but to shake hands with Mickey and get away from it all.

Spiritual magnetism—the pilgrimage center's drawing power—is not hinged solely upon the intrinsic holiness of a site but is also affected by social, geographical, historical, and economic factors, and the variable needs of individual pilgrims.[38] It is also enhanced by the strength of national, civic, or cultural identity at the site. Americana is a "civil religion" of sorts with its own cult of relics including the flag, the Constitution, and Mickey Mouse (the model of American innocence, ingenuity, and integrity), and rites of passage, including the trip to Disney World.[39]

Walt Disney, like the Wizard of Oz working miracles from behind a curtain, conceived of Disney World as a metaphor for the ideal society, a prototype for other cultures to follow.[40] His utopia was intended to do more than entertain good citizens—it would also fortify and sustain them. Disneyland was the first amusement park to be themed; all of the characters, costumes, food, architecture, landscaping, and merchandise are interrelated to create a fantastic atmosphere where everything is cleaner and friendlier than in real life. The "Other" is alive and well at Disney World; technology offers the supernatural promise of the twentieth century, the triumph of humankind and machine over the future and death. According to designer John Hench, fears are squelched by testing ourselves in Disney's safe environment:

> Actually, what we're selling through the park is reassurance. We offer adventures in which you survive a kind of personal challenge. . . . But in every case, we let you win. We let your survival instincts triumph over adversity.[41]

As a "touristic space" set up specifically for the performance of rituals to reassure and divert us, Disney World may appear to be unstructured, but the experience actually offers us more control than we have in our everyday lives.[42] Touristic spaces are permissible and even beneficial, sociologist Erik Cohen advises us, as long as the visitor to them is a "willing accomplice, rather than a stooge," in the "semi-conscious illusion [of the] game of touristic make-believe."[43] At Disney World, one can jump into the future, have local color neatly packaged for them, or visit nearly all of Continental Europe in one day. A Disney engineer explains: "It's a *concentrated* form of nature . . . we string together all the experiences you might see in a lifetime into one thing."[44]

The unnaturalness of Disney experiences should draw our attention, if not our concern. These are so smoothly navigated, however, that the contention that what is offered is a "concentrated form of nature"

seems reasonable. Disney World is a place of "staged authenticity" at which the falseness of the experiences and relics is known to and forgiven by the pilgrims (compare this to traditional religious pilgrimages which lost clout when the authenticity of relics was questioned).[45] Disney World echoes our own secondhand, "museumized" culture displaying all for our delectation, as we have homogenized experiences in which everything is done for us and brought to us.[46] Here we make no concessions or adjustments to others, but rather expect to be spoon-fed the exotic and different in small, digestible doses that mirror our own culture rather than depart from it. At Disney World, nothing is experienced in situ but is encountered out of context,[47] yet the power of the Disney simulacrum is so intense we accept it as authentic.[48] Entranced by—yet lamenting the vigor of—Disneyism, architect and critic Michael Sorkin observes:

> Disney is the cool P. T. Barnum—there's a simulation born every minute—and Disneyland the ultimate Big Top . . . propelling its visitors to an unvisitable past or future, or to some (inconvenient) geography. . . . One has gone nowhere in spite of the equivalent ease of going somewhere. . . . For millions of visitors, Disneyland is like the world, only better.[49]

It may be too early to assess the dangers implicit within the simulacrum. I myself am aware of these potential hazards, however, I still cannot imagine a better respite from world-weariness than that found in Orlando. Disney World, here I come.

NOTES

1. Arnold van Gennap, *The Rites of Passage* (1909; London: Routledge & Kegan Paul, 1960). Van Gennap's tripartite structure of pilgrimage is outlined by Edith Turner, "Pilgrimage: An Overview," *The Encyclopedia of Religion*, vol. 2, ed. Mircea Eliade (New York: Macmillan Publishing, 1987) 328.

2. We may count visits to Elvis Presley's Graceland, Lenin's Tomb, and the Vietnam War Memorial as examples of such secular pilgrimages.

3. These are the fantasies of children's literature, adolescent literature, the romantic, untamed environs of the world, epic history, the future, and nostalgic Americana respectively.

4. Instrumental pilgrims pursue finite, limited goals such as entertainment and escapism; normative pigrimages are made to break routine cycles and are often at times of celebration; initiatory pilgrims aspire to a sort of transformative status via rites of passage; an obligatory pilgrimage is made out of a sense of duty;

while devotional pilgrims pay homage to and seek encounters—often solely symbolic—with a divinity. See Alan Morinis, "Introduction: The Territory of the Anthropology of Pilgrimage," *Sacred Journeys: The Anthropology of Pilgrimage*, ed. Alan Morinis (Westport, CT and London: Greenwood Press, 1992) for a fuller explication of these pilgrimage typologies.

5. Morinis 24.

6. Emile Durkheim, *The Elementary Forms of Religious Life*, trans. J. W. Swain (London: Allen & Unwin, 1915) 5.

7. Victor Turner, *Process, Performance and Pilgrimage* (Atlantic Highlands, NJ: Humanities Press, 1979) 154.

8. Victor and Edith Turner, *Image and Pilgrimage in Christian Culture: Anthropological Perspectives* (New York: Columbia University Press, 1978) 37.

9. Victor and Edith Turner, *Image* 38.

10. Michael Costen, "The Pilgrimage to Santiago de Compostela in Medieval Europe," *Pilgrimage in Popular Culture*, ed. Ian Reader and Tony Walter (London: Macmillan Press, 1993) 153.

11. Victor and Edith Turner, *Image* 31.

12. Alexander Moore, "Walt Disney World: Bounded Ritual Space and the Playful Pilgrimage Center," *Anthropological Quarterly* 53.4 (1980): 207.

13. Notoji Masako, *Dizunirando to iu Seichi* (The Sacred Place Called Disneyland) 141, quoted by Reader and Walter 6.

14. Eric Sevargid, quoted by Randy Bright, *Disneyland: Inside Story* (New York: Harry N. Abrams, 1987) 88.

15. Moore 208–9.

16. See Richard Schickel, *The Disney Version: The Life Times, Art and Commerce of Walt Disney* (New York: Simon and Schuster, 1985) for a detailed discussion of Disney World's conception and evolution, as well as the financial and commercial aspects connected with it. Also, "Recreation: Disneyland East," *Newsweek* 29 November 1965: 82 provides a brief contemporary account of Walt Disney's disillusionment with the overnight development of Anaheim around Disneyland, and the initial planning of the Florida park.

17. Maxine Feifer, *Tourism in History: From Imperial Rome to the Present* (New York: Stein and Day, 1985) 252.

18. As relics were exchanged, relocated, or brought on fundraising campaigns during the Middle Ages in order to make them accessible to the masses, so too must Disney offer more than one shrine.

19. Moore 214.

20. Moore 214.

21. Moore 214.

22. Santiago de Compostela, St. Peter's in Rome, and the Holy Sepulchre in Jerusalem were the three major centers for medieval pilgrims.

23. According to legend, St. James "The Moorslayer" was beheaded by King Herod. By the ninth century St. James had a cultic following, intensified by

the rediscovery of his body over which a new chapel was built, as well as the later successes of the Crusaders.

24. While journeying to and once at Compostela, the pilgrims were treated with great hospitality and to great spectacles which satisfied the need for sensual experience and made the pilgrim feel the hardships of pilgrimage were all worthwhile.

25. At times the Cluny monks also sponsored pilgrims and organized trips to other pilgrimage centers. Even the archbishop of Compostela did promotional tours to Italy and France in the early twelfth century to stimulate pilgrimage traffic to his city.

26. Marilyn Stokstad, *Santiago de Compostela: In the Age of the Great Pilgrimages* (Norman, OK: University of Oklahoma Press, 1978) 41.

27. Marie-Madeleine Gauthier, *Highways of the Faith: Relics and Reliquaries from Jerusalem to Compostela*, trans, J. A. Underwood (London: Alpine Fine Arts Collection, 1987) 19.

28. Stephen M. Fjellman, *Vinyl Leaves: Walt Disney World and America* (Boulder, CO: Westview Press, 1992) 11.

29. Christine King, "His Truth Goes Marching On: Elvis Presley and the Pilgrimage to Graceland," Reader and Walter 100.

30. Fjellman 11–12.

31. The first such guide books offered basic information regarding lodging, measurement of distances, and way stations along the pilgrimage route. Gradually, this format evolved to include rates of exchange, maps, and phrase books.

32. Actually, the Codex was written in the twelfth century by a French pilgrim, Aimery Picaud, who used the pope's name to lend Christian credence to his text.

33. The first book details the offices of the church at Compostela; the second explicates the miracles of St. James and the third his life; the fourth book is concerned with Charlemagne's expedition to Spain.

34. Eleanor Munro, *On Glory Roads: A Pilgrim's Book about Pilgrimages* (New York: Thames and Hudson, 1987) 198.

35. Erik Cohen, "Toward a Sociology of International Tourism," *Social Research* 39.1 (1972): 171–72.

36. Daniel Boorstin, *The Image: A Guide to Pseudo-Events in American Society* (New York: Harper and Row, 1964) 77–78, 104.

37. Stokstad 49.

38. In terms of finance, pilgrimage was a fashionable practice and the expense of travel often meant that only the wealthiest or most important individuals got to make the journey. Geographical location was also an important factor. Since many revered sites are often set away from society—like Compostela and Orlando—the pilgrimage may have been undertaken only once in a lifetime. Difficult distances and terrain, the fear of crime or being taken advantage of, made pilgrimage a danger, which still exists to some extent today. Consider recent news stories of car-jacked and murdered pilgrims to Disney World. But the difficult

journey often paid off in the end with a sunny climate and a beautiful location. See James J. Preston, "Spiritual Magnetism: An Organizing Principle for the Study of Pilgrimage," Morinis 32.

39. An interesting comparison is the Grand Tour which was a rite of passage for European aristocrats. Grand Tourists, often accompanied by a guide like the "host" or "hostess" (Disney employee) who edifies the "guest" (Disney pilgrim), achieved moral improvement on Tour. The Grand Tourist also got to travel back in time, so it seemed, by visiting ancient and famous sites, and sought the exotic much as the Disney pilgrim would at Disney.

40. The original title for the Disney kiddie park was "Walt Disney's America," which reminds us that the utopianism of Disney World is derived from Walt's perspective. He intended Disney World to be a series of walk-through models of Norman Rockwell paintings, and attempted to sell this rosy-colored ideal of America with his "Disneylandia," a traveling exhibition for school children of animated shows on American folklore and history.

41. John Hench, quoted by Bright 237.

42. See Dean MacCannell, *The Tourist: A New Theory of the Leisure Class* (New York: Schocken Books, 1976) for a detailed account of the form and function of "touristic space."

43. Erik Cohen, "A Phenomenology of Tourist Experiences," *Sociology* 13.1 (1979): 194.

44. As told to Anthony Haden-Guest, quoted by Feifer 253.

45. See Dean MacCannell, "Staged Authenticity: Arrangements of Social Space in Tourist Settings," *American Journal of Sociology* 79 (1973) for examples of the use of "staged authenticites."

46. Morinis 52.

47. Boorstin 102.

48. Boorstin 145–46.

49. Michael Sorkin, "See You in Disneyland," *Variations on a Theme Park: The New American City and the End of Public Space*, ed. Michael Sorkin (New York: Hill and Wang, the Noonday Press, 1992) 208, 216.

4

FEMINIST REVISIONS

DEBRA KOPPMAN

What we see is what we are. . . . The very language we use to
discuss the past speaks of tools, hunters, and men, when every
statue and painting we discover cries out to us that this Ice Age
humanity was a culture of art, the love of animals, and
women. We have to use the "imagination" to recover a sense
of the sacred. The sacred is the emotional force which connects
the parts to the whole; the profane or the secular is that which
has been broken off from, or has fallen off, its emotive bond to
the universe. . . . The only chance . . . to reconnect the part
with the whole is through art.

—William Irwin Thompson,
The Time Falling Bodies Take to Light

Contemporary art is rarely associated with an official religion; shared
meanings and a common language cannot be assumed. Even if it were
possible to take shared meanings for granted among members of the same
religion, cultural differences in American society make it imperative that
we continually question our assumptions and use of language. Definitions
and beliefs stemming from Jewish and Christian ideology have silently in-
formed the interpretation of the sacred in art and the practice of art crit-
icism in general. Feminist approaches to art criticism have attempted to
address these issues. Feminist redefinitions of the sacred provide one base
from which to reexamine the possibility of the existence of contemporary
manifestations of the sacred in art.

Contemporary feminist visions of the sacred are fundamentally cross-cultural visions. Feminists in the present have taken the existence of enormous numbers of artifacts of women as archeological evidence of the existence of periods and contexts in which the status of women was elevated, and in which systems of valuation were based in ideals of connection and a reverence for the earth. In spite of the difficulty of conclusively proving the existence of so-called matriarchal societies, feminist explorations into the realm of archeology have created a rich source of inspiration for contemporary artists, anthropologists, scholars, and religious thinkers. Feminists have also culled the world's religious traditions in acts of syncretization. New images, meanings, and ideologies, relevant to a contemporary context, have emerged. The acts of syncretization in contemporary art follow a similar trajectory; cross-cultural traditions serve as the launching point for the creation of new images and meanings in the present.

FEMINIST CRITICISM

Feminist approaches to art criticism have challenged male-defined assumptions and biases, fostered greater openness in the artworld concerning issues of content and materials, acknowledged and encouraged an intimate relationship between art and spectator, and elucidated how male-defined perspectives have negated the experiences of women. Postmodern challenges to cultural hegemony; to the false neutrality and ethnocentric and phallocentric assumptions inherent in the ideas of beauty, quality, and the canon; to the artificial divisions between art and craft, high and low art; to the norms of artmaking; and to the methodologies of art history and art criticism owe much to feminist artists, critics, historians, and theoreticians.

Through the visible, the previously invisible was manifested; untapped energies were mined as the silent spoke and connections were drawn where none had been perceived. The contributions of ignored artists were recognized, the religious and folk traditions of denigrated cultures were reclaimed as valid sources, the possibilities for multiple and alternative meanings were explored, the hybridization of distinct media and modes of expression were forged. Although the notion of feminism itself owes much to Enlightenment ideas of the possibility of social progress[1] and the existence of a unifying social category of "woman,"[2] both postmodern and feminist positions have challenged the veracity of knowledge claims supposedly based on neutrality and objectivity, and have highlighted the ways in which these knowledge claims have simply reflected the values of men of a particular culture, class, race, and time.[3]

Feminist art criticism is not a clearly defined methodology practiced with uniformity; feminist aesthetics is a multifarious attempt to trace an understanding of the ways that the specific experiences of women are or can be manifested in works of art. The very project of categorizing in order to talk about feminist art seems antithetical to the antidichotomizing goals of feminism. Nevertheless, attempts to define particular characteristics that distinguish work as coming specifically out of the experiences of women has been an ongoing concern for two decades.

The approach taken in the early 1970s by Judy Chicago and Miriam Shapiro claimed that the work of women working either abstractly or representationally was noteworthy for its proliferation of central core imagery and rounded and biomorphic forms.[4] Most probably one could find examples of women's work to prove this; equally one could find examples of women's and men's work to disprove it. In any case, the search for the quintessentially "feminine" would not necessarily result in the discovery of a feminist art; on the contrary, it could easily fall into the kind of sex-role stereotyping feminists have tried to escape. Gisela Ecker has effectively articulated this problem:

> The criteria which determine whether a work of art is feminine—in the feminist sense of the word—describe quite closely the opposite of what language allocates to the 'sexually neutral masculine'; the 'feminine' is subjective, subversive [anticlassical], physical, irrational or 'deranged', agitated, fleeting. . . . Such criteria overlook women's capacity for abstraction. On the contrary, they promote the exclusion of women's creativity from the areas of art which do transcend gender. . . . Such attitudes do not transcend patriarchal dualistic thinking; rather they articulate resistance merely as the negation of the dominant norm which is thereby not only recognized [revealed] to be masculine but also recognized [accepted] as such.[5]

A similar problem arises if one tries to identify specific symbols as somehow belonging to women. Women have been associated with darkness, caves, the earth, the sea, that which is hidden, enclosed, and circular; however, these associations have functioned as symbols of an elusive "feminine," and not necessarily as sources of female power.[6]

> He says that woman speaks with nature. That she hears voices from under the earth. That wind blows in her ears and trees whisper to her. But for him this dialogue is over. He says he is not part of this world, that he was set on this world as a stranger. He sets himself apart from woman and nature.[7]

The fact that nature and culture have been seen as polarities, that women have been connected with a primal, beastlike, grimy nature and

men with an elevated, rational, sublime culture, has caused some feminists to reject any such associations as essentialistic and reactionary. The category of "woman" itself is a crucial point of feminist debate; contention arises between those who believe "woman" to be ontologically, biologically distinct from "man," and between those who believe gender to be completely an issue of cultural construction. In any case, the nature/culture dichotomy is not a useful one on which to base discussions of art; it, in fact, would seem impossible to make art which would refer only to nature and not to culture.

As opposed to attempting to define, at the critical stage, either a spontaneously or deliberately occurring female iconography, some feminist artists have developed an approach to making art which effectively presets the conditions for making feminist work. In this context feminist art is based in artists' intentions and recognizable subject matter portraying either the oppression or liberation of women. Claiming that women are supposedly inherently possessed of specific traits—that is, that women are particularly attuned to what is sensual, nonrational, and nonlinear, and that women have been trained against their nature to speak and think in the language of male-defined culture—these feminists call for the reinvention of an aesthetic language appropriate for women.

This position has programmatically stipulated that feminist art should be anticlassical, generally not involved with painting and sculpture, not abstract. In stipulating what feminist art should be, its potential powers are prematurely cut off; ambiguity and allusion are laid to rest. Women, or at least those who wish to be identified as feminists, are excluded from painting, sculpture, abstraction; these forms are considered, at best, the vestiges of a dead culture, and at worst, reactionary.

There is a point of intersection between artists' and critics' desire to create and define a feminist aesthetics and feminist theories of the sacred. The rise of the feminist spirituality movement has been accompanied by a proliferation of artworks relating to the goddess. Gloria Feman Orenstein describes this as

> the birth of a movement that I have called feminist matristic art. As contrasted with feminist art, with which it obviously intersects and overlaps, feminist matristic art acknowledges the larger shift in cosmogony, mythology, spirituality, psychology, and history that comes about as women reclaim the Great Mother Goddess Creatress of all life, and work creatively to bring about Her re-emergence on many levels. . . . Feminist matristic artists . . . are striving to render the existence of subtle, invisible dimensions, real. Their desire is to bring us face to face with the histories and mysteries in which all matristic art has been, and is, grounded.[8]

Taking Marija Gimbutas's description of the multiple aspects of the Great Mother Goddess, Orenstein looks at paintings, installations, and the creation of new symbols and iconography, as well as the work of ritual and performance artists.[9] These artists are working with themes which Orenstein identifies as relating to cycles of history and the world, to the goddess as cosmic and artistic creator, and to fertility reinterpreted as ecology.[10] Orenstein's overview of "feminist matristic artists" includes among many others, the work of Monica Sjoo, Buffie Johnson, Sylvia Sleigh, Anne Healy, Faith Wilding, Nancy Spero, Betye Saar, Ana Mendieta, Mary Beth Edelson, and Betsy Damon. In these works, the fine lines separating art and spiritual practice become blurred,

> for in the aesthetic of a feminist matristic vision, where all is interconnected, rigid distinctions such as these will fade as the energy flow linking all forms of expression to the sacred activities performed in daily reality becomes intensified.[11]

Heide Gottner-Abendroth, weaving the threads of a similar theory, sets out to define a "matriarchal aesthetic," which is both descriptive and prescriptive in calling for the reintegration of art and life by returning to prepatriarchal forms of art.[12]

> . . . a matriarchal aesthetic has a historical context and reference to a concrete form of society. . . . A matriarchal aesthetic, or art, is not bound to one sex, but it does have a perspective different from that of all other aesthetic theories and forms of art: society and art are not under the domination of men but are the creation of women.[13]

Derived from an interpretation of historical matriarchal art combined with various elements of contemporary feminist theory, Gottner-Abendroth sets out to develop a "matriarchal art-utopia" through a "partially descriptive, partially programmatic theory of certain variants of modern art."[14] Her matriarchal aesthetic consists of nine theses, which when fully elucidated and put into practice, will help "the Goddess dance again."[15]

Matriarchal aesthetics takes the contents and structure of matriarchal mythology as its framework and point of reference; this structure is familiar to all participants in the experience of matriarchal art. Art changes psychic and social human reality through magic, which is a process not limited to the creation of art products, nor susceptible to the separation of genres or the distinction between art and nonart. Matriarchal art is driven by erotic power rather than by "work, discipline, or renunciation," and strives to "bring about the aestheticization of the entire society. Matriarchal art . . . is not 'art' in the patriarchal sense of the term. . . . It is the ability to create and reshape life."[16]

Orenstein's and Gottner-Abendroth's theoretical constructions are both descriptive and normative, helping to create a context for a very specific category of works. However, they are not enlightening as art criticism, as their words are reminiscent of the absolutist spiritual manifestos of an earlier generation of male artists. In their zeal, they ascribe powers to art visible only to the predisposed, and they define matriarchal art in terms which could also be applicable to any or all art.

If one uses artist's intentions, content, and the historical experience of women in interpretation, the problem of whether or not art work is feminist disappears; one wins by default, as the conditions for making feminist work have been predetermined. Feminist criticism then functions as merely explanation and rationale for why the work was made and what it intends to communicate. Feminist criticism of this sort "forgets that what appears as feminine in art is not only transitory, but partly defined in relation to what is considered male."[17] In stipulating the acceptable forms and contents of a "truly" feminist art, one set of confining definitions is replaced with another.

Joanna Freuh's "Towards a Feminist Theory of Art Criticism" attempts to define another methodology for a feminist art critical practice. Emphasis is placed on issues of content, artist's intentions, and the particular experience and expression of women. Factual information—such as biography, sources of an individual artist's work, and stylistic connections with other artists and movements—and formal issues are combined with analyses and interpretations of social and conceptual contexts, as well as with an attempt to forge a deeply personal intimacy with the art. In practice, much criticism which takes this approach inadequately refers to aesthetic qualities of works of art and becomes social, psychological, historical, or political commentary.

However, the notions of identifying alternative feminist approaches to aesthetics and to developing feminist uses of images and language are not necessarily doomed to essentialist classification. One of the issues that has arisen in attempting to define feminist art has been the realization that art, criticism, and history have been falsely seen as gender neutral, when in fact the terms of evaluation and theory have been male-defined. A feminist call for a genderized approach to art criticism takes into account the sex of both the artist and the critic in order to deconstruct this myth of gender neutrality.[18] Gender analysis challenges the male-defined perspective which negates or ignores issues of content, which exalts issues of form to the exclusion of all else, which posits an impossible notion of objectivity, and which attempts to prove art truths while creating a system of "correct" preferences and "right" reasons. Gender analysis emphasizes the interconnectedness between text and object and the work's

historical context and culture.[19] In this way, the possibility of the existence of different sensibilities in the work of men and women can be accepted without programmatically resorting to limiting and inconclusive definitions.

To self-consciously attempt through criticism to attach feminist concerns onto traditional art forms, or to stipulate either the form or the content of "approved" feminist art is effective neither aesthetically nor intellectually. Perhaps the most significant contribution feminist criticism could make to historical and critical discourse would be to refuse to look at art history as a very clear and orderly time line. In this way, it would be possible to show how a variety of art practices, overlaps, and cross-influences have always coexisted. At the same time the sexist, ethnocentric, and religious roots of the operating systems of valuation and omission would be highlighted.

> It is good—in two respects—that no formal criteria for "feminist art" can be definitively laid down. It enables us to reject categorically the notion of artistic norms, and it prevents renewal of the calcified aesthetics debate, this time under the guise of the feminist "approach."[20]

Feminism is a word which is inherently politically charged. Implicitly or explicitly, "critique," "change," "agenda" accompany it. A plethora of questions spring up immediately when the concept of feminism is applied to art, making analysis difficult. In order for art to be seen as feminist, does it need to be espousing a specific agenda? Is only art which is overtly political understood as feminist? Does "feminist art" need to incorporate words, photographs, or explicit images? Does "feminist art" need to deal directly with clearly articulated social issues or the current popular preoccupation with the construction of gender? Is it possible for abstract art to be either feminist or political? Just as making images of goddesses is not the only possible way to talk about the sacred in art, theoretical explorations of gender as a construct of language and how female images are used as instruments of repression in patriarchy are not the only ways to express the political.

Tranquility, a state of being calm, "free from agitation of mind or spirit," is not a word we normally associate with the political.[21] In the strict sense of politics as "the art or science concerned with guiding or influencing governmental policy," tranquility might be the farthest thing from our minds.[22] When we use politics in the sense of "the total complex of relations between men in society," tranquility would still not come to mind.[23] Yet tranquility as a concept can indeed be politically charged, while at the same time it is paradoxically associated with spirituality.

Paula Gunn Allen, a Keres Pueblo Indian and anthropologist, talks of tranquility as simultaneously a religious concept and a tool of repression—terms that deconstruct its benign connotations. The lessons of passivity have been used by Western patriarchs to teach docile slaves the sins of violence and the virtues of serenity so as not to disturb the holy peace enjoyed by the ruling class. Allen argues that in accordance with the rumblings of the planet, spiritual integrity demands an active and appropriate human response to injustice; her deconstruction of tranquility shows how the most seemingly innocuous terms are culturally determined.[24]

The issue is a complicated one; if as tame an idea as tranquility is politically charged, what isn't? Does political art refer to the statements it makes or does it refer to the actions it causes? Is it enough merely to have the intention to cause action? Is it enough merely to refer to a particular situation commonly understood as political? If art causes a change in consciousness or moves a viewer in any way, could this also be said to be political?

Discussing the exhibition "The Spiritual in Abstract Painting," Roger Lipsey talks about the effect that the paintings of Reinhardt and Rothko had on him: "One responded to their simplicity and quietness by becoming like them. One sensed the truth of the dark sign each was, as if all things emerge from this sort of quiescence and return to it."[25] Postmodern critics attack the philosophy of modernism for placing art outside the realm of society. But if art is perceived as being at all capable of transforming viewers in the way that Lipsey describes, a case could be made for the inherent political character of all art. To encourage a form of passivity is no less significant in political terms than to incite activism; the means for inspiring action are not at all as transparent as self-styled "political artists" would hope.

Two popular themes of postmodernism are the inevitability of co-optation and the delusion of believing in the possibility of change and originality. The resulting works of appropriation—which are supposedly about "stripping away the ideological myths that held modernism together" and negating the modernist myth of the heroic artist who will continue to feed a culture hungry for innovation—effectively advocate a form of apathy and passivity which is self-fulfilling, and incredibly powerful for the maintenance of the status quo.[26] This ideological myth of the apocalypse has the same religious origin as the out-of-fashion myths of modernism; the linear notion of time, which in this case refers to the inevitability of human destruction as opposed to the inevitability of human progress, is orders of magnitude more insidious.

What is clear is that it is impossible to talk about the spiritual in art, the political in art, or the feminist in art, without an accompanying inter-

pretative and ideological context. Powerful feminist insights into contemporary art are possible through a continued examination of language and categories falsely assumed to be gender neutral, and the construction of new and appropriate interpretative frameworks.

FEMINIST SPIRITUALITY

> I know I am made from this earth, as my mother's hands were made from this earth, as her dreams were made from this earth, and this paper, these hands, this tongue speaking, all that I know speaks to me through this earth and I long to tell you, you who are earth too, and listen as we speak to each other of what we know: the light is in us.[27]

Not only are exact meanings of the spiritual not equivalent cross-culturally, but great diversity in defining and experiencing the sacred exists within our own society, between members of different ethnic groups, and between men and women. The Western definition of the spiritual only refers to one specific worldview, which has been taken as immutable and true. Women may have adapted their experience of the world to mesh with this perspective, but they have not generally framed the terms of discourse.

A body of related ideas being developed by feminist scholars of religion in response to the recognition "that women's perspectives had not been included in the Jewish or Christian naming of God"[28] and the realization that the study of "religious man" excluded a wide range of women's experiences emphasizes an integration of body, mind, and soul, to reclaim values which have been denigrated in Judaic and Christian traditions precisely because of their associations with women.[29]

In suggesting that women's spiritual lives are possessed of characteristics distinct from those of men's, Maria Harris in *Dance of the Spirit* draws on spiritual traditions from both East and West to replace the dominant image in Western religions of an ascendant ladder to heaven with a cyclical notion of feminist spirituality.[30] Rejecting the idea that spirituality can be expressed by a series of linear steps leading up to a predetermined destination which begins on a lowly, physical, bodily earth and culminates in the exalted heights of bodiless truth and understanding, Harris uses the image of the dance as a metaphor for a feminist understanding of the sacred. Harris's dance focuses on the unity of body with mind and soul, on the rhythms and cycles of life, and on women's particular connections with these cycles and with the physical world.

> . . . to make something sacred, one must reconnect the past to the universal whole. The chimpanzees re-make connections in their rain dance, and we, in kinship with all living

things, also know how to dance. . . . To understand events, or
what comes to pass, one must understand the cosmic dance, that
musical and geometrical pattern of movement in Creation. . . .[31]

What if our understanding of the spiritual were turned upside
down? As opposed to Plato's equation of the physical world and the
body with a grim darkness that could only be lit by the transcendent
light of reason, what if we were to experience this darkness as fertile,
nurturing, embracing? What would happen if we rejected the idea that
humans are superior to nature, but began to realize that we are all con-
nected to the earth?

What if the spiritual were defined in terms of immanence rather
than transcendence? What if physicality were seen as embodying spiritu-
ality, rather than as being separate from it? What if the divine were be-
lieved to be immanent in nature, and if the earth were conceived of as a
physical and spiritual being, possessed of intelligence and wisdom? What
if passion were to replace reason as the guiding definition of the spiritual?
What if every expression of sorrow and every celebration of life were un-
derstood also to be a celebration of spirituality?

A critical component in the construction of feminist redefinitions of
the sacred is the rejection of dichotomies which function to isolate hu-
mans from their experiences and from the life of the cosmos. The distinc-
tion between transcendence and immanence, with the favoring of a
perceived spiritual transcendence over a trapped material immanence, is
understood as false. Human beings and human spirituality flow back and
forth between these two worlds. To be human means to be embodied; this
life, this body, this earth, is in itself sacred. This idea is found in many
spiritual traditions; feminists have embraced it as potentially liberating
for living, contemporary women. Paula Gunn Allen talks about the
American Indian vision of the physical and the spiritual as inherently
intertwined:

> The planet, our mother, Grandmother Earth, is physical and
> therefore a spiritual, mental, and emotional being. Planets
> are alive, as are all their by-products or expressions, such as
> animals, vegetables, minerals, climatic and meteorological
> phenomena.[32]

What would happen if the divinity were conceived of as verb rather
than noun? If we were to embrace a worldview based on interactive en-
ergy, constantly ebbing and flowing, formed by the nonvisible and non-
material as well as the visible and material? What if one's own spirituality
were conceived of in terms of a dance; cyclical, moving, turning, chang-
ing, having no set pattern, no clear destination, but rather focused on the

unity of body with mind and soul, to be danced for its own sake and not for its completion? What would it mean to stop seeing our own lives and the life of the planet as a linear and upward progression? How would it change our lives if we were to accept change as constant, to see death as part of life as part of death? What if we were to reclaim the linguistic roots of religion, *religaré*, to bind up the wounds which keep us from wholeness and integrity?[33]

Mary Daly, in *Beyond God the Father*, suggests the necessity of replacing the concept of divinity as a static, never-changing, fixed noun, with that of an active, always flowing, verb. "Being," evoking growth, movement, change, unfolding, becomes a liberating feminist expression of divinity, standing in opposition to the concept of an angry supreme male father god who sits in immutable and immobile judgment.

> The Naming of Be-ing as Verb—as intransitive Verb that does not require an "object"—expresses an Other way of understanding ultimate/intimate reality. The experiences of many feminists continue to confirm the original intuition that Naming Be-ing as Verb is an essential leap in the cognitive/affective journey beyond patriarchal fixations.[34]

God-as-noun in Daly's view, encourages us to think of power and action as being outside of ourselves. To replace images of god with that of goddess is useless as long as those images serve as models of passivity and self-absorption, effectively perpetuating the status quo.

> Really moving beyond god the father and his surrogates means Living the process of participation in Powers of Be-ing. Elementally Metaphoric works and the actions they encourage and reflect are signals of these Powers. They are Metamorphic, shifting the shapes of space and time, rearranging energy patterns, breaking through and relocating boundaries.[35]

The struggle of women is defined by Daly as a religious struggle, precisely because of the continuing influence of religious myths on American culture. Patriarchal religion has denied women not only status but the participation in humanity.

> . . . we are dealing with powerful symbols that invade our beings from all sides, from the most banal television commercial or textbook, to the doctor's office, to a billboard with a three-dimensional figure of a local political candidate, telling voters to "put your faith in him." All say one thing: that to be human is to be male is to be the Son of God.
> What is involved then is a religious struggle, and this is so because the conflict is on the level of being versus nonbeing.

> The affirmation of being by women is a religious affirmation, confronting the archaic projections that deny our humanity. . . . It is the bringing forth into the world of New Being, which by its very coming annihilates the credibility of myths contrived to support the structures of alienation.[36]

Feminist redefinitions of the sacred encompass a consciousness of immanence and an awareness of the entire universe as dynamic, alive, interacting, and interdependent; the world is conceived of as a living being, a weaving dance, in and of itself sacred.[37] Power is believed to be an expression of a life force composed simultaneously of matter and energy, internally present in every being, rather than externally located.[38] Energy, which moves continually in cycles, is simultaneously tangible and intangible.[39]

DECONSTRUCTING DEFINITIONS

In order to reapproach discussions concerning manifestations of the sacred in art, we need to look both at our use of everyday language as well as the less frequently addressed underlying assumptions attached to dictionary definitions. In order to clarify the terms of our discourse, we turn to the *Oxford English Dictionary* for some common usages of "sacred," "sacredly," "spirit," "spiritual," "secular," and "profane."

> **sacred:** dedicated, set apart, exclusively appropriated to some special person or special purpose; of things, places, of persons and their offices, etc. Set apart for or dedicated to some religious purpose, and hence entitled to veneration or religious respect; made holy by association with a god or other object of worship; consecrated, hallowed; figurative. Regarded with or entitled to respect or reverence similar to that which attaches to holy things.

> **sacredly:** with religious or strict care; inviolably; with rigid attention to the truth.

> **spirit:** to make of a more active or lively character; to infuse life, ardor or energy into; to animate, encourage; to invest with an animating principle.

> **spiritual:** of or pertaining to, affecting or concerning, the spirit or higher moral qualities, esp. as regarded in a religious aspect (freq. in express or implied distinction to bodily, corporeal or temporal); applied to material things, substances, in a figurative or symbolical sense; devout, holy, pious; morally good; of or pertaining to, consisting of spirit, regarded in either a religious or intellectual aspect; of the nature of a spirit or incorporeal supernatural essence; immaterial.

secular: chiefly used as a negative term, with the meaning non-ecclesiastical, non-religious or non-sacred; of or belonging to the present or visible world as distinguished from the eternal or spiritual world, temporal.

profane: applied to persons or things regarded as unholy or as desecrating what is holy or sacred; unhallowed; ritually unclean or polluted; especially said of the rites of an alien religion; heathen, pagan.[40]

Beginning simply with these definitions, we can attempt to unravel the ways in which the category of sacred has been falsely conceived as both culture and gender neutral. The definitions we use are derived from Western religions; in accordance with these traditions, the words themselves contain much which is male-defined and are laden with alleged "truths" and absolute values. One obvious place to start is with the strict separation of categories into sacred/secular, spiritual/profane; these we take as natural descriptions of our experiences. However, this perceived dichotomy is neither natural nor inevitable, as even the most casual study of comparative religions will show. This separation of categories is underscored by the definition of sacred: "entitled to respect or reverence similar to that which attaches to holy things." Our determination of what is worthy of respect and reverence is carefully circumscribed and rationed. Although "holy" originally comes from "whole," only rigidly specified items are in exclusive possession of, and therefore entitled to, respect. Similarly, to approach something "sacredly," "with rigid attention to the truth," implies not only the existence of one, clearly defined and knowable truth, but contains within its definition the moral justification for alleged "sacred" acts.

We can then make the patriarchal leap from "spirit" to "spiritual." Patriarchal religious thought makes a rigid distinction between earthly matter and heavenly essence, clearly privileging immaterial over material. So, spirit, "an animating principle held to infuse life, ardor, or energy," becomes disembodied in the spiritual, becomes an "incorporeal supernatural essence," associated with "higher moral qualities."

By definition, our visible, material, albeit temporal world, is secular, nonsacred, not entitled to respect or reverence. To be profane is to be polluted, to be alien, heathen, pagan, strange, uncivilized, and polytheistic. To be profane is to be different, identified with everything other than oneself.

Clearly, these are not neutral conceptual categories but are both the basis for, and the embodiment of, highly charged ideological and political structures. Jewish and Christian theology teaches the separation of immanence from transcendence, of matter from spirit, of temporal from

eternal, of this world from otherworld, of body from mind. What is considered sacred is always higher, purer, cleaner, bodiless, formless, imageless, and not coincidentally associated with men. It is specifically this definition of the sacred which has generally informed the discussion of the spiritual in art.

Feminist reconstructions of the meaning of the sacred may in turn affect interpretations of the sacred in art. An expansion of the definition of the sacred may cause us to experience the work of a broader range of artists as connected to a sense of the sacred. Regardless of artists' intentions, a broad worldview on the part of interpreters and an understanding of the embedded assumptions in language will enlarge our categories and leave us open to myriad possibilities.

Notes

1. Linda J. Nicholson, *Feminism/Postmodernism* (New York and London: Routledge, 1990) 99.

2. Nicholson 7.

3. Nicholson 5.

4. Lucy Lippard, *From the Center* (New York: E.P. Dutton and Co., 1976).

5. Gisela Ecker, ed., *Feminist Aesthetics* (Boston: Beacon Press, 1986) 173–74.

6. Mary Daly, *Gyn/Ecology: The Metaethics of Radical Feminism* (Boston: Beacon Press, 1978) 44–72.

7. Susan Griffin, *Woman and Nature: The Roaring Inside Her* (New York: Harper and Row, 1978) 1.

8. Gloria Feman Orenstein, *The Reflowering of the Goddess* (New York: Pergamon Press, 1990) 78, 79.

9. Marija Gimbutas, *The Language of the Goddess* (San Francisco: Harper and Row, 1989). This is the basis of her entire book.

10. Orenstein 80.

11. Orenstein 97.

12. Heide Gottner-Abendroth, *The Dancing Goddess: Principles of a Matriarchal Aesthetic* (Boston: Beacon Press, 1991).

13. Gottner-Abendroth 30.

14. Gottner-Abendroth 48.

15. Gottner-Abendroth 53.

16. Gottner-Abendroth 48–53.

17. Ecker 16.

18. Ecker 22.

19. Joanna Freuh, "Towards a Feminist Theory of Art Criticism," *Feminist Art Criticism, An Anthology*, ed. Arlene Raven, Cassandra Langer, and Joanna Freuh (Ann Arbor, MI: UMI Research Press, 1988).

20. Ecker 44, 47.

21. *Webster's New Collegiate Dictionary* (Springfield, MA: G. and C. Merriam Company, 1976) 1239.

22. *Webster's* 890.

23. *Webster's* 890.

24. Irene Diamond and Gloria Feman Orenstein, eds., *Reweaving the World: The Emergence of Ecofeminism* (San Francisco: Sierra Club Books, 1990) 53–54.

25. Roger Lipsey, *An Art of Our Own: The Spiritual in Twentieth Century Art* (Boston, MA: Shambhala Publications, 1989) 326.

26. Suzi Gablik, *The Reenchantment of Art* (New York and London: Thames and Hudson, 1991) 17.

27. Griffin 227.

28. Carol P. Christ and Judith Plaskow, eds., *Weaving the Visions: New Patterns in Feminist Spirituality* (San Francisco: Harper and Row, 1989) 3.

29. Nancy Auer Falk and Rita M. Gross, *Unspoken Worlds: Women's Religious Lives* (Belmont, CA: Wadsworth Publishing, 1989) xiii.

30. Maria Harris, *Dance of the Spirit* (New York: Bantam Books, 1989) This is the basis of her entire book.

31. Thompson 83.

32. Paula Gunn Allen, quoted in Diamond and Orenstein 52.

33. Thompson 102.

34. Mary Daly, *Beyond God the Father: Toward a Philosophy of Women's Liberation* (Boston: Beacon Press, 1973) xvii.

35. Daly, *Beyond God* xx.

36. Daly, *Beyond God* 138–39.

37. Charlene Spretnak, ed., *The Politics of Women's Spirituality* (Garden City, NY: Doubleday, 1982) 177.

38. Spretnak 294.

39. Spretnak 182.

40. *Oxford English Dictionary*, Oxford: Oxford University Press, 1978).

5

(DIS)INTEGRATION
AS THEORY AND METHOD
IN AN ARTMAKING PRACTICE

SUSAN SHANTZ

Several years ago, in the spring, I began to break finger-thick twigs from fallen poplars into palm-width pieces. I was following the dictates of an image that had come to me earlier that year, a disembodied image of my hands doing this repetitive, insistent work. I might have easily ignored the image but for its persistence and my growing awareness that such inexplicable gestures are trying to tell me something. So I went into the woods, broke twigs into buckets, and dumped them onto the floor of my studio. I took pleasure in this labor that allowed me to be out on the forty acres of prairie to which I'd recently moved and I was held to the work by the physical vibrations that stayed in my body even after the gesture had ended. Several weeks later, by which time the pile in my studio had grown considerably in scale, it became clear to me what I was to do with the twigs.

That such an activity—apart from the art product to which it eventually led—might have something to do with the spiritual would not have occurred to me when I first began to make art. At that time I was an undergraduate in a Mennonite college, being exposed to fine art for the first time. Given the iconoclasm of my background and the absence of art in my home and church, I experienced a deep conflict between my love of

making art and the suspicion of images I was taught. "Art" had barely existed as a word in my home, while "the spiritual," defined by very particular religious practices, had been all-encompassing. I had been trained in the "crafts" of sewing and quiltmaking and had loved these, but I set them aside when my formal art education trained me to draw, paint, and sculpt. Yet neither sewing nor painting seemed to have anything to do with religion, which was defined as a set of articulable beliefs.

My experience of this dichotomy was not unique. "Art" and "the spiritual" have existed as two separate but seldom intersecting cultures in the twentieth century.[1] While some religious traditions have been strongly opposed to art, there is an equally deep mistrust of the spiritual within the secular culture of modern art. Only abstract painting has offered a recurrent locus for the spiritual since Kandinsky's 1914 publication, *Concerning the Spiritual in Art*.[2] Despite immense social and artistic changes from the beginning to the end of this century, painting was again at the center, in 1986, of the Los Angeles County Museum exhibition and catalogue, *The Spiritual in Art: Abstract Painting 1890–1985*.[3] Abstract art's nonspecific content seems to offer an irreducible, nondiscursive, silent experience readily linked with the spiritual when the spiritual is identified as that which lies "beyond," "above," or "outside" this world, what is numinous rather than phenomenal. Formalism's claim to be a universal language of art also appears to correspond to religious descriptions of oneness and transcendence while abstraction's preferred medium, paint, seems more ethereal than, for example, a sculptor's clay, which is so clearly bound to matter.

Implicit in these discussions of the spiritual in art is a valuation of spirit over matter, transcendence over immanence. Alongside the dominant tradition of abstraction is another modernism with roots in Duchampian ready-mades—Dada and Surrealism, which corresponds more readily with the type of specific, cultural-bound life experiences I describe above. In my earliest exhibited artworks, I drew on this other tradition of modern art and the frameworks of Western religious art, filling in details of my own cultural tradition. Photocopied images of my ancestors, so important in defining community in traditional ethnic Mennonite culture, replaced the rows and rows of "official" saints. A hand-knit lace sock, retrieved from my grandmother's attic and emblematic of domestic arts and rituals that had existed invisibly, became the central icon. I built cathedrals the scale of one person, constructing spires out of found ceramic "Mennonites" that I colorfully painted; (these statues are usually sold as souvenirs in local markets, austerely painted in black and gray). The repetitive, labor-intensive textile traditions I drew on were the inspiration for works in which painted surfaces were highly crafted and decorative like medieval miniatures.

Everyday objects and events are claimed to be art by virtue of being brought into the gallery in the Dada-inspired strand of twentieth-century art. Iconoclastic and self-consciously critical of its own idols, this tradition was renewed by, among others, the German artist Joseph Beuys, and feminist artists who questioned hierarchies between art and craft, and art historical accounts from which women were notably absent.[4] Many of these late-twentieth-century artists questioned the separation of art from life. In the work and words of Beuys, who believed that works of art are materialized fields of energy and that matter has an inner meaning which can generate a transformative spiritual atmosphere, an "alchemical spiritual art" was defined.[5] The symbolism of medieval alchemy was inherent in his valuation of matter as spiritually resonant. Artistic process, the ongoing site where transformation occurs, receives as much attention as the art product, the "residue" that remains. The "consistency of spiritual conception" of the maker, his or her degree of self-integration, is revealed in the artwork.[6]

"Depth," "breadth," and "interdependence" are descriptors of where the spiritual is located in alchemical discussions of the spiritual in art providing radically different spatial metaphors than those used in discussions of the spiritual in abstract painting. "Oneness" is not an abstract philosophical ideal in these discussions, but for a number of artists who share an ecological imperative, is redefined as a lived awareness of our connectedness to other human and nonhuman life. Alchemical notions of the spiritual in art, indebted as well to Jungian theories of myth and symbol in the unconscious and dreams, inform both Suzi Gablik's, *The Reenchantment of Art*,[7] and Roger Lipsey's *An Art of Our Own: The Spiritual in Twentieth-Century Art*.[8] Both of these writers explore the possibility of understanding a wider range of artwork as manifesting the spiritual.

Despite attempts by Gablik and others to open new directions for discussion of the spiritual in art, a language that might bridge the terms may come more readily from the culture of religion.[9] If our understanding of religion can be opened beyond the narrow institutional definitions many of us were raised with, a breadth of experience might be subsumed. It was while pursuing graduate work in religion that I became aware, for example, of ways in which my cultural experience of being Mennonite was inextricably tied to my religious experience. The two could not be separated. What happened at home or in the church basement might also be considered religious expression. Theories of religion that emphasize the social aspects of symbols, such as that of anthropologist Clifford Geertz, suggest ways in which a people's beliefs not only attempt to describe the divine, but also act as models for human behavior.[10] Belief as *enactment*, sometimes in contradiction of statements of belief, is also

described in theories of gesture and ritual.[11] Thus I began to see that the women gathering to make quilts in the church basement were making a committed religious statement, one that was perhaps more heartfelt than the words they uttered in church Sunday morning. I began to consider other nonliturgical enactments, other repetitive, domestic activities, particularly those which resulted in carefully crafted objects, as possible religious expressions.

Both my work as an artist and my graduate studies in religion in a secular institution opened up the spaces my imagination needed. As someone who had always found words an inadequate language for religion, I was relieved to be able to consider cultural performances as manifestations of the spiritual. I'd been given by my tradition an awareness of and longing for things spiritual, but I now found myself more and more on the edge of that very community. I sought a language that would allow me to speak of the spiritual in broader terms. The culture of art into which I was moving might, I thought, offer this. Making art had become a kind of making sense, an embodied speech that allowed for the kinds of contradictions and paradoxes I experienced. The process of making art, described by social anthropologist Czikszentmihalyi as a state of timelessness, when action and awareness are united on a limited stimulus field, was very pleasurable and offered a vastness of possibility I experienced nowhere else.[12] Yet the more involved I became in this culture, the more aware I was of only silence or nervous avoidance concerning "the spiritual."

Having attempted to think through the relationship between "art" and "the spiritual" in religious studies, the lack of space in which to speak about "the spiritual in art" in the graduate program in studio art forced it into subjugation. In retrospect I see the usefulness of this silence which led me into a deeper, less analytical articulation. Finding it difficult to make art in a large, urban institution whose values and ideals seemed distant from my own, I became disoriented, unable to proceed. In confusion I stopped making art altogether for a time and found myself reading for solace the anonymous spiritual classic, *The Cloud of Unknowing*.[13]

I was attracted by the title. Secretly, I acknowledged that it described the state in which I now found myself. I spent a summer reading this small book. Often I read no more than a page in a day, observing the places it resonated with longings I could barely articulate. I was distressed by my lack of activity and achievement but also unable to act, uncertain as to what it was I needed to do. The book recounts, first-hand, its medieval author's spiritual experience of *apophaticism*, a Western theological tradition that is less well known than its *kataphatic* counterpart. Although neither of these words are currently familiar in popular reli-

gion, kataphaticism was, I realized, the spirituality of the religious tradition in which I'd been raised: I had been expected to make positive, affirmative statements of belief. In adolescence, I questioned these, wondering how one could possibly *know* such things; now, years later, I realized I had begun an apophatic spiritual quest. Apophaticism is a "negative way," a "knowing by unknowing," which means more than simply an absence of knowledge but asks as well for a surrender of ego, a receptive waiting for the hidden god.[14] While my youthful questioning had sought reasonable explanations, now I understood that the negative way does not proceed by reason but as the author of *The Cloud of Unknowing* makes clear, by contemplation, by an admission of ignorance and longing: "You will seem to know nothing and to feel nothing except a naked intent toward God in the depths of your being . . . learn to be at home in this darkness."[15]

In response to a dream image that summer and needing to apply what I was reading to my circumstances, I began to grow mushrooms in my studio at the university. Underground things that thrive in manure and darkness, I recognized them as a resonant metaphor which began to define my space and myself in that inhospitable environment. "Learn to be at home in this darkness," contradicted my impulse to escape, to leave the "darkness," and suggested some larger, not yet comprehensible purpose to assuming an attitude of receptivity and openness rather than resistance and control. Before I could make art in that space, it seemed to be saying, I had to make that place "home." In so doing, I discovered what materials, textures, and spatial configurations signified "home" for me at a deep level, and in the process, I began to recognize an expanded vocabulary of artmaking that drew on the strength of instinctual and embodied ways of knowing. The ways of knowing I was exploring seemed to be an "unknowing" in the face of the analytical and theoretical models I'd been taught to value.

Improvisation "may be the religious ritual and thought of the contemporary world," Lynda Sexson suggests in *Ordinarily Sacred*, a text which seeks to illuminate the sacred qualities of mundane experiences. When we recognize everyday events as "metaphorically saturated," we may find ourselves on the threshold of religion.[16] While the sacred has been named in Christianity as that which is "up" and "away," separate from the mundane and secular, women's renaming of the sacred has often involved going toward the reality of life: "toward bodies, toward nature, toward food, toward dust" and finding that which nourishes and deepens life.[17] Feminist scholars of religion have found useful theologian Paul Tillich's definition of religion as the articulation of longing for a center of meaning and value; women's experiences of the spiritual have often

had to find a home outside of institutions that have excluded and deval-
ued them.[18] These broader definitions of religion have allowed women to
seek the spiritual as it has arisen from deep longings even when these have
led them outside of established systems of religion.

"Let your longing relentlessly beat upon the cloud," I was surprised
to find in a medieval, not contemporary, text.[19] These simple words,
forceful in image, moved me more deeply than the theoretical reconsid-
erations of religious experience that had first loosened my preconcep-
tions. Learning to trust those longings and emerging dream and fantasy
images was to accept a knowledge for which my formal education and
formative religious tradition had done little to prepare me. Learning to
read at the immensely slow pace with which I entered *The Cloud of Un-
knowing* undid me as the consumer of knowledge I'd been trained to be,
opening me more deeply to the prod and quest of the words I encoun-
tered. I had come instinctively, needfully, to this way of reading only to
discover later that it is a monastic prayer tradition known as *lectio divina*
(meditative reading). In such reading and, I was to learn, in such artmak-
ing and such living, control must be relinquished; what is received in the
darkness is a gift which cannot be sought.

"What is the spiritual?" Lipsey asks in *An Art of Our Own: The
Spiritual in Twentieth-Century Art*. One of the answers he offers is "an
incursion from above or deep within to which [we] . . . can only surren-
der . . . an undoing of what we take to be ourselves."[20] Such an approach
to artmaking is given credence in discussions of depth psychology more
often than in contexts that deal overtly with "the spiritual in art," which
seek to locate it as something concrete and discernible in a particular
"style." Any definition, as we have seen, must be more provisional than
that, limited as we are by conventions of both verbal and visual lan-
guages. Historian of religion and art, John W. Dixon, cautions that
"none of these [theories] is sufficient as a response to the question . . . al-
though each is among the resources available to us for seeking the cor-
rect response."[21]

While Dixon has written most extensively about specific artists such
as Giotto and Klee in relation to the spiritual, his insights into art as a
nonverbal, physically embodied language speak to my own experience
and perhaps begin to define what he means by "the correct response."
Matter and spirit are, for Dixon, not opponents or elements of a higher
synthesis, but "aspects of ourselves [that] we must learn to live with,"
and the nonverbal, physically embodied language of art is "the reality of
the embodiment of the spiritual."[22] Contemporary art theory's depen-
dence on the insights of literary theory have, in many ways, kept art sub-
servient to the verbal and rational.[23] Dixon encourages awareness of these

theories as "one of the resources" available to us, but cautions against equating, as many modern critics have done, the relativity of meaning many of them describe, with a relativity of truth. Truth can still be sought, he offers, not as a general, abstract Idea, but in the "immediate, specific, concrete, the fittingness of act and thing and word to a particular situation" in light of what is permanent and enduring.[24]

Shortly after moving to the prairies, I made an object of steel rebar which I thought of as a "rooting device," a "root ball," or "trap" for my feet to attach me to the flat land where I felt without roots, exposed beneath the immense sky. Several years later, I began the activity of breaking twigs in the woods near my house. Like the image of the mushrooms which had located me on the urban campus while in graduate school, the gesture of breaking served, in a different way, to connect me physically to the site I now inhabit. My commitment to carry out this activity, even though I didn't understand it, reveals a receptivity to what Lipsey describes as an "incursion from within."

It was several months later, and only after countless walks past the woodshed, that I realized how I would order the twigs: into stacks, like a miniature but extensive woodpile. I did this for a year and a half, building eleven seven-foot by three-foot units that eventually created a curved wall with distinctive inner and outer spaces. The gesture of breaking the twigs is akin to the gestures of quilting, rug hooking, and farming known to me from my Mennonite background: different, but similar in the degree of repetition and the laboring hand. Like those older gestures, my gesture led to the creation of a relatively large space with which I remained involved from inception to completion. This type of work is very different from the types of work and productivity that dominate our culture. The structure of a large institution like the urban campus where I teach demands an equally repetitive and seemingly endless amount of administrative work. Routines of school and work contribute to the "dismemberment of the body," as phenomenological psychologist David Michael Levin notes in his analysis of how our culture is unkind to the body.[25] Shortly after beginning to teach four years ago, I spontaneously began to tape all the phone memos that passed through my hands onto my office walls. Only later did I realize that my office was becoming a "site-specific installation," a visual response to my work there.[26] After the wall of twigs was completed, a friend pointed out the correspondence between it and the wall of memos: both use materials from their sites in gestural responses that locate my body in a particular space.[27] My office wall is "evidence" of one aspect of my job that would otherwise be invisible, ephemeral, draining of energy with no return. The twig wall uses that same pattern of energy, potentially dissipating, and makes with it a new

space, a "sacred" space, where, rather than being closed down, my existence is open.

Now I recognize the gesture of breaking twigs as articulating a desire for space, for a new space, an enlarged space, a space that would connect me more fully to myself and to the place where I live. Mircea Eliade is the historian of religion who has written most extensively about "sacred space" although the examples he cites frequently belong to cultures less secular than our own.[28] In a recent article, Raimundo Panikkar, also a scholar of religion, expands the definition of sacred space by calling it "space where our existence is open," and goes on to state that "the landscape which permits us fully to be is created by a sacred action."[29] Labor, my body's gesture of breaking and stacking, is what created the link between inner imaginative space and outer physical space. Cultural artifacts as projections of the body, artmaking as "turning the body inside-out," or reversing the two bodily linings, interior and exterior, is described by Elaine Scarry in *The Body in Pain*: "the natural hand (burnable, breakable, small and silent) now becomes the artifact hand (unburnable, unbreakable, large and endlessly vocal)."[30]

The kind of self-knowledge and self-consciousness which I have come to by entering my work through my body, by paying attention to gestural images and impulses as articulations of interior space and desire, has opened my understanding not only of myself but also of the larger cultural contexts within which I work. "If truth is particular to situations," Dixon states, "it is essential that we know our situations fully and accurately." He cites the need for intellectuals today to work with an awareness of social, psychological, deconstructive, and gender analyses, making these not authoritative but "accounts of the conditions of our work." We are more aware, more self-conscious than were people in the past about the complexities and contradictions of our situations, making it difficult to hold to inherited beliefs. Yet destroyed innocence and naivety can lead to cynicism or nostalgia. A third alternative which Dixon offers is the "recovery of a language within which truth can be said and made and done."[31] Understanding as embodied, as "first and foremost, a free surrender or submission of the body," and truth as "our capacity for opening and the character of our receptivity" are also described by Levin who sees the retrieval of the life of the body as part of our culture's answer to the dangers of nihilism.[32] The arts, both theorists emphasize, are another form of analysis, not simply the material to be analyzed.

The breaking of twigs on my land led to my gradual awareness and analysis of ways in which this activity was connecting me to place as well as to the larger cycles of growth and change. The repetition seemed nonsensical—not even a record of memos answered—but its persistence be-

gan to insist on a meaning not readily available in our culture. The poplar bush that surrounds my house has a lifespan that is less than that of a human and so makes readily apparent flux and change as the larger reality within which we live. Trees frequently fall over in heavy wind storms and one small wood behind the house that existed when I moved here four years ago is no longer standing. It is branches from these fallen trees that I used. I collected them on a piece of sandy land in the forgotten middle of the country, land that is considered "useless," both geographically and politically. While from the lands' perspective I may have been hastening decomposition somewhat, from a human point of view I was expending a lot of energy to construct something of little obvious worth in a place where it was apt to receive minimal public attention. As analysis, the arts may speak a language that is not logical, philosopher and poet Jan Zwicky points out. Their language may be lyrical, springing from a "love that attends to the most minute details of difference, and in this attention experiences connection rather than isolation."[33] As lyric expression, the wall of twigs acknowledges mortality. Lyrical expression, Zwicky suggests, aims toward this acknowledgment, for relinquishment of the ego rather than its celebration.[34] Letting go of control and respecting the state of internal impermanence, which I'd learned as I read *The Cloud of Unknowing* several years before, was also the ground of this work with the twigs. Again I felt "decentered," able only to respond, assist, attend to what was given, and continue to check, as I carried out the long labor, my commitment to the work. I always remained engaged. Levin sees this "rigorously sustained attending to openings the only test we have of the truth of our thinking."[35]

When after a year and a half of breaking and stacking I moved the units to the gallery and constructed the wall in a public space, I was hardly prepared for its life in a less private context. My performance of the labor had been almost entirely solitary, although I had worked with some sense of a future audience as I knew I was to have an exhibition. Still, receptivity for this work had been more imagined than actual.[36] In the gallery, what had seemed intensely interior was turned inside-out: a skin flayed, laid open. The long back of the wall was rough, textural, slightly chaotic while the front, twig ends packed tightly against glass, was orderly, almost coolly industrial.[37] The contrast between inner and outer, distant and more intimate experience of the twigs, called for viewers to become participants, to engage in a physical and visceral as well as visual response. Smell—the scent of the poplar wood—became an unexpected but locating element for those who entered the space. Visitors paused at the entrance, startled and moved by the sweep of curved space the wall defined in the white rectangle of the gallery. I recalled the small,

fragile, hand-sized gesture with which the piece began and was amazed by the large, solid wall to which it had led.[38] Faithfulness to that initial gesture, that image as evidence of the particular place in which I found myself, had been translated into something of architectural, encompassing proportions, creating a new and transformative space that was responsive to the interior longings of my soul.[39]

I would offer that this way of working is not unlike "prayer," prayer as prelinguistic, image-laden speech that opens a door to unconscious images and "leads straight to the workings of our souls."[40] Carried out in the body through gesture, in this case a rhythmic breathing/breaking that took me through the long labor of making the wall of twigs, it was a sort of physical incantation joining inner and outer spaces. "Attending to openings,"[41] "the fittingness of act and thing and word to a particular situation,"[42] "an awareness that is vulnerable to the world. Open"[43]—these are attitudes that call for paying attention, with loosened preconceptions, to the place and time and moment in which we find ourselves. This "apophatic unknowing" is a challenging stance in a time which is so defined by rationality, yet is a way of knowing that art, a different language in its nonverbal embodiedness, may enable.

NOTES

A version of this article was read as a paper for the panel *The Subjugation of the Spiritual in Art*, a session of the College Art Association, San Antonio, Texas, January 27, 1995.

1. Roger Lipsey makes this point in *An Art of Our Own: The Spiritual in Twentieth-Century Art* (Boston: Shambhala Publishing, 1989) 5.

2. Wassily Kandinsky, *Concerning the Spiritual in Art and Painting in Particular* (1914; New York: Wittenborn, Shultz, 1947).

3. Maurice Tuchman, ed., *The Spiritual in Art: Abstract Painting 1890–1985* (New York: Abbeville, 1986).

4. There are currently numerous texts by feminist artists and theorists on this subject. For early work in this area see Linda Nochlin, "Why Have There Been No Great Women Artists?" in *Art and Sexual Politics*, ed. E. Baker and T. Hess (London: Collier Macmillan, 1973); L. Nochlin and A. Sutherland Harris, *Women Artists 1550–1950* (New York: Alfred Knopf, 1976); N. Broude and M. Garrard, *Feminism and Art History* (New York: Harper and Row, 1982).

5. Donald Kuspit, "Concerning the Spiritual in Contemporary Art," *The Spiritual in Art: Abstract Painting 1890–1985*, ed. Maurice Tuchman (New York: Abbeville, 1986) 315. Kuspit makes passing reference to this "other" spiritual art in an essay that focuses, like the exhibition, on abstract painting.

6. Kuspit 321.

7. Suzi Gablik, *The Reenchantment of Art* (New York: Thames and Hudson, 1991).

8. Lipsey.

9. See also Michael Tucker, *Dreaming With Open Eyes: The Shamanic Spirit in Twentieth-Century Art and Culture* (London: Aquarian-HarperCollins, 1992).

10. Clifford Geertz, "Religion as a Cultural System," *Reader in Comparative Religion*, ed. William Leesa and Evon Vogt, 2nd ed. (New York: Harper and Row, 1972) 204–16.

11. See especially Ronald L. Grimes, "Defining Nascent Ritual" *Beginnings in Ritual Studies* (London: University Press of America, Inc., 1982) 53–69. Grimes elaborates on the following definition: "Ritualizing transpires as animated persons enact formative gestures in the face of receptivity during crucial times in founded places" (55).

12. Mihaly Czikszenmihalyi, *Beyond Boredom and Anxiety* (San Francisco: Jossey-Bass, 1975) 37–47.

13. William Johnston, ed., *The Cloud of Unknowing and The Book of Privy Counseling* (New York: Doubleday and Co., 1973).

14. Veselin Kesich, "Via Negativa," *Encyclopedia of Religion*, ed. Mircea Eliade (New York: Macmillan, 1987) 15:252–54.

15. Johnston 48–49.

16. Lynda Sexson, *Ordinarily Sacred* (New York: Crossroads, 1982) 1–3.

17. Elizabeth Dodson Gray, ed., *Sacred Dimensions of Women's Experience* (Wellesley, Massachusetts: Roundtable Press, 1988) 2.

18. See one of the first collections of essays on this subject by Carol P. Christ and Judith Plaskow, eds., *Womanspirit Rising: A Feminist Reader in Religion* (San Francisco: Harper and Row, 1979).

19. Johnston 63.

20. Lipsey 10.

21. John W. Dixon, "What Makes Religious Art Religious?" *Cross Currents* 43.1 (1993): 14.

22. Dixon 18.

23. Support for this idea may be found in Barbara Maria Stafford, *Body Criticism: Imagining the Unseen in Enlightenment Art and Medicine* (Cambridge: The MIT Press, 1991) and in Ernest B. Gilman, "Interart Studies and the 'Imperialism' of Language," *Poetics Today* 10.1 (1989): 5–30.

24. Dixon 12.

25. David Michael Levin, *The Body's Recollection of Being: Phenomenological Psychology and the Deconstruction of Nihilism* (London: Routledge and Kegan Paul, 1985) 201.

26. This "piece" has since become a collaborative project with my colleague and office partner, Janet Werner. We both confess a degree of relief and even glee as we tape no-longer-relevant memos to the wall.

27. Thanks to Betsy Warland for pointing out this correspondence and the way in which the wall functions to positively redirect that pattern of energy.

28. Mircea Eliade, *The Sacred and the Profane: The Nature of Religion* (New York: Harcourt, Brace & World, 1959).

29. Raimundo Panikker, "There is No Outer without Inner Space," *Cross Currents*, 43.1 (1993): 60–81.

30. Elaine Scarry, *The Body in Pain: The Making and Unmaking of the World* (New York: Oxford University Press, 1985) 282–84, 254.

31. Dixon 15-16.

32. Levin 215, 27.

33. Jan Zwicky, *Lyric Philosophy* (Toronto: University of Toronto Press, 1992) 126.

34. Zwicky 130, 126.

35. Levin 24.

36. Grimes (note 11, above) emphasizes the importance of "the face of receptivity" in ritual which can be "variously located in the unconscious, society, surrounding environment, or attendant spirits . . . is not objectifiable . . . [and] is as much inside the ritual actor as outside" (64). Although I describe my work as an artist as primarily private, the "face of receptivity" is located in part in an external audience, even if this audience is made up of strangers or largely imagined; I doubt I would have carried this activity to such lengths, were I its only recipient.

37. The work, entitled *Hibernaculum*, was first exhibited at the Mendel Art Gallery, Saskatoon, November 4, 1994–January 8, 1995. An exhibition catalog accompanied the exhibit; the show was reviewed by Ann Newdigate in *Canadian Art*, 12.1 (1995): 90–91. Included in the exhibition, but not discussed in this article, were four tall cabinets, based on the body's dimensions, filled to various levels with poplar ash.

38. The end product—the wall—seemed solid with each panel weighing over 200 pounds. It was, however, made to exist for the duration of the exhibition with the intention of returning the twigs to the woods and the glass to the business from which I had bought it. While this may still be its final destination, the "wall" took on new meaning in the gallery, entering into the art economy of traveling exhibitions and possible commodification as a piece of "permanent" art.

39. Thomas Moore describes "soul" as the third element that relieves the Cartesian dualism of mind and body: soul values attachments, is willing to remain patiently amidst the contradictions and paradoxes of the present that ego would prefer to escape or control (xvii). Like Lynda Sexson (note 16, above), he seeks the sacred in the ordinary regarding the everyday as the primary source of religion. See *Care of the Soul: A Guide for Cultivating Depth and Sacredness in Everyday Life* (New York: HarperCollins, 1992).

40. Ann and Barry Ulanov, *Primary Speech: A Psychology of Prayer* (Atlanta: John Knox Press, 1982) 2–3.

41. Levin 28.

42. Dixon 12.

43. Zwicky 130.

6

BETWEEN THE SACRED AND THE PROFANE

THE ALTARS OF NIKI DE SAINT PHALLE AND JEAN TINGUELY

ANDREW DOERR

The traditional altar is a site at which the human world of Eros intersects with the Thanatos of religious transcendence and release. It is also one of the most important repositories of the distinctive marks of the continual development of individual cultures. In recent years, the altar form has been used by various artists including Betye Saar, Amalia Mesa-Bains, Renée Stout, and Michael Tracy to examine the formation of identity within a United States increasingly defined by the diversity of its peoples. These explorations have been chronicled by Lucy Lippard in her remarkable book *Mixed Blessings*.[1]

My aim in this chapter is to analyze altars made by two Europe-based artists, Niki de Saint Phalle and Jean Tinguely, who after they began living together in 1960, worked independently but also collaborated on numerous works until Tinguely's untimely death in 1991. Although separated chronologically, the altars of de Saint Phalle and Tinguely are related thematically. Like the work of the artists mentioned above, the work of de Saint Phalle and Tinguely addresses issues of national and individual identity and is framed by the emergence of technology-based consumer cultures in France and the United States during the postwar

years. Their confrontation with the issues raised by the emergence of these new cultural forms will be the focus of my analysis.

Perhaps heeding Mao Zedong's pronouncement that politics must at times be made out of the barrel of a gun, Niki de Saint Phalle first came to the attention of the international press in 1961 by making art with the same measure of violence. Her "shooting pictures," some of which were in the form of Gothic altars, were created/destroyed by being shot at so that they bled from bags of paint embedded behind their virginal white plaster surfaces.[2] At the time she made and performed these works, de Saint Phalle stated that her shooting actions were not attacks on god but on institutionalized religion, and in a broader sense, a demand that all received or traditional notions that inhibit spontaneity and individual creativity be questioned. Significantly, especially considering the date, they also questioned the role of women as individuals and as creative artists. As de Saint Phalle has written: "In 1961 I shot at: DADDY, all men, small men, tall men, BIG MEN, FAT MEN, men, my brother, society, the church, the convent school, my family, my mother, ALL MEN, DADDY myself, MEN. I SHOT BECAUSE it was fun and made me feel great. I shot because I was fascinated watching the painting bleed and die. I shot for that moment of MAGIC. ECSTASY. It was a moment of Scorpion truth. WHITE PURITY. SACRIFICE. READY AIM FIRE! Red, yellow, blue—the painting is crying, the painting is DEAD. I killed the painting. It is reborn. WAR WITH NO VICTIMS."[3] In addition, the inclusion of warplanes, model skyscrapers, American flags, and in one altar, the letters O.A.S. make these altars political statements at a time when most art with metaphysical associations, especially in the United States, was largely depoliticized and praised for being concerned with timeless human universals.[4]

Tinguely first came to the attention of the American public on March 17, 1960, one year before de Saint Phalle's first shooting actions. The spectacular suicide of his self-destroying machine, *Homage to New York*, which literally burst into flames in the sculpture garden of New York's Museum of Modern Art, was reported in newspapers around the world as either the ultimate confirmation of the nihilism of contemporary artists or as a fiery reminder of the frighteningly real possibility that humanity will annihilate itself with the technology of the nuclear age. Tinguely began making altars much later in his career. The first, the *Cenedoxus Isenheim Altarpiece*, was made in 1981, and the one which I will focus on in this essay, the *Altar of Occidental Abundance and Totalitarian Mercantilism*, was first exhibited in Moscow in 1990.

Whether it is in a grand Gothic cathedral or in the modest home of a Haitian vodun priest, the altar is the spiritual heart of the sacred ground

in which it resides. Symbolically an altar is both an individual and a communal endeavor. It is activated by the community and the individual in a ritual exchange. As a material object, it is made up of various components. Each is significant in terms of representing an important concern or strongly held belief. These concerns and beliefs taken together define the culture of the makers so that the altar becomes a symbol, which is in effect part of the flesh and blood of the believer as an individual and as part of a distinct community. Doing violence to such an object violates the believer in his or her innermost being. Thus the aggressiveness of de Saint Phalle's shooting actions cannot be overestimated.

De Saint Phalle's shooting altars were indeed extraordinarily violent, and as her statement above suggests, this violence was in large measure directed at men, or more accurately, at patriarchal culture. In fact, de Saint Phalle's feminism has been examined at length by numerous writers including herself and it is an important aspect of her entire *ouevre*.[5] But the desecration of altars has a long history and the nature of this desecration in de Saint Phalle's case is what interests me here. What in addition to men was she shooting at in 1961?

De Saint Phalle was born in France in 1930 and raised in the United States. Her French father was a member of a well-connected banking family. Her half-French, half-American mother also came from a wealthy family. She was, according to de Saint Phalle, a strikingly beautiful woman whose looks and refined attention to the details of dress and *toilette* she admired as a girl and still appreciates. Both of de Saint Phalle's parents were traditional and Catholic, but also cosmopolitan. They divided their time between the United States and France. During part of her youth de Saint Phalle attended the Convent School of the Sacred Heart in New York City. She also modeled for *Vogue* and *Harper's Bazaar*, and while still in her teens, she was presented on the cover of *Life* magazine as a popular New York débutante.

She has said that she felt half-French, half-American and also half-man, half-woman. At an early age, she became aware that society grants men access to kinds of power denied women and that she would need to appropriate that power. She moved to France with her first husband, the writer Harry Matthews, and young daughter, Laura, in 1952 and has essentially lived and worked in France since that time. She began living with Jean Tinguely in his studio in the *Impasse Ronsin* in Paris in October 1960 after leaving her family to devote herself fully to being an artist—an active maker of culture.

The France of the 1950s and 1960s was suffering from a severe identity crisis. The repressed memory of widespread collaboration with the Nazis during World War II was a source of guilt that could not be

removed. The self-image of France as a country that had resisted the Nazis to the last man was a myth, and many knew this. In addition, France emerged from the war a decidedly second-rate power in world affairs. A succession of weak governments and the threat of a coup d'état on the eve of General de Gaulle's return to power in 1958 undermined any remaining pretensions France may have had of regaining its great power status. The United States and the Soviet Union had excluded France from most of the important policymaking discussions of the immediate postwar years, and often France was described in American policymaking circles as petty, dangerous, and implicitly feminine or impotent.[6] Although with de Gaulle's return to power France had a tall, virile war hero for a leader, who through his policy of *grandeur* actively sought to return France to some semblance of her former glory, even the general was enough of a realist to recognize that the game was up.

More importantly for artists working after the war, it was clear that the West's cultural center of gravity was shifting from Paris to New York and Hollywood. This shift was trumpeted loudly by critics in the United States, in particular those supporting the work of what became known as the Abstract Expressionists or the New York School. The situation did not improve during the 1960s and artists that chose to work in Europe were often ignored in the United States.

On the level of popular culture, demands made by the United States in conjunction with the Blum-Byrnes loan agreements, originally concluded in 1946 to aid French recovery from World War II, virtually assured the flooding of the French market with Hollywood films and the attendant decline of the French film industry. This frontal attack on French culture came at a time when France was traumatized by its long, bloody, and often humiliating withdrawal from its colonial possessions abroad. To many of the French, it appeared that France was itself being colonized by a consumer and artistic culture emphatically stamped "Made in U.S.A."[7]

Is it purely coincidental that Roland Barthes's seminal essay "The Death of the Author," which calls into question the authority of the author as the generative source of the meaning of a text, was published at precisely this time? It was a time when French national identity was being challenged, not only by the United States from the outside, but also by internal demographic changes that greatly accelerated the urbanization of France and by a massive influx of settlers—French but not quite French—from the former colonies, in particular Algeria. De Saint Phalle's works include numerous references to many of the forces that were seen as actively undermining the identity of the country in which both she and Barthes were working.

Such developments perhaps help account for the notably violent streak that runs through the work not only of de Saint Phalle, but also of her associates in the group of artists designated as the *Nouveaux Réalistes*.[8] The members of this group, including de Saint Phalle, critiqued the consumer culture emerging around them and in the spirit of Dada, often derisively challenged the presumptions of their artistic contemporaries.[9] The choice of the altar form is paradoxically just such a challenge.

In addition to being a spiritual and cultural marker, the altar is one of the most traditional forms of Western art. Altars were often decorated with painting for the Catholic Church in a decorously conservative style. Thus, de Saint Phalle not only shot at the church's restriction of individual freedom, as she declared. She also shot at traditional painting and by extension at limitations of artistic creativity resulting from dogmatic adherence to accepted norms.

A good example is the *Altar Black/White*, 1962. It is a triptych decorated with numerous crucifixes, figures of male and female saints, a rose, and at its center, a classical male torso. After the shooting, the figures were splattered with paint which ran down the surface of the altar like sacrificial blood and marred the ideal beauty of the torso.

It is worth noting that what resulted from the impact of the bullets was a work whose expressive force has a great deal in common with paintings done in the style called *Informel* or *Tachisme* in France. This style, which had developed parallel to American Abstract Expressionism, was considered by many to be a weaker counterpart to the bold American experiment. By the late 1950s, this style had already been attacked by, among others, Jean Tinguely who felt that its initial vigor was now exhausted. He, like the other artists who would become part of the *Nouveaux Réalistes* group, turned to found objects and the discarded products of contemporary consumer culture. They argued for an art that would be more immediate and more firmly grounded in the materialist reality of postwar France.[10]

Seen from this perspective, the shooting altars are a brilliant critique. Not only did de Saint Phalle, as a woman, appropriate the explicitly virile and violent character of both Abstract Expressionism and *Informel*, she at the same time undermined the notion of individual gesture, a central component in the definition of expressionist painting.[11] The implicitly male physical action of "action painting" was replaced by the impersonal action of a gun, a machine, which never touched the canvas, but still caused it to explode with expressive fury and created an appropriately confrontational avant-garde work of art.

For de Saint Phalle, the shooting altars and shooting pictures in general became vehicles for spiritual transcendence of a particularly twentieth-

century variety.[12] Rather than allow herself to be defined by others or by a religious dogma, she claimed individual authorship and responsibility. She confronted not only the forces of humankind, nature, and the heavens, which have been the subject of art throughout its long history. As we shall see, she also sought to use art as a means of mastering the forces unleashed by the ever-increasing productivity of the industrial state. Finally, she chose to create herself in defiance of traditional expectations by transforming a weapon of male terror into a means of making art. In the process, she defined herself internationally as a serious artist and invented a radically new way of "painting."[13]

Having now created a thoroughly modern Niki, I will shift gears and focus on two shooting works which are not explicitly Gothic altars but are altarlike in that they are divided into panels. Both *New York Alp*, 1962 and *King Kong*, 1963 are assemblages and postmodern in spirit. In both, the work of art becomes a site of accumulation. This postmodern accumulation mirrors the way that the individual is formed by language and highlights the existence of "master narratives" which are seamlessly naturalized as part of a process that calls into question the possibility of individual agency.

New York Alp and *King Kong* are part of a distinct phase in de Saint Phalle's career, which began with her first interactive work, *Saint Sebastian, Portrait of my Lover* in 1961, and effectively ended with the creation of the first *Nanas* in 1964.[14] The works in question are all assemblages. Whether in the form of panels or human figures, they are built up of plaster, string, chicken wire, cloth, gauze, and significantly, plastic toys, including baby dolls, model warplanes, cars, and tanks—mass-produced objects that refer to the consumer and the military cultures that were perceived by many as agents of the aforementioned colonization of France and Europe in general.

De Saint Phalle's figures look as though the skin has been worn off to reveal flesh and internal organs—a cross between Giacometti and Dubuffet. Some, like *The Large Man-Red* (Munich Shooting Picture), 1962, are white and bleed blood-red paint. Others, like the *Red Witch*, 1962–1963, are covered with red and look flayed alive. Writing about the robust female figures or *Nanas* de Saint Phalle began producing in 1964, the French critic Pierre Descargues described the de Saint Phalle of the preceding phase as "the young woman who not only ran babies through the meat grinder, but also priests, generals, and philosophers."[15] She also shot them!

New York Alp consists of two panels whose white plaster surfaces have been splattered with paint. The right half includes two New York skyscrapers seen frontally and revealing an underlying chicken-wire ar-

mature. These are the "Alps" that tower over the closed-in valleys of the
city's streets. To their immediate right we look down on cars in one of
these streets. In the bottom left corner of the left-hand panel, there is a
small shelf that supports a small reproduction of a sculpture of Christ or
perhaps one of the Christian saints from a cathedral, and a bust of the
Virgin. To the right of this pair is a cross bearing the crucified Christ.
Above the cross is a large prehistoric bird whose body has a nude child's
doll stuck to it and whose outstretched wing is encrusted with model air-
planes, guns, cars, and two cans of spray paint. There is a large jagged
mouthlike opening under the bird's head, which suggests the monsters
that appear in other works that de Saint Phalle made around this time, in-
cluding *King Kong*. The colors are jarring red, blue, yellow, green, or-
ange, and black. They have exploded onto the surface from internal paint
packets or cans of spray paint placed in front of the panel. The effect is
nightmarish.[16] The sun above the skyscrapers bleeds black paint.

 King Kong is an elaboration of *New York Alp*. Here the bleeding
sun is at the center and has a Gorgonlike face. Below this is a monster
who leers at the viewer and whose body consists of baby dolls, reptiles,
guns, a skull, and a whole host of creatures which give it the effect of an
active termite mound. The monster faces to the viewer's right and reaches
for the first building in a row of skyscrapers which extend to the edge of
the panel. Above these model jets dive down and the word "BOOM" is
stamped on the plaster in a cartoon bubble which surely refers to the Pop
work of Roy Lichtenstein. Below the city, a black widowlike figure com-
posed of skulls and surrounded by electrical wires and doll appendages
sprawls and confronts the viewer with a hideous death head. To the left
of the central axis, there are two rows of plaster heads. The faces include
Khrushchev, Kennedy, Mao, and Castro.[17] Below these is an American
flag, perhaps a nod to Jasper Johns. Above the heads is a miniature
church facade surmounted by a cross. In the upper left corner of the
panel, a splayed female figure gives birth to a baby doll and a macabre
bouquet of flora and reptilian fauna, including snakes that hark back to
the Garden of Eden and Minoan snake cults. Below this bouquet, a wed-
ding couple stands ready, the man wearing the face of a figure from the
Mexican Day of the Dead. Finally, at the viewer's far left, two children
play ball above a heart and a motorcycle with rider.[18] The white surface
of *King Kong* is splattered with black paint from concealed packets and
spray cans. The whole has a charred appearance. The blackness of death
has brutally violated the purity of the white background.

 Both *King Kong* and *New York Alp* were made during and shortly
after the time when the smell of plastic explosives and gunpowder filled
the streets of Paris as the right-wing terrorist O.A.S. resorted to desperate

measures to prevent France from granting Algeria independence. The Cold War was at its height. The Berlin Wall went up in 1961 amidst threats of nuclear war, and the stand-off between the Soviet Union and the United States reached a fever pitch during the Cuban missile crisis, which played itself out in the following year. There was a great deal to shoot at in the male world of Cold War politics. On the female side, there was the whole range of social expectations limiting the creative possibilities of women, while painting a rosy picture of hearts, flowers, lovers on motorcycles, weddings, and babies. These elements of the traditional realm assigned to women are certainly not negative in themselves, but even today they are often deployed by advertising and the mass media to marginalize women in a world in which "important" culture is made in traditionally male terms.[19] At the time of de Saint Phalle's shooting actions, American-inspired women's magazines actively shaped notions of femininity in France. Significantly this femininity centered around the home, a home equipped with the latest appliances and run by a high-heeled woman always looking her best.[20]

For Niki de Saint Phalle and Jean Tinguely, personal freedom and creativity have been of utmost importance, and it is for this reason that they have critiqued a consumer culture in which the producers of that culture are only too happy to make our choices for us. They have not been alone. Since the 1960s many artists and writers, including Herbert Marcuse and Jean Baudrillard, have pointed out how the mass media and advertising deaden or completely eliminate our ability to experience the world spontaneously.[21]

In part as a response to this threat, de Saint Phalle increasingly explored the realm of magic and the spiritual in her art. She has described herself as an all-devouring mother who consumed artistic influences ranging from Giotto and early Sienese painting, to the macabre festival art of the Mexican Day of the Dead, to the art of contemporaries, including Robert Rauschenberg and Jasper Johns. In large measure, the art she made between 1960 and 1965 almost literally reveals this often violent digestive process. It, in turn, gives birth to an art that increasingly deals with magic, fairy tales, myths, and the world of symbols, while at the same time continuing to question the roles assigned to women in the "real" world.

Seen in this light, de Saint Phalle's shooting altars were part of a process of purging in which she confronted received notions of spirituality. She shot at the Church, but not at the gods or the goddesses. As the altars bled, they were transformed into art. As sites of individual creativity, they admitted a wider range of spiritual experience than that promised by the Catholicism of her childhood. Are they in fact markers of a violent rebirth?

At the time of the shooting actions, de Saint Phalle was coming to terms with the implications of her own transformation into a full-time artist. She has recalled how impressed she was by the total dedication of the artists of the *Impasse Ronsin*, which she first visited in 1955 while still trying to combine her life as an artist with the traditional role of wife and mother. By the time of the shooting actions, she had left her husband and children and had herself become part of the creative community of the *Impasse Ronsin*. With the shooting actions, she literally underwent a baptism by fire.

In the mid-1960s, she went further and broke with her friends in the *Nouveaux Réaliste* group, by emphatically returning to figuration. Ultimately, she brought to life the *Nanas* and later works which speak of primal, atavistic, and magical forces. Since 1979, she has been working on, and for much of the year living in, the splendid, brightly colored figures of her *Tarot Garden* in Garavicchio, Italy. She has also created a host of other works, many of which reflect her continuing exploration of the mysteries of creation and destruction.

In 1981 almost exactly 20 years after de Saint Phalle created her first shooting painting, Jean Tinguely built his first altar, the *Cenedoxus Isenheim Altarpiece* (the *Cenedoxus Altarpiece*). As the title suggests, it is an homage to Matthias Grünewald's *Isenheim Altarpiece*, which includes the most riveting image of Christ nailed to the cross in the history of art.[22] As with most of Tinguely's works, the serious tone of this altar is cunningly opposed by humorous, ironic elements that, as Tinguely puts it, sugar coat the work for easier consumption. Pontus Hulten has noted in his biography of Tinguely, *A Magic Stronger than Death*:

> In Tinguely's altars there is a strong element of satire and deception. Looking at [the altars] we hardly know whether to be frightened or laugh, and the memory they leave behind can be more frightening than the first shock. The Tinguely altars perhaps have a religious content that goes back to his Roman Catholic upbringing; they refer to a recognizable system, an iconography related to good and evil, life and death, salvation and damnation, paradise and hell.[23]

The most important element in the *Cenedoxus Altarpiece* is the inclusion of ox skulls, jawbones, and other macabre Christian symbols of mortality.[24] Heidi Violand has noted:

> In medieval tradition death is personified by a skull, a reminder of the transience of living on earth, and as such appears frequently in *vanitas* still life. . . . The skull crowns the human frame, it is the seat of the intellect, containing life in its highest state and hence is the most potent *momento mori*. As such,

> the ox cranium heads Tinguely's composition, becoming an
> emblem of mortality that is all the more striking for being rep-
> resented by a mouldering, unclean bone, as if to emphasize the
> physical decay of death.[25]

Violand convincingly argues that the role of death in this and other works
by Tinguely is meant as a spur to live life to the fullest. He himself af-
firmed that "death helps me to live," "without him one could not live—
without death—no life—without night—no day."[26]

Like all of Tinguely's works, the *Cenedoxus Altarpiece* is con-
structed from scrap metal. It is a machine that moves and makes a variety
of noises. Like many of his later works it is lit by the kind of lights that
decorate ferris wheels and other carnival rides. This carnival illumination
is calculated and the atmosphere it creates is heightened further in one of
Tinguely's last large works, the *Altar of Occidental Abundance and To-
talitarian Mercantilism* (the *Altar of Occidental Abundance*) which was
created specifically to be shown at a major exhibition of Tinguely's works
sponsored by the Swiss government and held in Moscow in 1990.

As we have seen, part of Niki de Saint Phalle's critique from the
early 1960s focused on the emergence of postwar consumer culture. For
Tinguely many of the issues raised by the expansion of this culture are
still very much with us in the 1990s and his entire *ouevre* reflects these
concerns. The *Altar of Occidental Abundance* is interesting because it
was calculated by Tinguely to serve as an ironic and cautionary import of
Western "technology" to the Soviet Union, which at this time was on the
verge of the historic rejection and ultimate disintegration of communism.

Tinguely had wanted to exhibit in the Soviet Union for many years.
The rise to power of Mikhail Gorbachev during the 1980s finally made
this possible. Tinguely's own stature in Switzerland had risen during the
1970s and 1980s. As an artist and as a personality, he enjoyed an enor-
mous popularity in his home country and in Europe.

Like the *Cenedoxus Altarpiece*, the mechanical *Altar of Occidental
Abundance* is made from scrap metal and includes a centrally placed ox
skull. It is also lit by carnival lights. However, the *Cenedoxus Altarpiece*
is far more elegant. In contrast, the *Altar of Occidental Abundance* looks
like a monstrous collection of junk salvaged from flea markets, scrap
heaps, city dumps, derelict carnivals, and the remains of Mardi Gras in
New Orleans.[27]

The *Altar of Occidental Abundance* is a very large work measuring
approximately twenty feet across by fifteen feet high. It literally has stage
presence. As with many of Tinguely's works of the 1980s, great care was
given to lighting the work in such a way that this presence is accentuated.
It is calculated to be ironically carnivalesque or tragically festive and these

effects are heightened by the sounds Tinguely incorporated into his infernal machine.

The altar's mechanism includes numerous large industrial drivewheels. These spoked wheels, made of wood and iron, evoke the early days of the industrial revolution. They groan as they are driven by long leather drivebelts. There is also an all-pervasive, high-pitched squealing from smaller wheels and pulleys that need attention, lubrication, a better fit. Other sounds include a loud clanking at irregular intervals resulting from the lifting and dropping of a long metal beam. The lifting is continually repeated and has a poignantly futile erotic effect. Chains creak and children's toys make a haunting sound to which I will return later.

The scrap metal armature is decorated with brightly colored, happy plastic dolls, and various other sparkling items again referring to the child's world of carousels and ferris wheels. At the top center is a cheap plastic clock built into a frame having the form of a silver plastic peacock. Most likely unbeknownst to the original manufacturer, a contemporary timekeeping mechanism is thus suggestively fused with a traditional Christian symbol of immortality. Peacock flesh was thought to resist decomposition. Plastic is also resistant to the ravages of time. This infinitely mutable material, the quintessential substance of mass production, is available in a virtually unlimited variety of colors whose intensity rivals those of the lavishly decorated peacock. Behind and to the right of this union, a large silver Star of Bethlehem rises to mark the site of a miraculous birth.

Below the clock we find the familiar bovine cranium above a large spoked wooden wheel whose hub is a golden plastic mask. Itself a cross between a skull and a robot's head, it looks as though it has been pierced by a ring of swords whose hilts form a golden aureole and give the whole a sunlike, divine splendor. The ox cranium's Christian association with mortality has been mentioned. The wheel represents life for Tinguely. The sun gives life to the living world, while the halo is evidence of a divine spirit. The central axis of the altar is thus decorated with symbols of life, death, and mass production. We experience a head-on collision of signs and systems of meaning framed by the overarching connection with sacred traditional altars.

In the *Cenedoxus Altar* and the *Altar of Occidental Abundance*, there is a tension between the gravity of the religious symbols and the variety of banal, melodramatic effects created by the inclusion of mass-produced consumer items whose sounds suggest the circus rather than the cathedral. In each, we are confronted with symbolic Christian references to physical mortality, often represented by skulls. But the promise of transcendence implied by the altar form must compete with the sweet music of the material world created by consumer capitalism.

As mentioned, the *Altar of Occidental Abundance* includes a variety of brightly colored plastic children's toys. One of these is a cylinder on the end of a stick which makes a characteristic clinking sound when rolled across the floor. In this altar, it is pushed by a mechanism attached to its handle—back and forth, back and forth, back and forth. In the midst of the altar's mechanical squeals and groans, it is the sound of this toy that I find most evocative. It is like a Siren's song which promises not a beautiful maiden, but a kind of innocent happiness. It says: "Play with me. Give yourself to me."[28]

The *Altar of Occidental Abundance* was exhibited in the Soviet Union at a time when the Soviet Union and the world were approaching the end of an era. It appeared that Western-style capitalism and consumer culture had emerged triumphant. The infidel was vanquished and driven eastward. It was fervently hoped by many that the world would achieve a medieval unity of faith. This new faith, the power and glory of limitless consumption, would supplant the now discredited unifying systems of the Church and Marxism. Tinguely, to celebrate the dawning of the glorious new age, supplied an altar that ironically addresses the concerns of the newly converted.[29]

Niki de Saint Phalle and Jean Tinguely worked in Europe during an era of unprecedented economic growth. In France, it was a time during which technology and central economic planning played an increasingly prominent role in defining the lives of millions of people. Neither de Saint Phalle nor Tinguely rejected technology or capitalism out of hand.[30] They recognized that much of the freedom that they enjoyed as creative individuals was made possible by the wealth and dynamic cultures of postwar Europe and America. However, in their art they also sound a note of caution. Tinguely in particular has spoken out against the threats to the integrity of the individual by a profit-driven system whose productive capacity is virtually limitless—a system that must and does coerce people to consume its products without questioning their necessity or desirability.[31]

In their work, de Saint Phalle and Tinguely used the altar form in the traditional manner as a site for integrating the concerns of the flesh and spirit in an object which stands at the crossroads between mortality and transcendence. Their questioning is both violently direct and humorously ambiguous. As Tinguely's longtime friend and supporter, Pontus Hulten has written:

> The message in Tinguely's altars exists on an aesthetic level. The artist does not propose any answer or solution to the miseries of the world—he only expresses his anguish, his questions about death and life afterward, and his secret sense of the

sacred. He holds up the horrors to our face in a mocking fashion so that we can deal with them more easily, because they are not "real." His altars are dedicated to the intelligence and sensibility of humanity, and do not attempt to reveal a solution.[32]

Although it is true that Tinguely's and de Saint Phalle's altars exist on an aesthetic level, and although Tinguely has himself objected to the direct involvement of the artist in politics, the work of both de Saint Phalle and Tinguely has a political dimension that roots it firmly within contemporary culture. It is this provocative political dimension, in addition to the aesthetic and the personal concerns addressed, that give their work its resonance.

De Saint Phalle's altars, and the shooting actions in general, were a way out for her. They were both a social critique and a violent settling of accounts. In these works she redefined and reclaimed the spiritual in her own terms. The result was a newfound confidence which ultimately led to a breakthrough in her creative life and a powerful confirmation of the validity of her artistic and individual explorations.

Tinguely's *Altar of Occidental Abundance and Totalitarian Mercantilism* was an ironic commentary on the productivity of consumer society. It was intended as a warning to those seeking to transform the Soviet Union in the image of the West. His choice of the altar form emphasizes the extent to which under consumer capitalism the production-consumption cycle is powered with a quasi-religious fervor. At the same time, it is a reminder that this fervor is not to be confused with a genuine spirituality, which for Tinguely took the form of individual creativity and a life lived making conscious choices in a time of profound social and cultural transformation.

In response to the superpower holy wars and economic miracles of the postwar years, Niki de Saint Phalle and Jean Tinguely have each produced a body of work ranging from the unrelentingly material reality of the machine to the organic world of death and birth. In de Saint Phalle's case in particular, an opening has also been made out into the larger realm of the spiritual.

NOTES

1. Lucy Lippard, *Mixed Blessings* (New York: Pantheon Books, 1990).

2. The paintings and altars varied in size. Some were quite large, and assorted found objects were embedded in their surfaces. They will be described in greater detail below. In the earliest shooting pictures, de Saint Phalle and her

friends took turns shooting at the pictures. In later works de Saint Phalle did the shooting dressed to kill in a tight-fitting white jumpsuit.

3. Copied as written by de Saint Phalle in Carla Schula-Hoffman, *Niki de Saint Phalle: Bilder-Figuren-Phantastische Garten* (Munich: Prestel Verlag, 1987) See also Schulz-Hoffman, "Die Allverschlingende Mutter," 9–24 in the same catalog.

4. Serge Guilbert, *How New York Stole the Idea of Modern Art: Abstract Expressionism, Freedom, and the Cold War*, trans. Arthur Goldhammer (Chicago: University of Chicago Press, 1983) and Max Kozloff, "American Painting During the Cold War," *Artforum* 11.9 (1973): 43–54.

5. Jo Ortel, *Re-creation, Self-creation: A Feminist Analysis of the Early Art and Life of Niki de Saint Phalle* (PhD dissertation, Stanford University, 1992, available from UMI Dissertation Services, 1994).

6. See Frank Costigliola, *France and the United States: The Cold Alliance since World War II* (New York: Twayne Publishers, 1992). For overviews of the France of the fourth and fifth Republics see Jean Pierre Rioux, *The Fourth Republic 1944–1958*, trans. Godfrey Rogers (Cambridge: Cambridge University Press, 1987) and Serge Berstein, *The Republic of de Gaulle, 1958–1969*, trans. Peter Morris (Cambridge: Cambridge University Press, 1993). See also Richard F. Kuisel, *Seducing the French: The Dilemma of Americanization* (Berkeley: University of California Press, 1993).

7. Kirstin Ross, *Fast Cars, Clean Bodies: Decolonization and the Reordering of French Culture* (Cambridge: MIT Press, 1994) and Kirstin Ross, "Starting Afresh: Hygiene and Modernization in Postwar France," *October* 68 (1994): 22–57.

8. In addition to de Saint Phalle, this group, which was defined by the French critic Pierre Restany in May 1960, included Jean Tinguely, Arman, Cesar, Yves Klein, Daniel Spoerri, Raymond Hains, Martial Rayasse, Jacques Villegle, and Francois Dufrene.

9. See Pierre Restany, *Le nouveau realisme* (Paris: Union generale d'editions, 1978) and *Pierre Restany: Un vie dans l'art* (Neuchatel: Editions Ides et Calendes, 1983). See also Ortel 121–58.

10. For a general discussion of the conflictual relationship between high art and popular culture in the postwar years, see Andreas Huyssen *After the Great Divide: Modernism, Mass Culture, Postmodernism* (Bloomington, IN: Indiana University Press, 1986).

11. For a critical undermining of this notion see Hal Foster, "The Expressive Fallacy," *Art in America* 2.4 (1988).

12. Perhaps it would be more accurate to describe this transcendence as Nietzschean.

13. Ortel 59–61. As Ortel notes, the notion of the unitary self has been questioned by many scholars. See Jane Flax, *Thinking Fragments: Psychoanalysis, Feminism, and Postmodernism in the Contemporary West* (Berkeley: University of California Press, 1990) and Griselda Pollock, "Artist's Mythologies and Media Genius, Madness and History," *Screen* 21.3 (1980).

14. The Nanas are large brightly colored female figures. They are intended to be celebratory. Their large bodies are vigorous affirmations of physical power and *joie de vivre*. De Saint Phalle produced numerous versions over many years.

15. Pierre Descargues, "Les Nanas," *Niki de Saint Phalle* (Exhibition catalog, Galerie Alexander Iolas, 1965), reprinted and translated into German in Schulz-Hoffman 32–35.

16. In German, an *Alptraum* is a nightmare, a connection which could have been suggested by Tinguely who grew up in Basel.

17. These heads were included in a study for *King Kong* entitled *L'autel des politiques* (The altar of the politicians), 1962. See *Niki de Saint Phalle*, ed. Pontus Hulten, Ex. Cat. Kunst-und Austellungshalle der Bundesrepublik Deutschland (Verlag Gerd Hatje, 1992) 207.

18. At this time, de Saint Phalle made a number of hearts encrusted with various objects that undermine their usual meaning as pure unencumbered love.

19. My thanks to Ann Bermingham for clarifying this point. In fact, throughout her career de Saint Phalle has celebrated certain aspects of femininity as intrinsic strengths which define women and make them different from men. This stance is echoed in the work of today's leading French feminist writers, Helene Cixous, Luce Iragaray, and Julia Kristeva. See Elaine Marks and Isabelle Courtivon, eds., *New French Feminisms: An Anthology* (Brighton: Harvester, 1980) and Tori Moi, *Sexual/Textual/Politics: Feminist Literary Theory* (London and New York: Methuen and Co., 1985).

20. Ross, *Fast Cars, Clean Bodies* 71–122.

21. See Herbert Marcuse, *One-dimensional Man* (New York: Beacon Press, 1964) and Jean Baudrillard, *Consumer Society* excerpted in *Jean Baudrillard: Selected Writings*, ed. Mark Poster, trans. Jacques Mourrain (Palo Alto: Stanford University Press, 1988) 29–56.

22. See Heidi Violand, "Jean Tinguely's Cenedoxus Isenheim Altarpiece," *Arts Magazine* 62.2 (1987) for the most detailed discussion of this work. See also Pontus Hulten, *A Magic Stronger than Death* (New York: Abbeville Press, 1987).

23. Hulten 289.

24. *The Cenedoxus Isenheim Altarpiece* marks the beginning of a phase in Tinguely's work in which skulls and bones would play an increasingly prominent role. Tinguely's increasing preoccupation with death and the macabre during the 1980s has been attributed, in part, to personal crises, including the death of his mother and his own near death from a heart attack which left him in a coma for ten days in 1984.

25. Violand 81.

26. Quoted in Violand 82.

27. The carnival aspect of much of Tinguely's work has been documented by Violand with particular attention to the *Fasnacht* in Basel where Tinguely spent his youth. Beginning in 1973, Tinguely figured prominently in this Mardi Gras–like carnival.

28. Tinguely himself described the altar as a kind of Pied Piper who as the story goes, attracted not only rats but also children. He then goes on to say that at present the West is infatuating those people of the East who have not managed to create a functioning consumer society under communism. See Jean Tinguely, "Eine Uberlegung von Jean Tinguely," from a 1989 interview with Milena Palakarkina reproduced in *Jean Tinguely Moskau Fribourg*, (Ex. Cat. Museum fur Kunst und Geschichte, Fribourg, Switzerland, 1991).

29. It is perhaps worth noting that like de Saint Phalle, who utilized the altar form in 1961 when France's national identity was under siege, Tinguely chose the altar form at precisely the time when, according to many observers, Western industrial capitalism was itself being transformed by fundamental changes in its identifying structures. See Daniel Bell, *The Coming of Post-Industrial Society: A Venture in Social Forecasting* (New York: Basic Books, Inc., Publishers, 1973).

30. Tinguely was critical of the United States for various reasons, including the blatant commercialization of art, but as he once commented, "How can I reject a system that is so remarkably dynamic" (from a personal interview with Mrs. Monique Barbier-Muller, November 1993).

31. See *Jean Tinguely Moscau Fribourg* 26–27. See also *Jean Baudrillard: Selected Writings* 38, and John Galbraith, *The New Industrial State* (New York: The New American Library, Inc., 1967).

32. Hulten 291.

7

MULTIPLE VISIONS

REVISIONING AESTHETICS IN A PLURALIST AMERICA

DEBRA KOPPMAN

Every viewing of art simultaneously involves an act of interpretation, conditioned by the viewer's culture, biases, and experiences. American culture is continually undergoing processes of mutation; ideas and images of multiple cultural origins are constantly influencing our perceptions. Western theories of art often appear inadequate to describe our actual responses to art; this limitation also conditions our experiences. Not only may we be changed by contact with alternative images and visions, but our perceptions and beliefs are challenged and transformed by an awareness of multiple concepts regarding the creation and existence of art. All cultures and philosophies of art are in a continual process of adaptation and modification. Our society is characterized by a multiplicity of cultural perspectives, manifested in contemporary art in a resurgence of cross-culturally influenced images and syntheses of meanings. These images must not be merely appropriated and subsumed into a Western context; rather, non-Western images and ideas potentially serve as the jumping-off point for the creation of new images and syncretized contexts. The influence of African, Asian, Latin American, and Native American traditions on American culture are strong and need to be more explicitly acknowledged and understood. What also needs to be

more specifically attended to is the fact that many of these ideas have their origins in religious traditions in which art and the world of the sacred remain integrally intertwined. Memory, magic, transformation, reclamation, and a variously defined "spirit" are several of the overlapping and recurring themes which suggest a contemporary "respiritualization" of art.

The development of a multicultural framework to use in the interpretation of art would ideally give us a way of better understanding all art. Rather than subsuming myriad cultural traditions into a falsely unified Western analysis, we would be in a stronger position to experience each art on its own terms. This approach is particularly appropriate when looking at work which owes its inspiration to multiple sources; contemporary art is replete with such references. A brief overview of a range of cross-cultural aesthetic systems corresponding to the diversity of possible attitudes toward art and artmaking will be offered in order to expand our own ideas about the functions and meanings of art.

Each of the world's cultures is possessed of a matrix of aesthetic ideas which vary widely in terms of specifics and of complexity. Six general categories have been identified which broadly encompass a multiplicity of principles seen cross-culturally. The majority of aesthetic systems are governed by multiple ideas consisting of a combination of overlapping precepts. These categories, which include an aesthetics of invocation, an aesthetics of transformation, an aesthetics of energy, an aesthetics of process, an aesthetics of improvisation, and an aesthetics of magic are not meant to be conclusive nor narrowly to typecast particular cultures, but to provide both a context in which to talk about multiple aesthetic systems and a glimpse of the way we may begin to perceive cross-culturally.

The aesthetic categories that I will be outlining and calling cross-cultural are not foreign to Western aesthetics. Due to centuries of cultural domination by the West, many ideas as well as images have been wantonly appropriated without sufficient acknowledgment, understanding, or appreciation as to their complexity, richness, sources, or original contexts. The first step in creating a contemporary cross-cultural framework to use in both art criticism and art education may be to explore and acknowledge what has been consumed and subsumed of the world's cultures into Western thought.

In this way, the tracing of a multilineage of artistic debts can be seen as a recovery, a kind of de-consumption, which will potentially result in a reconstruction of aesthetic thought appropriate to a pluralist America. In the past, critical practice has encouraged a primary tracing of artistic heritage through the male, white, Western line so as to provide maximum art

historical and economic validation. These distortions have ranged from blatant to insidious, but the overall effect has been to minimize, neglect, or denigrate the more complex patterns of cross-pollination which may owe much to non-Western, nonwhite, or female parentage.

When we talk of a minimalist aesthetic could we also speak of Zen? Might we learn to associate the notion of art as ongoing process in its Native American origins rather than with the Native-American-inspired Jackson Pollock? Might we recognize the enormous debt Western artists owe to African art rather than simply tracing the line of descent of geometric abstraction through the Cubist Father Picasso? When we think of found objects as art why should our vision be limited to Duchamp or to a Pop aesthetic? Why not also learn of a strong interest and use of found objects seen cross-culturally? Why are we so infrequently looking at art objects created out of discarded inner tubes, coiled wires, snatches of old quilts made by Native Americans, Latin Americans, African Americans? Why are we so taken with site-specific works and installations and so unfamiliar with African American traditions such as bottle trees and yard art? When we think of collage, why do we immediately flash to Cubism? Why have we so little knowledge of an African principle which associates collage and assemblage with dynamic charges and accumulations of power?

Each artifact produced by human hands carries with it overlays of influences, symbolism, iconography, and cultural history; to understand any specific work as fully as possible, one will need to examine as many layers of these referents as necessary. In trying to identify aesthetic ideas seen cross-culturally, I do not mean to negate the strong and complicated differences between cultures and artifacts, nor to subsume all previously denigrated cultural systems into one monolithic "multiculture." What I want to suggest is that there are many overlapping aesthetic ideas which are seen cross-culturally, which do not have their origins in the West, which may in effect be already operating in our own culture, and which may give broader clues to understanding contemporary art than a Western postmodern analysis will allow.

Contemporary art, whether made by artists of European, African, Latin American, Native American, or Asian descent is often in acknowledged and unacknowledged ways unavoidably informed by cross-cultural sources. The United States is a multicultural country. We are not only influenced by the Western art canon. Exactly because of the multiple histories and traditions of the United States' diverse population, it is important to look at the art histories of as many cultures as possible, and to realize the limitations of Western art history and theory. The basis of both our art criticism and art education needs to be multicultural. To repeat, the

six aesthetic categories I will be trying to outline include an aesthetics of invocation, an aesthetics of transformation, an aesthetics of process, an aesthetics of energy, an aesthetics of improvisation, and an aesthetics of magic.

AN AESTHETICS OF INVOCATION

To quote Jamake Highwater:

> The objects of [American] Indians are expressive and not decorative because they are alive, living in our experience of them. When the Indian potter collects clay, she asks the consent of the river-bed and sings its praises for having made something as beautiful as clay. When she fires her pottery, to this day, she still offers songs to the fire so it will not discolor or burst her wares. And finally, when she paints her pottery, she imprints it with the images that give it life and power—because for an Indian, pottery is something significant, not just a utility but a 'being' for which there is as much of a natural order as there is for persons or foxes or trees.[1]

The idea that art may have the power to invoke the spirits, connect ordinary reality with the supernatural, or intercede with the gods on humanity's behalf exists in many cultures. Closely related to this is a contemporary longing for home, a reclaiming of long-forgotten collective memories, and a reinvention of popular traditions.

Art makes several crucial contributions to Yoruba culture and has both religious and educational functions. The arts are conceptualized as earthly incarnations of divine wisdom, knowledge, and understanding. Art serves as a two-way conduit whereby earthly humans and divine spirits may interact.[2] The gods are also praised through art; once praised, it is assumed that they will be disposed to intervene on the Yoruba's behalf, rewarding them with material prosperity, fertility, and good health.[3]

Understood broadly to encompass poetry, symbol, metaphor, and all things possessed of meaningful beauty, art alone was real for the Aztecs. True art was believed to be of divine origin; as such it was perceived as everlasting, even after the disintegration of its material evidence. Art's crucial function was its role in the protection of human souls from inevitable destruction; as the only eternal essence, art invoked the gods and offered the artist the possibility of immortality.[4]

Sacred and secular are completely intertwined in the cosmology of the Huichol. Informal education focuses on creativity, as artwork provides a means of practicing religion and is the way people learn about be-

coming Huichol. Art is believed to be divinely inspired; therefore all images are symbolic of an entire belief system. Art provides a means of recording and transmitting sacred knowledge; at the same time the attainment of mastery makes it possible for the artist to bring the powers of the supernatural into artwork and life. Aesthetic life and spiritual life are unified; the enjoyment of pure beauty is seen as the height of spiritual delight[5] so that art essentially invokes spirit.

The Aboriginal peoples of Australia produce a wide range of art forms, including body art in the form of painting and scarification, rock art, bark paintings, three-dimensional slabs of wood or stone called *tjurungas*, bullroarers, carved heads and animals, sand sculptures, baskets, song, and dance. Along with ritual, art is the primary means by which aboriginal Australians connect with the sacred world of mystery which exists in parallel with the ordinary world of everyday existence. The principles and powers that emanate from this world of mystery—the Eternal Dreamtime—are responsible for everything which happens in the mundane world, and are therefore of the utmost significance.[6] Art explains and embodies this philosophy; through art humans can connect immediately and intimately with these spirits.[7] For the Aboriginal people, human existence ultimately depends upon art. The supernatural spirits which inhabit the Dreamtime are influenced through the ritual art of song, dance, and decorated ceremonial objects; humans need the blessings of these spirits and are therefore compelled to create art.[8] Not only do humans communicate with the spirits through art; by reenacting what these spirit ancestors did at the beginning of time, they potentially become spirits themselves.

AN AESTHETICS OF TRANSFORMATION

The idea that art is involved with, the impetus for, or the source of, various levels of transformations of viewer, artist, or materials is seen cross-culturally in both secular and sacred contexts. The Latin American notion of *rasquachismo* embodies the idea of transformation as an aesthetic precept; from discarded, fragmented, recycled, everyday materials, ordinary people and experiences are transformed into extraordinary yard shrines, domestic altars, and cars.[9] Contemporary African artists often interpret their own creative process as one of transformation: "see, look, take something and transform it into something of your own."[10] A Native American aesthetics of transformation is expressed by Jamake Highwater:

> the image of art is not a substitute for the original. . . . An image is not a deliberately puzzling sign that points to something

else. It means what it is, and to share in its meaning we must be-
come the painting we are seeing, for that is the creative aspect
of vision; just as the painter is necessarily transformed into
what he is painting by the very process of making images.[11]

Art occupies important roles in both the secular and sacred aspects
of Eskimo life. Eskimo aesthetics recognizes art's capacity to enhance life;
not only does the making of art give pleasure to its creator, the art object
adds sensuous beauty to an otherwise harsh environment. In addition,
through the making of art, humans are able to influence events in the oth-
erwise indifferent realms of the spirit world. Art functions as a transfor-
mative agent, serving as a symbolic bridge between the daily world of the
Eskimo, the supernatural world of the spirits, and the material world of
plants, animals, and inanimate objects. Art, in the form of body decora-
tions and amulets, can influence the future by bringing health, food, and
fertility, and by improving one's fate after death.[12]

Two distinct reasons for the existence of art were identified at the
earliest point of the classical period in India; art gives pleasure and en-
gages human emotions, and it provides an ideal means of instruction,
showing humans how to improve themselves. The value of art as educa-
tion was not meant to be in the exposition of narrowly didactic or explicit
lessons; rather the value of art was seen to be in the transformative expe-
rience it offers.[13]

Abhinavagupta (950–1020 c.e.), India's greatest aesthetician, re-
fined the theory of *rasa* which is at the core of Indian aesthetics. Rasa is
the Sanskrit word used to describe the emotional satisfaction one expe-
riences via art; meaning not only taste but sensuous pleasure, rasa is
characterized by a sensation of oneness between the viewer and the
work of art. Abhinavagupta differentiated rasa into nine states of mind
and argued that all humans are born with an instinctive ability to expe-
rience these emotions: happiness, pride, laughter, sorrow, anger, disgust,
fear, wonder, and tranquility (*santarasa*). When a person clears the
mind of outside distractions and becomes totally immersed in an art
work, these emotions are transformed into affective responses that we
associate with art.[14]

Rasa theory is based on practical experience; art is capable of
sweeping both artist and viewers away from the petty cares of daily exis-
tence. Freed even momentarily from deadening anxieties, one is able to
experience moments of focused intensity and heightened awareness.
Thus, rasa refers to both the sensory and spiritual gratification art may
provide. Moved by art, the sensitive viewer is able to forget the self and
through this experience of total immersion, merge with the cosmic Self

that is Brahman. The experience of art begins with the senses, but simultaneously provides a path to spiritual transcendence.[15]

Through the use of mandalas to instruct initiates of the myriad forms of absolute truth potentially manifested in the Buddha and in every devotee, esoteric Buddhism justified art's existence as primary; art provides the only path to spiritual salvation, and is thus inherently transformative.[16] Zen Buddhism provided a theory of meditation which functioned as a metaphysical theory of artmaking. Through a total focusing of concentration and a rigorous mental discipline, the boundaries between the self and a universe of perfect beauty would be dissolved; art and reality would be indistinguishable.[17]

AN AESTHETICS OF PROCESS

The notion of art as ongoing verb, or process, rather than static noun, or object, was taken up to form an entire genre of "Process" art in the 1960s and 1970s. The idea is not a unique invention of avant-garde Western artists, but has precedents and counterparts in numerous native traditions. One could start by citing Tibetan sand paintings, generally destroyed as soon as, or shortly after, their ritualistic function is completed. Most traditional Aboriginal art also is ephemeral, produced in ritual settings, either forgotten, left to disintegrate, or purposely destroyed. A contemporary Mexican and Caribbean aesthetic, as manifested in a 1993 exhibition in San Francisco entitled *Ceremony of Spirit*, also places emphasis on an ephemeral, momentary, and fugitive world that promises no permanency.

Navajo aesthetics is based on the concept of *hozho*; every human action manifests and helps perpetuate the goodness and beauty embodied in hozho. The concept of hozho is active, so that goodness and beauty have never simply been created, but are in a constant state of being created. Therefore, beauty is found in processes rather than products; this combined with a belief in the superiority of inner spirit over outer manifestation means that the Navajo approach to artmaking emphasizes internal processes which produce beauty, rather than external activities involving art media.[18]

Eskimo aesthetics also focuses on artistic acts over products. Form is believed to be temporary and transient. Art is an act of seeing and of expressing life's values, a ritual of discovery by which patterns of all nature are revealed by humankind. "A carving, like a song, is not a thing; it is an action. When you feel a song within you, you sing it; when you sense a form emerging from ivory, you release it."[19]

AN AESTHETICS OF ENERGY

The idea of power, meaning force, vitality, energy, or dynamics, is one of the informing principles of Yoruba aesthetics. Form is the visible manifestation of energy; base matter is transmuted into powerful affect through two types of energy. Substantive energy derives from the implied content of the work, and metaphoric energy emerges from the "activities of the various incarnative processes by means of which the work comes into being and persists."[20]

Through experience, art provides models which embody the ideals by which the Yoruba attempt to structure their lives. The conflicting demands of "harmony" and "energy" provide the existential bases for creating both communal values and making aesthetic judgments. Through the creation and experience of art which incarnates this basic contradiction, people are empowered to imagine creative methods of reconciling the simultaneous demands of social cohesion and individual autonomy and creativity. Through stylistic conventions and subject matter, Yoruba art encourages people to live harmoniously, respectful of tradition and authority; however, the most successful art is dynamic, vital, and powerful, suggesting the individual and communal need for continual innovation and creativity.[21]

AN AESTHETICS OF IMPROVISATION

An aesthetics of improvisation has been identified by Eli Leon and Robert Farris Thompson as particularly African and African American. The making of vibrantly colored, multistrip textiles is one of two important visual traditions of the Mande people. The textiles are marked by a system of patterning in which the main accents of one strip are staggered in relation to those of an immediately adjoining strip, then coordinated with those of another. This system of staggered design visually parallels the offbeat phrasing of melodic accents in African and African American music, and refers to an ability to hear two different kinds of beats at once.[22] The creation of irregular designs through the deliberate suspension of expected patterning seems to be a strategy for preventing easy comprehension; the textiles encode matters too serious to communicate directly, and become visual analogues to danger. Meaning remains indistinct and allusive, and knowledge and interpretation rest with the aged or exceptionally gifted.[23] The influence of the rhythmized, pattern-breaking textiles extended widely in the Americas, where the use of patchwork and a strategy of deliberate mismatching was interpreted as a means by which to break up the power of the evil eye, since "evil travels in straight lines."[24]

Improvisation in the building of African American quilts empha-
sizes values of surprise and spontaneity, along with an acceptance of ac-
cident and contingency. While occurring within the context of traditional
restrictions, improvisation may be an expression of underlying values
which favor variation and the unexpected. Quiltmakers "play the fabric"
in rhythmized oscillations which allow for fresh visions and express joy at
the discovery of new ways of seeing pattern. Colors are often handled in
a percussive manner, placing high-decibel clashing hues together in a kind
of "technicolor staccato."

An Aesthetics of Magic

An aesthetics of magic is perhaps paradoxically also an aesthetics of re-
ality; ideas suggesting that the mystical and the visionary are merely areas
of reality specifically accessible through art exist in Native American,
Latin American, and African American thought. To again quote Jamake
Highwater, who summarizes these ideas most eloquently:

> Artists all over the world have always known that art is fun-
> damentally a way of seeing. Art, like matter-of-fact reality, has
> a real existence within all of us even though it seems to exist
> in the imaginal world. Artists are among the very few people in
> Western civilizations who have been permitted to deal with
> this visionary reality as something tangible and significant.[25]
>
> Art is a way of seeing, and what we see in art helps to
> define what we understand by the word "reality." We do not
> all see the same things . . . each society sees reality uniquely.
> The complex process by which the artist transforms the act of
> seeing into a vision of the world is one of the consummate
> mysteries of the arts—one of the reasons that art is inseparable
> from religion and philosophy for most tribal peoples. This act
> of envisioning and then engendering a work of art represents
> an important and powerful ritual. Making images is one of the
> central ways by which humankind ritualizes experience and
> gains personal and tribal access to the ineffable . . . the un-
> speakable and ultimate substance of reality.[26]

Even a cursory overview of randomly selected aesthetic principles
shows that the contemporary Western separation of art from life, from
the sacred, and from meaning is not shared cross-culturally, past or pres-
ent. Removing ourselves even momentarily from our culture-bound posi-
tions, we become free to imagine an expansion of the functions of art.
Rather than being separated by the dubious distinctions and elite status

we accord art in our own culture, art plays a crucial role in the material and spiritual vitality of numerous peoples; this role is both sacred and secular, as distinctions such as these have no meaning outside of our own context. Attention to these possibilities offers the potential to increase our understanding of the entire spectrum of the world's artlike production. It may also suggest that overlapping aesthetic systems are already operating in our own culture. The following examples are intended to illustrate how these ideas may be implemented in the expansion and enhancement of approaches to contemporary art criticism and education.

The work of Faith Ringgold invokes complex memories uniting past traditions with living culture. At the same time, many of her pieces sing with energy, suggest ongoing process, move outward towards personal and collective transformation. The *Witch Mask* series is composed of pieces that are at once charming, witty, and powerful, conjuring up the bodies, voices, and visions of forgotten women. *Women's Liberation Talking Mask*, *Weeping Woman #4*, *Kissing Witch #1*, *Faith #1*, and *Faith #2* use straw, beads, gourds, tapestries, and woven cloths to bring life to unique aspects of women's experience. With their deep golds, greens, reds, and blacks, the figures, in ensemble, evoke an atmosphere of depth and mystery reminiscent of a densely populated forest. The gold gourds playfully projecting from *Women's Liberation Talking Mask*'s flat torso function as breasts. Beads become the silently suffering *Weeping Woman*'s tears and plush red velvet the sensuous lips of *Kissing Witch #1*. The distinct, expressive faces of *Faith #1* and *Faith #2* convey both power and outrage. Open mouths provide the means and encouragement for formerly silent women to speak out.

Wake and Resurrection of the Bicentennial Negro, an installation composed of several life-size soft sculptures, functions like silent theater. Even without knowing its story or witnessing the performance for which it was composed, one feels privy not to a wake but to a story of faith in the possibility for change. Bena and Buba, the tale's main characters, lie dead on a red, black, and green flag-covered pad. (Bena was a junkie who died of an overdose; Buba, his wife, died of grief.) Mama and Nana stand crying nearby. Several masked figures and tribal-like masks surround the scene. As Thalia Gouma-Peterson describes it:

> After a lengthy and emotional wake (combining music and dance) they come back to life through the love of their family and especially of their mother, and become reformed. . . . The performance combines elements of the Black-American wake with African beliefs that . . . "hold ancestral deities in a state of limbo until they are released through dance to return to the

community in search of new lives." That is, African beliefs in
the continued life of the spirits of the dead are here superim-
posed on the realities of 20th-century life in America.

Connections are made between the dead and the living, hope and de-
spair, past, present, and future, joy and sorrow, and the theatrical and
the mundane.

Ringgold's painted story quilts continue this process of connection
by creating links between individual creativity and communal activity
and by providing the means by which the work can be appreciated by a
broad audience. By tapping so effectively into the traditions of women's
crafts and communal storytelling, Ringgold weaves the threads of ances-
try, family, women, and community into a continuous chain. Fragments
are ingeniously pieced together so that the resultant cloth, incorporating
visual with verbal, is multilayered and lushly textured, becoming both art
and craft.

Who's Afraid of Aunt Jemima? combines a folk art motif with a
folktale to transform the negative stereotype of Aunt Jemima into the
vivid, elegant, and successful Jemima Blakely: businesswoman, wife,
mother, and grandmother. Squares of traditionally quilted cloth alternate
with painted squares of disarmingly simple portraits and a lyrical and
witty text. The figures, at once funny and serious, stare directly at the
viewer as they tell their stories. Like life itself, the tales ramble as they re-
veal successes, failures, triumphs, and tribulations. Unlike traditional
folktales, however, the piece resists moralizing; the characters are not eas-
ily categorized as good or bad, hero or villain, but rather mirror some-
thing more complex of the human experience.

Ringgold's ongoing *Woman on a Bridge* series reiterates themes of
change and hope, even redemption. Black girls and women, as carriers of
faith and celebration, appear flying, dancing, skipping, and singing.
Bridges signify possibility and connection, freedom and release. Exuber-
antly and brightly painted images are framed in borders of lively pat-
terned quilting. *Tar Beach*, the first of this series, is a modern fairy tale
told from the point of view of a young girl for whom the majesty of the
George Washington Bridge provides the inspiration for liberation. As she
gazes up at the stars from her mattress on the roof, she sees herself flying
high over the bridge, over the skyscrapers of the city, over her family play-
ing cards, over her little brother lying next to her.

Larry Beck's *Punk Walrus* series draws on an ancient Native Amer-
ican tradition of mask-making to create time-specific masks made unmis-
takably of contemporary found objects. Beck's mixed-media materials
include chrome, aluminum, plastic, discarded dental tools, and a vast ar-

ray of items found in junkyards, auto supply houses, and hardware stores. In *Punk Walrus Spirit*, a shiny, round chrome plate serves as the face; two white plastic spatulas, complete with tiny, stylized figures running across them become eyes covered with glasses, and a tin cup gets nostrils and a tongue and is converted into a snout. Feathers, wire, and spatulas adorn the mask's outer rim, while one dangling fishhook functions as an earring. Red metal tubing becomes the tusks for *Punk Walrus Inua*. Straight pins or nails, reminiscent of quills or thorns, adorn its snout and forehead, suggesting both fragility and aggression. These nails, combined with *Punk Walrus Inua*'s open gaping mouth, evoke a feeling of cold, of pain, and of suffering. We can almost hear the animal call, almost feel the icy wind blow.

Beck's pieces are simultaneously playful and inventive transformations of everyday objects, while functioning as biting social commentary. References to traditional Native forms are expanded by the use of contemporary found materials; in the process, multiple possibilities are suggested by ordinary objects which might otherwise be quickly discarded. Materials generally experienced in a throw-away culture as sterile are used to recreate special objects endowed with humor and beauty. The use of humble nonart materials speaks of an attitude which favors creative, improvisational process over exalted, finished art object. The objects themselves are not only embodied transformations; they transform the viewer's perceptions while stimulating the senses of sound and touch as well as sight.

One is drawn in to Sharon Chinen's work by a palpable presence which is simultaneously full of power and extremely fragile. Apart from their visual impact, her pieces appeal most strongly to a sense of touch, invoking primordial memories of enclosure and warmth, followed by separation and decay. Life processes are suggested at every turn; the transformations of birth/death/rebirth are embodied in pieces which feel simultaneously earth-bound and earth-released: earthly spirits.

The skeletal structure of *Leaf* goes beyond its own simple framework to suggest connections with the innards of other life forms. Our vision does double and triple takes as first we see the leaf, then perhaps the remains of a fish, next a human rib cage, then back to the leaf again. *Mango* and *Small Open Pod* are both small, intimate, open containers which suggest at first the comfort, protection, and nurturance of early existence. The openness of these cocoonlike pieces also suggests that the safety of containment is followed by release and exploration in a cycle which endlessly repeats itself. Chinen's large pod pieces continue and expand this theme. The sentinel-like *Open Pods* suggests thresholds, break-

through, possibility, new life, while the reclining . . . *and into the Fire* suggests a kind of burnt offering: repose, regression, a return back to a muddy, dusty, gritty earth—interior lives/exterior selves—branching out/taking root—enclosure/exposure.

Invocation—transformation—improvisation—process—energy—magic—this incantation is particularly appropriate to accompany and to apprehend the work of Betye Saar. Interested in the ancient civilizations of Africa, Asia, the Pacific, and the Americas, involved with mysticism and the occult, Saar makes mixed-media objects and installations which reflect an almost ritualistic approach to both materials and artistic processes. Attracted to a wide variety of discarded objects—such as containers, furniture, charms, shells, feathers, photographs, fabrics, and computer parts—because of their possibility for embodying multiple meanings as well as a fascination with an African-inspired belief in the power and energy released through changing the uses of a material, Saar refers to her addiction to collecting discards as "power-gathering." Through an ongoing *process* of *transformation* of materials, *improvisation* is honored, *energy* is generated, spirits are *invoked, magic* is released. Artistic processes of regeneration mirror natural processes of birth and decay. The negative, the useless, the ugly, become positive, powerful, and beautiful.

In *Mano Azul*, apothecary bottles of varied shapes and sizes, each holding a burnt-down candle sit within the ledge of a painted metal frame. A smaller frame, flanked by stars on either side, enclosing a hand which points to a knife, floats above these bottles and is crowned by an all-seeing eye. The altarlike structure of the container, the symmetrical placing of the elements, the references to alchemy and the occult, and the restriction of color to brilliant blue, work together to create a mysterious space which invites meditation.

A more playful mood is created in *Sanctuary's Edge*, which more blatantly juxtaposes ancient images with contemporary materials. A pale green printed circuit board is encased in a spare altarlike frame. Attached to this board are various charms and electronic parts which seem to dance in and around the surface. Ordinary and extraordinary materials are given new form and new life through an almost alchemical recombination.

In My Solitude created a quiet corner of reflection to invite the return of spirits of women gone. An empty chair, a single hanging bulb, a standing black dress, a painted ghostlike silhouette of a woman reading sit in a room carpeted with moss and dried flowers—invocation—transformation—improvisation—process—energy—magic.

Notes

A version of this chapter was presented at the American Society for Aesthetics Fifty-first annual meeting in 1993. Another revised version was presented at the National Art Education Association annual meeting in 1994.

1. David Maybury-Lewis, *Millennium: Tribal Wisdom and the Modern World* (New York: Viking, 1992) 156.

2. Richard Anderson, *Calliope's Sisters* (Englewood Cliffs, NJ: Prentice Hall, 1990) 139.

3. Anderson 130.

4. Anderson 149–56.

5. Kathleen Berrin, ed., *Art of the Huichol Indians* (New York: Harry Abrams with the Fine Arts Museums of San Francisco, 1978).

6. Maybury-Lewis 197.

7. Anderson 71.

8. Anderson 65.

9. The Mexican Museum, *Ceremony of Spirit: Nature and Memory in Contemporary Latino Art* (Exhibition catalog, San Francisco: The Mexican Museum, 1993) 12.

10. Jean Kennedy, *New Currents, Ancient Rivers: Contemporary African Artists in a Generation of Change* (Washington and London: Smithsonian Institution Press, 1992).

11. Jamake Highwater, *The Primal Mind: Vision and Reality in Indian America* (New York: Meridian, 1981) 64.

12. Anderson 45–54.

13. Anderson 162.

14. Anderson 165–66.

15. Anderson 168–69, 171.

16. Anderson 183.

17. Anderson 190, 197.

18. Anderson 106.

19. Charlotte Otten, ed., *Anthropology and Art: Readings in Cross-Cultural Aesthetics* (Austin and London: University of Texas Press, 1971) 165.

20. Robert Plant Armstrong, *Wellspring: On the Myth and Source of Culture* (Berkeley: University of California Press, 1975) 27, 31–32.

21. Anderson 137.

22. Robert Farris Thompson, *Flash of the Spirit: African and Afro-American Art and Philosophy* (New York: Vintage Books, 1983) 207.

23. Robert Farris Thompson 222; Cf. Sarah Brett-Smith, "Speech Made Visible: The Irregular as a System of Meaning," conference paper (August 15, 1980) 22.

24. Robert Farris Thompson 222; Cf. David P. Gamble, *The Wolof of Senegambia* (London: International African Institute, 1967) 41.

25. Highwater 13.

26. Highwater 58.

8

BLOOD RELATIONS

JOSE BEDIA, JOSEPH BEUYS, DAVID HAMMONS, AND ANA MENDIETA

MELISSA E. FELDMAN

Owing to its Dadaist past and postmodern present, most conceptual art divorces itself from matters of the spiritual. From the moment Duchamp proposed that a urinal may function not only as a work of art (when signed), but as an analogue of an altar or the Madonna, avant-gardism became coextensive with iconoclasm. The duplicitous arts of illusion—traditional painting and sculpture—which had evolved from original service to the church to that of bourgeois consumerism, were cast out along with the spiritual, the heroic, the mythic, the expressionistic, the personal, and any other inherently meaning-generating condition.

With conceptualism's emergence since the 1960s as an influential international art language, conceptual artists have focused on phenomenological and epistemological areas of inquiry that mostly deal with extending the boundaries of art by inserting art into real life. Critiquing the social and philosophical ramifications of past styles through appropriation, and grappling with the media world have been other important subjects for conceptual artists. With the art world's recent redirection, or extension of vision, however, towards art of the Third World and people of color, it has had to readmit the viability of spiritual and personal content in art. Often produced outside of the postmodern mainstream and

within more religion-infused cultures than contemporary Western cul-
ture, this work from the "fringe" openly engages such heretofore cen-
sored content. Politics also enters into this work via feminist and African
American artists whose primary objective is to give voice to their experi-
ences as "other" and to reveal the politics of exclusion and negation
maintained by the largely white, largely male structures of power and
influence.

The artists who form the basis of this investigation—Joseph Beuys,
Jose Bedia, David Hammons, and Ana Mendieta—variously represent
these fringe art communities. Until recently, the work of German artist
Joseph Beuys stood as the sole spiritual stronghold in conceptual art. The
other artists included follow his example of seeking out the philosophies
and traditions of ancient cultures, when humankind lived in unison with
nature and valued communal life, as a guide for their art. The work of
Cuban artist Jose Bedia and Cuban American artist Ana Mendieta comes
out of a Latin American culture with deep religious underpinnings in-
formed as much by primeval influences—Indian and African—as by Eu-
ropean Catholicism. Ana Mendieta, who met a premature death in 1985,
was also part of the feminist body-art movement that sought to empower
women by renaming as positive the archetypal association of women with
nature, and by reclaiming a lost history of ancient matriarchal societies
and goddess cults. Bedia's work is dedicated to sustaining his religion,
palomonte of the African Kongo, and others of aboriginal origin in the
modern world. Uncovering African traditions embedded within African
American culture, both past and present, is the subject of African Ameri-
can artist David Hammons's work. Collectively, the work of these four
artists offers an antidote to the Western world's alienation from the meta-
physical realm by its emphasis on science and technology. These artists all
pursue artmaking as a way of life, as a sacred task, and as a vehicle for so-
cial change.

Several important characteristics link the work of these four artists:
the use of nonart materials for their social or metaphorical implications
and for their spiritual "charge," a preference for site-specific or tempo-
rary installations that often involve performance, and the reenactment or
adaptation of ritual practice and symbolism based on ancient cultures.
Consistent with the aboriginal model that inspires them, spirituality is the
central, unifying force in every aspect of their lives. For them, artistic and
spiritual endeavor are so closely allied as to be indistinguishable. Though
this trend is by no means widespread in conceptual art, there are a num-
ber of other artists working in this vein. The German sculptor Wolfgang
Laib and American video/installation artist Bill Viola, to cite just two ex-
amples, are both highly involved with Buddhist and Islamic theology. The

four artists in question, however, are all primarily influenced by Native American or African religions. Initially they were drawn to the study of ancient cultures by a curiosity about their own ethnic ancestry, be it Celtic or Kongo. Ultimately, however, their research went beyond individual history and evolved into a personalized, hybridized system of belief. Hence, Beuys, of Celtic descent, found a kinship with Native Americans, as did Bedia, a Cuban. A partial explanation for this cultural crossover might be found in the numerous similarities, in terms of thought as well as ritual and visual expression, between different and distant aboriginal belief systems. The artists recognize these overlaps. Regardless of its derivation, the spiritual imperative guides the symbolism, mode of production, and the formal character of their art.

The work of Jose Bedia is closest to the aboriginal source in that it springs from a culture in which African-based religions are still widely practiced. A kind of magical-mythological thinking persists in Cuba alongside modern developments there.[1] As a priest of palomonte, one of the most purely African religions among Afro-Cuban sects, Bedia's art is a way of fulfilling his priestly duty to pass on the teachings of his religion: "What I am trying to establish are connections with the cosmological forms of the Afro-American world, which has not yet disappeared among us and which serve us as symbols."[2]

Bedia's multimedia installations and drawings serve as public enactments of his faith. Through materials, presentation, and imagery, the 1994 installation *Iron Flies* (1994) essentially functions as an altar. In fact, the constructed altar is linked by a chain to an actual *nkisi* hidden in the corner behind a cloth. Like all Kongo shrines, *Iron Flies* is dedicated to a deity, in this case Oggun, the god of iron and war. Painted by hand in vigorous strokes of black, his spectral figure rises from the engine like an enormous puff of smoke, alluding to the use of fire in Kongo ritual. Following customary Cuban display of the nkisi, it is adorned with scythes and feathers and rests on a bed of soil to indicate its connection to the earth. Car parts are often used in altars dedicated to Oggun due to the god's identification with the metal worker—a connection dating from the nineteenth century when African slaves were brought to Cuba to work on the railroad. The feathers suggest the remnants of a chicken sacrifice, the rite for ushering the spirit to a ceremonial site. *Iron Flies* reiterates a common theme in Bedia's work, the cooperation between natural and humanmade power. Hence the deity has the benefit of propellers as well as horns, the tools of farmers (scythes) and those of mechanics (the engine).

In keeping with his priestly role as religious instructor, Bedia provides a recipe for making *minkisi* (plural of *nkisi*) in a series of cartoon-like pencil drawings from 1984, *The Cauldron*, *The Ingredients*, and *The*

Iron Pot. They feature a three-legged iron cooking pot, or *prenda*, the vessel used by Cubans—as opposed to cloth bundles or filled figures—to hold "the medicine of the gods." Various metaphorical and metonymical ingredients—such as feathers to draw the spirit down from the heavens, relics of the dead such as bones, teeth, and cemetery earth, iron tools, herbs, and wooden scythes—are among its fragmentary contents, a world in miniature. By manipulating these materials, its owner or *nganga* can heal, harm, and otherwise exert control over people and his environment. The nkisi and its nganga are one, the former being the divining instrument of the latter.[3] Bedia, his art, and his religion are similarly unified.

Minkisi require only ordinary, readily available ingredients for easy assemblage and also for portability. Accordingly, Bedia's altars can be easily transported or remade in various locations. The peripatetic nature of his art reflects the mutable condition of African culture—and specifically the highly mestizo Afro-Cuban strain—which has blended so stealthily into whatever culture it was forced into contact with. Hybridization and transference have been key to the survival of African culture. Such adaptability allows for substitutions, such as replacing an iron pot with a car engine in *Iron Flies*. This flexibility and economy of means in religious practice also dovetails with the actual working conditions of contemporary Cuban artists, who often resort to the use of found materials due to the lack of professional art supplies. Bedia's habit of painting with his hands on walls as demonstrated in *Iron Flies*, which stands thirty feet high and twice as wide, exemplifies the flexibility necessary to work large scale, while simultaneously relating to the performative nature of aboriginal religious practice.

In his art, Bedia alludes to various non-Western religions besides Kongo palomonte, predominantly referencing various Native American religions. In mixing symbolism and imagery from different aboriginal traditions, Bedia arrives at his own iconographic blend that reveals the essential similarities between these diverse sources. For example, in a series of charcoal drawings, *Knives Do Not Penetrate*, *Bullets Do Not Enter*, and *Owner of Iron* from 1984, Bedia alludes to the multicultural presence of the notion of psychic shields. The style and imagery of these drawings, which demonstrate the resilience of Oggun, can be traced to Sioux ledger drawings and African blade images. In Bedia's drawings, Oggun remains calm and unharmed despite an onslaught of daggers in the first episode and a shower of bullets in the second. The simplified graphic style, centralized silhouetted figure, and use of explanatory text are related to nineteenth-century Sioux drawings of war exploits. Frequently the Indian brave is shown as impervious to a shower of bullets or other weapons, alarmingly numerous as in Bedia's drawings, because

he is wearing a magical protective garment known as the "ghost shirt." The African equivalent is the so-called blade image in which a carved wooden figure is pierced like a porcupine with nails or blades. The insertions are executed during Kongo rites for protection and healing. The frontal stance of Oggun in Bedia's drawing, with knees slightly bent and hands on hips, follows the African version. The pose signifies vitality and confidence, calmness in the midst of violence.

A modern corollary of the psychic shield can be found in Beuy's *Felt Suit* of 1970. For Beuys felt is a protective, life-generating material with aboriginal resonance. The tribal association stems from a traumatic incident during World War II when the plane he was piloting was shot down in the Crimea. Nearly frozen to death, he was rescued by a nomadic clan of Tartars, who resuscitated him by covering his body with fat and wrapping him in felt. Beuys considers the incident, which he may have fabricated, as a spiritual rebirth.[4] Beuys's art reenacts this physical and psychic transformation in presentations of materials undergoing the transition from an ordered, intellectual state of coldness, to a chaotic, but positive, state of warmth. In *Felt Suit*, there is the contrast between its angular form, signifying the rational, business-minded Western world, and its cuddly material, made from rabbit hair, signifying the natural world.

The most profound connection between Beuys and Bedia lies in their regard for nature as the source of spiritual knowledge, a belief drawn from their attachment to Native American cultures. While the literature acknowledges Beuys's dialogue with ancient cultures, the pervasive references to Native American and African belief systems in his work have been overlooked or neglected. Both Beuys and Bedia subscribe to an indigenous view of animals as magical beings possessing supernatural powers. Such beliefs are manifest, for example, in an indigenous custom of wearing animal masks during hunting and fighting with the belief that the hunter will acquire the attributes of the represented animal, for example, an eagle's sharp vision or a butterfly's elusiveness. Animals are also seen as mediators between the land of the dead and the living.

Beuys clearly invokes such beliefs in *How to Explain Pictures to a Dead Hare*, a 1965 "action," as Beuys called his performance pieces. For three hours, as people watched through a doorway, Beuys mouthed to the limp animal, silently discussing the surrounding drawings. To aid communication, a "radio" made of bones fitted with electrical components was placed underneath the chair, which had one felt-covered leg. The artist's head was anointed with honey and covered with gold leaf to symbolize the light of creativity, irrational thought, and also to conceal his human identity.[5] The gold mask also corresponds to the Kongo notion of the head as the site of communication with the spirits, and the idea that

all exceptional powers result from communication with the dead.[6] In Beuys words, "The idea of explaining to an animal conveys the sense of the secrecy of the world and of existence that appeals to the imagination . . . even a dead animal preserves more powers of intuition than some human beings with their stubborn rationality."[7] A 1993 conté drawing by Bedia called *Much More Inside of You*, in which a male chimera leaps into a female consciousness, conveys a similar sense of magical, human-animal communication, here aided by a sexual pull. The elkman's red color relates to Bakongo rituals in which red clay applied to the initiate's body signifies the transmission of mystical powers of the dead to the living.[8]

In another recent work of Bedia's, a round painting called *Star Comes to Light the Way* (1992), a spirit bearing a human torso and a stag head with real horns guides a toy boat traveling by night. The work conflates the idea of a spiritual journey with the very real one of Cuban emigration, a theme that preoccupied Bedia during this period as he contemplated his own emigration to the United States. (He finally moved to Miami in 1994.) Consider this image in light of a statement by Beuys about the significance of the stag, which was one of his favorite animals: "The stag appears in times of distress and anger. It brings a special element: the warm positive element of life. At the same time it is endowed with spiritual powers and insight and it is the accompanier of the soul."[9] Corroborating Beuys's description, the painting's yellow-spotted background is derived from Kongo imagery signifying souls in flight. The spotted motif is also common in Lakota hide painting where it represents a starry night sky—a common sight for these nomadic people living on the great plains.[10] Certainly Bedia's imagery speaks to these different meanings. Beuys's comment about the stag indicates a potential common knowledge.

Exceptional in Beuys's *oeuvre* is the 1974 performance piece called *Coyote—I Like America and America Likes Me*, which stands as his most overt gesture of empathy with the American Indian. To execute this work, Beuys lived with a coyote for a week in a New York gallery. Amenities were minimal but significant: lengths of felt sometimes worn by the artist as a cape, a walking stick, a daily delivery of a stack of *Wall Street Journal*s, and straw. The piece served as a peacemaking rite in response to the conquest of the American Indian, which the artist saw as our nation's "trauma point." Dressed like a shepherd with his felt cape, Beuys proposed tolerance between humankind with our need for possession and control of our environment, and the coyote, a shepherd's nemesis, with its need for freedom and space. Beuys chose the coyote as his companion because it is the most revered American Indian animal deity and also the

most hunted by whites, who saw coyotes as tricksters and sheep-poach-ers.[11] The coyote symbolically repossesses his land by chewing up and uri-nating on the newspapers. The work is meant to restore peace between human and animal, between whites and American Indians, through a symbolic cohabitation.

Part-human, part-animal figures abound in the work of Bedia and Beuys. Such images invoke an indigenous belief, which exists in many other aboriginal cultures, that every person has an animal counterpart or soul who lives in the forest. This so-called animal-familiar can travel into the otherworld and deal with aspects of nature that are beyond human ability. American Indian lore also holds that at the beginning of creation, animals and humans lived together as one race.[12] In the drawing *Self-Recognition* (1985), four nearly identical male figures peering into a pond discover their individuality in the four different animal heads reflected. Beuys's early drawings and sculptures, in particular, feature chimera fig-ures. The bronze sculpture *Animal Woman* from 1949 adopts the frontal pose and podlike physique of fertility idols, but her voluptuous human body is topped by a leopard's head. A head drawn in pencil is overlaid on a ferric chloride stag, in a related work from 1955, *Stag with Human Head*. The mixed media reiterate the bringing together of oppositional elements.

Cuban American artist Ana Mendieta, like Beuys and Bedia, sought out a primeval consciousness through spiritual communion with nature, but she focused on the earth itself as opposed to the animal world. Her work consists primarily of ritualistic performance works involving mark-ing her body in the landscape. These are documented in photographs and films. Separated from her parents and her homeland at thirteen, when she was sent to live in an American orphanage, Mendieta's body tracings are driven by a desire to reconnect with her ancestral origins through direct contact with the earth as the maternal source.[13] Mendieta wrote in 1981: "My art is the way I re-establish bonds that unite me to the universe. . . . Through my earth/body sculptures I become one with the earth. . . . I be-come an extension of nature and nature becomes an extension of my body. This obsessive act of reasserting my ties with the earth is really the reactivation of primeval beliefs."[14] Of particular importance to Mendieta is the identification of the female spirit with the earth and the sea; ac-cordingly, her works are reminiscent of goddess and fertility images. The performance works also invoke the earth-body connection that is central to such Afro-Cuban rituals as initiation ceremonies and mystic ground drawings. For example, by standing on a cosmogram chalked in the ground, the oath-taker "situates himself between life and death" and summons the concentration of God's power to that spot.[15] Moreover, the

Yoruban and Spanish Catholic hybrid, *Santería*, holds that the earth is "a living thing from which one gains power."[16]

Mendieta executed no less than two hundred earth-body works, called "siluetas" or silhouettes, between 1976 and 1980. Like Beuys's actions and Bedia's altarlike installations, these pieces were enacted as a kind of personal religious rite. In contrast to Beuys and Bedia, Mendieta preferred to work in isolation, alone in remote natural areas. In *Mud Flats, Iowa City* (1979), for example, she made multiple impressions of her body in the mud, echoing and enhancing the puckered topography. A 1976 silueta made on the beach in Mexico is meant to represent Yemaya, the Santería goddess of the sea and symbol of maternity. Mendieta's imprint, with arms raised in an incantatory gesture, is filled with red flowers to symbolize blood for vitality. These locations—mud flats, the beach—where land meets water, signify transition and rebirth by the eventual reunion of the body with the earth and the sea as the body's trace is washed away.

If the siluetas are generally reminiscent of aboriginal rituals and symbols, there are several early performance works in which Mendieta makes specific references to the rites of Santería, which conflates Christian saints and African deities. In a work from 1972 referring to the common Santería rite of chicken sacrifice, the artist holds a just-beheaded white chicken who, in its last shudders of death, splatters blood on her naked body. This work relates to the initiation rites of the Abakua society during which the initiate must parade with the head of a freshly sacrificed white rooster in his mouth, while blood drips down his body.[17] In a related filmed piece of the same year, entitled *Bird Transformation*, which was executed at Old's Man Creek, Iowa, Mendieta offers herself as the sacrifice by rolling her blood covered body in a bed of white feathers. Her compatriot Bedia also conducts sacrifices; a rooster sacrifice was done to sanctify each of the three spaces that comprise *He Lives on the Railroad* (1989), dedicated to the three warrior gods. Though the rites were conducted privately, the remnants were left as part of the work. Mendieta's use of gunpowder and fire in performance works relates to both Santería and Kongo practice in which fire functions as a purifying element and also as a way to attract spirits to the ceremonial site. Ideographic markings, for example, are cut into the skin of Kongo initiates and the wounds are then filled with gunpowder. In a 1976 work executed in Oaxaca, Mexico, Mendieta traces her standing silhouette in fire. The arms of the effigy are raised in exaltation, intensifying the movement of the flames. A year later, she burned her silhouette into a tree stump and set it on fire with gunpowder, leaving a fertile bed of ash.

The African tradition comes to David Hammons in a more syncretic form via Southern black folk culture and contemporary urban life. Hammons's work is dedicated to the African American experience—its diverse heritage, its permutations through history, its perceptions and misperceptions. Hammons, an African American artist in his fifties, was raised in Illinois but has lived in Harlem for the last twenty years. With the current fashion for multiculturalism, Hammons, who had always made a point of evading the white-dominated mainstream, has been swept into the limelight. Part of Hammons's current popularity has to do with what is seen as his Duchampian-style recontextualization of racial issues. Little notice has been given to the Kongo influences that really drive the work.[18] That aboriginal forms and symbols can be mistaken for conceptual art underscores the idea that contemporary strategies are conducive to spiritual expression—a fact absent from, if not dismissed by, postmodern discourse.

First, consider Hammons's art materials: the detritus of impoverished African American inner cities—hair, wine bottles (cheap brands), bottle caps, second-hand coats, chicken bones. In tune with Kongo habits, such accumulations of grungy materials "charged" through human contact function as power objects. The hair was collected from the floors of Harlem barbershops. "I was actually going insane working with that hair so I had to stop. That's just how potent it is. You've got tons of people's spirits in your hands when you work with that stuff. The same with the wine bottles. A black person's lips have touched each one of those bottles, so you have to be very, very careful."[19] The Kongo notion of the resonance of human touch also infuses Southern black folk mysticism—called *hoodoo*—whose followers bury the dead with their last-touched object so as to direct the spirit into the tomb and thus keep it from harming the living.

Hammons's *Bottle Racks* from the mid-eighties, large standing circles made of attached Thunderbird wine bottles, pose as minimalist sculpture in their simple geometry and use of pure materials. But the materials subvert the clean formalism through association with their derelict users and by placing the rack on a stack of coal rocks found on railroad tracks. One was part of an 1989 installation, *Coal Train*, in which a blue electric toy train ran through a landscape of bottle racks and piano lids, all set to the music of John Coltrane. In this setting, the range of African American cultural references are full-blown: nineteenth-century African American railroad workers, the freedom train, song and booze as a means of escape for slaves, music as an African American profession, and the continuing depraved socioeconomic conditions that force African Americans into the streets and onto the bottle.

In *Hair Pyramid* (1976), an installation of same-sized perfect pyramids made of hair—and which, standing only four inches high, look like ant hills—Hammons again fashions minimalist sculpture from distinctly ethnic material. While parodying the great art monuments by its diminutive stature and fly-away material, at the same time the work alludes to Egyptian heritage, an association promoted by the black nationalist movement during its heyday in the seventies.

Other works using bottles are more specific in their Kongo derivation. The bottles trees, for example, which Hammons has made in vacant lots in Harlem over the years, brings a rural folk tradition to the inner city. Common in the South, bottle trees—empty bottles threaded on branches—are an adaptation of the Kongo means of protecting the home by trapping evil spirits within, who are drawn to the flash of the glass. For Hammons, another attraction of public works such as the bottle trees is to extend his audience, specifically to the non-museum-going and non-white public. This communal outlook is also consistent with tribal forms of worship and life.

Hammons uses bits and pieces of things to cobble together art. An untitled female figure from 1989 is fashioned from an inner tube, imitation designer bag, and scrub-brush. The use of abbreviated materials for metaphorical purposes relates to Kongo minkisi. It also captures the astonishing effect of African icons. The allusions drawn from these materials, however, are specifically racial and sexual. The brush, for example, may be seen as signifying female genitalia as well as the black woman's vocation as domestic servant. The fake designer bag alludes to a contemporary African American fashion of sporting white status symbols, whether in mockery or desperation. In a punning sense, it is also an "old bag," which, like the deflated tire, indicates arrested motion. For Hammons, like Bedia, the imaginative use of such nonart materials also reflects actual economic conditions of both African Americans and Cubans. Nineteenth-century African American folk art, like contemporary Cuban art, also relies on scavenged materials, which were the only kind available. Celebrating such resourcefulness, Hammons gathers shopping bags stained with grease to make the collage *Bag Lady in Flight* (1981). Simulating the remains of a chicken fry, a communal ritual of sorts, these residual materials (garbage really) are transformed into a serpentine-shaped shield, an image of freedom and grace. Similarly *Higher Goals*, a 1986 piece erected in an outdoor plaza in Brooklyn, New York, is made from telephone poles decorated with bottle caps in an African motif and fitted with basketball hoops at the top. Here Hammons conflates ancient and modern shrines, and points to the game's continuity with the participa-

tory nature of tribal life and worship. The telephone pole has attained a new level of communication by providing a spiritual link to the heavens.

The community-oriented, ritualistic, and performative nature of many of the works cited picks up on aboriginal religion, in which acts of worship and daily life are contiguous. Echoing shamanistic practice, the artistic gesture gives ordinary objects and locations a kind of magical charge or potency. Such permeability between art and life accords with the aims of conceptual art. In a conceptual art arena dominated by self-reflexiveness at the one extreme and popular culture at the other, these works demonstrate the potential for spiritual expression of ancient origin within a postmodern idiom.

NOTES

A version of this chapter was presented at the 1995 annual meeting of the College Art Association as part of the panel entitled *The Subjugation of the Spiritual in Art.*

1. Gerardo Mosquera, "Africa in Caribbean Art, Part II," in *Art Nexus* (January-March 1993): 161–62.

2. Cited in Leslie Judd Ahlander, "Jose Bedia: Master of Knives and Meteors," *Arte en Colombia* (Spring 1991): 157.

3. Wyatt Macgaffey, *Astonishment and Power: The Eyes of Understanding Kongo Minkisi* (Washington, DC: National Museum of African Art, Smithsonian Institution Press, 1993) 13, 80. See also Robert Farris Thompson, *Flash of the Spirit* (New York: Random House, 1983) 117–21.

4. For a critique of this and other Beuysian "myths," see Benjamin H. D. Buchloh, "Beuys: The Twilight of the Idol," *Artforum* (January 1980): 38.

5. Caroline Tisdall, *Joseph Beuys* (New York: Solomon R. Guggenheim Museum; London: Thames and Hudson, 1979).

6. MacGaffey 59.

7. Tisdall.

8. MacGaffey 54.

9. Tisdall.

10. *The Spirit World* (Alexandria, VA: Time-Life Books, 1992) 118.

11. Caroline Tisdall, *Joseph Beuys: Coyote* (Munich: Schirmer-Mosel, 1980) 25.

12. *The Spirit World* 55.

13. Lucy Lippard, "Quite Contrary: Body, Nature, Ritual in Women's Art," *Chrysalis* 2 (1977) 37.

14. Mary Jane Jacob, "The Silhueta Series, 1973–1980," *Ana Mendieta* (New York: Galerie Lelong, 1981).

15. Thompson 108–10.

16. Jacob 7.

17. Jacob 10.

18. The first in-depth analysis of African influences in Hammons's work finally appeared in 1994. See Dawoud Bey, "In the Spirit of Minkisi: The Art of David Hammons," *Third Text* (Summer 1994): 45–54.

19. Kellie Jones, "David Hammons," *Real Life Magazine* 16 (1986) 8.

MALICE GREEN DID LIKE JESUS
A DETROIT MIRACLE STORY

JANICE MANN

Not long after the year 1010, the renown of the miracle-working relics of Sainte Foy stirred Bernard, a well-educated priest and head of the cathedral school at Angers, to make a pilgrimage from his sophisticated, urban home to the rural monastery at Conques where the body of this third-century virgin martyr was venerated.[1] His pilgrimage was not motivated by belief but rather by a discriminating intellectual skepticism learned under the tutelage of no less an intellectual figure than Bishop Fulbert of Chartres. His goal was to test whether Sainte Foy's miracle stories were true or "so much worthless fiction."[2] In a letter to his former teacher, Bernard wrote that he did not believe the tales of Sainte Foy's miracles because they were too new, strangely unusual, and because it seemed to be the "common people" who promulgated these myths.[3] Bernard's academic detachment and resolve to debunk the miraculous acts of Sainte Foy, however, began to weaken when he himself bore witness to the restoration of a blind girl's sight at the saint's shrine. After Sainte Foy snatched Bernard's own brother from the jaws of death through a miraculous cure, her former detractor became an ardent promoter of her cult, authoring the first two books of a hagiographic text which recorded her miraculous works for posterity.[4]

Lately, I've felt a lot like Bernard of Angers. For I, too, have been displaced from my accustomed stance of academic objectivity by the

power of a martyred saint's shrine. Without my having sought it out, the role of hagiographer seems to have been added to my usual occupation of historian of medieval art. That is why I'd like to tell you of a *passio*—to use the word Bernard would have in the eleventh century—the narrative of a saint's suffering, death, and odyssey from ordinary human being to potent cultural symbol. Read on, and you'll learn the story of a Detroit martyr named Malice Green.

On November 5, 1992, two white Detroit police officers bludgeoned to death an unemployed African American steel worker named Malice Green.[5] Green had provoked the attack by refusing to obey their order to open his closed fist and reveal what he held within. Only six months after the acquittal of the white officers accused in the Rodney King beating had set Los Angeles ablaze with racial hatred, Detroit braced itself for a similar violent reaction. The outraged and aggrieved members of Green's impoverished Westside community, however, did not claim an eye for an eye. Instead, they harnessed their anguish to the creation of a memorial on the site of Green's murder so that pilgrimages could be made to this hallowed place.

Detroit's Malice Green Shrine is located in a poor neighborhood held hostage by the drug trade and on the outskirts of despair. Its residents are afraid to sit on their porches after dark and if they have to walk the streets at night, they often do so with a gun.[6] Here, as was Bernard at Conques, I'm an outsider—white, foreign, middle class, educated at an elite university, and informed by an arcane knowledge of holy sites from Constantine's Jerusalem to modern day Lourdes. But like so many other Detroiters, I felt compelled to make a visit shortly after the crime, to the shrine marking the spot where officers Walter Budzyn and Larry Nevers beat thirty-five-year-old Malice Green to death. Unlike most visitors to the shrine I sought not to quell grief, rage, fear of persecution, or to extinguish the disbelief that an African American man could still be murdered by over-zealous police in a city with a black mayor, a black police chief, and a police force in which fifty-three percent of the officers are people of color.[7] My initial interest, like Bernard's, was detached and academic: I hoped to expand my knowledge of medieval pilgrimage through gazing at its shadowy reflection in a contemporary mirror. But what I learned instead was how shared pain can result in a creative power capable of preventing a tear where the fabric of civilization has been worn thin by centuries of rough usage. Like Bernard, I too have been converted from a cool and impartial observer to one who is emotionally engaged.

Malice Green was a working-class African American.[8] He held a high school degree, had no criminal record, and he had worked steadily at the Morton Manufacturing Company near Chicago for thirteen years.

Nevertheless, he was not without his problems and bad habits. Green had several run-ins with police in Waukegan, a suburb of Chicago, but none of them led to criminal charges. Under the pressure of debts accrued through unjudicious spending and heavy child-support payments, he seems to have turned to alcohol and drugs for solace. Eventually, Green's work habits deteriorated, and he was fired from his job in February, 1992 for lateness and absenteeism. After losing his job, he returned to the neighborhood in Detroit where he had spent his teen years and where members of his family still lived.[9]

Around 10:00 P.M. on the night of November 5, Green gave a friend a ride to a residence suspected by police to be a crack house. A "booster crew"—plain clothes officers who bolster the uniformed patrol—composed of Nevers and Budzyn asked Green for his driver's license, claiming later that they suspected he was driving a stolen vehicle. During the course of their trials, however, testimony revealed that the officers already knew that Green was driving his own car when they approached it. In truth, they had received a message hours before informing them that the stolen car for which they were looking had been located and was under surveillance. Police records also indicated that at 8:10 P.M. someone had run a computer check of the license plate of Green's car and it had come back clean.[10]

Nevers and Budzyn, ironically called "Starsky and Hutch" because they were such inversions of the "good cops" of the 1970s TV series, ordered Green to open his closed fist.[11] When he refused, a struggle ensued which escalated to the point where the officers seemed unable to stop clubbing Green with their two-pound, police-issue flashlights. "They split his head open like a pig's foot," recalled Ralph Fletcher, who had been with Green in the car.[12] "Blunt force trauma to the head" was the more clinical description of the cause of Green's death given by the Medical Examiner's office.[13] Depending on the source consulted, Green died because he had failed to reveal his keys, lumps of crack cocaine, a piece of paper, or nothing at all.

The next day people began to visit the site of Green's murder. Although television coverage provided images of the scene, it was as if Detroiters, like the first pilgrims to Jerusalem who followed Christ's route from Pilate's prison to Calvary, needed to see the site of the atrocity with their own eyes in order to fully grasp its meaning. Among the first visitors was Green's mother, Patricia. She told a reporter that she had twice driven by the curb where Green was killed. When she finally stopped and got out of her car, she saw that her son's blood still stained the street. She described the scene saying, "It was like somebody had run over a cow. I don't think he even had a good bone left in his body after they got

through beating him."[14] Florence Frazier, who came with her grandchildren, on November 7, expressed her feelings to a reporter at the site saying, "People are numb. It's like who do you lash out at? Who can you trust? I'm having a hard time dealing with another Rodney King incident where my grandson lives, where my son lives. It could have been them."[15] Her nine-year-old grandson, Lawrence Newell, confessed to a *New York Times* reporter that he was now afraid of the police. "One day," he said, "it will probably be me."[16] Throughout that wintry day and for many days to follow, cars would pull up to the curb, pause briefly, then drive away. This was still occurring with frequency when I first visited the site on December 26.

Other visitors prolonged their stay, standing watch in night-long vigils during the first weeks after Green's death. A local newspaper recorded that three hundred visitors viewed the shrine on November 11, the day before Green's funeral.[17] Some, as if to mark their continued presence and symbolic support, left written messages, flowers, candles, shells, Bibles, and other objects associated with veneration in African and Christian traditions. Beginning with these tokens of respect, spontaneously at first, then with the more calculated design of poets and painters, the blighted urban landscape was transformed through objects, words, and images into a hallowed site that drew troubled Detroiters throughout the following months when their emotions ran high and they needed each other's support.

The inscriptions and visual images at Green's shrine refer most frequently to his role as a martyr and to the solidarity created in the community by commonly felt, intense emotions provoked by yet another in a seemingly infinite line of crimes motivated by racial hatred. At either end of the site, inscribed crosses mark off the sacred from the profane world. They elide Green's death with Jesus's, underlining the sacrificial role of both. The West cross supports a sign that reads:

> On this site I lost a brother I never knew but deep down I know the pain. There's always a shadow on our back. When we are right we are wrong. To the family, you are not alone.

The following words are inscribed on the cross itself:

> Malice Green did like Jesus. Took the pain. You and I know who are the blame.

The East cross reads:

> The Lord is my shepard [sic] I shall not want. They made me to lie down in my own blood. Rest in Peace brother Amen. It's not over until its over.

Bennie White's bust-length portrait of Green begun on the wall of the crack house five days after Green's death expresses visually a similar understanding of Green as a martyr. Reminiscent of images of Christ on Veronica's veil, Green's features have been idealized and softened to produce a beatific appearance. The visual language of the portrait—its frontality, exaggerated staring eyes, background designed to remove the figure to a region beyond the bounds of time and space—conjure up associations with both the formal language of Byzantine icons and the profound spirituality these images were meant to activate.

White credits the painting's final appearance in part to the miraculous intercession of God. A rainstorm disrupted his task for several days when he was in the process of painting the work. After the rain stopped, the artist returned to the site fearing that the portrait would be ruined. To his amazement, White discovered that although the paint had dripped and smudged, the work appeared to be of greater beauty. More uncanny was the way Green's eyes now seemed wondrously clouded by tears White had not painted. "It seemed the Lord gave me a helping hand," White still maintains.[18]

For a number of days immediately after the mural was painted, a small almond-shaped mirror rested against the wall below the dead man's portrait so that visitors saw themselves and Green's idealized image in the same glance, compelling them to acknowledge their own identity and to consider it against the backdrop of the cruel fate met by Malice Green. Individual reactions of course would vary. The sentiments of Florence Frazier and her grandson cited earlier suggest that for many people of color whose personal experiences often give them reason to expect unfair treatment at the hands of the police, the juxtaposition of their own reflection and Green's could have triggered fears that they could be the next victims of police brutality. Concomitantly, I would like to suggest, the combined image offers a transcendental alternative to any real or imagined horrors spawned by the slaying. Green's portrait, by means of its transfigured and beatific representation, serves to disrupt any uneasy reactions by providing an image of a metaphysical reality which transcends the arbitrariness of human suffering, and perhaps, even the finality of death itself.

When a viewer stood directly in front of Green's portrait, his or her own reflection fell across the middle of the almond-shaped mirror darkening its center as does the pigmented iris of an eye. The viewer's reflection thus became the agent that transformed the specular surface into at least the suggestion, if not the image, of an eye. While the viewer beheld her own reflection in the mirror, she might simultaneously experience her gaze being returned by a large, disembodied mirrored eye. Certainly, this visual

experience encouraged a deeper, more profound level of contemplation about the act of looking and the role played by physical appearance in both the construction of bigotry and racial solidarity.

Most viewers, however, did not choose to stand and contemplate the shrine from the sidewalk. Some, to use the ignominious term of radio traffic reports, were "rubber neckers," driving by slowly, gawking at the scene of the crime, and speeding away perhaps pondering "there but for the grace of god go I" as they pushed down harder on their accelerators and moved on with the flow of traffic. Other drivers actually pulled up and parked in front of the shrine in a space cordoned off from the traffic by two orange cones. Never leaving the perceived privacy and isolation of their vehicles, they regarded the shrine from a seemingly safer place than those who stood on the sidewalk. How many of these visitors, I wonder, realized that in their act of driving up and parking in front of 3410 West Warren, they were duplicating the last action of Malice Green before he was set upon by the police?

The shrine did not hold the high spiritual capital for all its visitors. Needless to say, the value of a shrine depends largely upon what currency its visitors bring with them. Once, shortly after its creation, and again at some point during the fall of 1994, vandals defaced Green's portrait. On this last occasion, red paint was sprayed over the dead man's face and "50" was added beside his head. Neighborhood gossip suggests that this number is not a gang tag or an arbitrary numeral, but rather "five o," a moniker for the police. The vandalism, no matter who is responsible, testifies to the shrine's ability to draw all types of visitors and to arouse a variety of responses, not all of them positive.

A pair of white shoes which have long since disappeared, decorated with crucifixes, biblical citations, and clocks, originally sat beside the portrait. Some sources say these were Green's favorites enshrined here as relics of his existence.[19] Others contend they were placed here by Detroit artist Tyree Guyton, who frequently uses footwear in his work.[20] In either case, the shoes, and the shells that were left later by visitors, make reference to the Kongo-Angola tradition of placing these objects on tombs as a means of activating the spirit-residing earth of deceased ancestors. According to Robert Farris Thompson, in this tradition, a sea shell, *luzingu*, placed on a grave is a visual reference punning the word, *zinga*, meaning "live forever." Shoes, he suggests, are provided so that the deceased can "walk to God in glory."[21] Here, at the Malice Green shrine, the objects have been displaced from the place of burial to the scene of death perhaps to activate the memory or signal the unseen presence of other black men whose violent deaths or persecutions make them Green's spiritual forefathers.

The Reverend Charles Adams, in his eulogy to Green, placed him at the end of a long line of black martyrs who through their deaths gave public witness to racism. For me, a medievalist, his words summoned up the image of Green enthroned at the top of a kind of African American Tree of Jesse, where kinship exists not through blood ties but through having courageously endured unjustified suffering in a racist world. At Green's funeral, attended by about two thousand people, Adams told the mourners:

> They crushed W. E. B. Du Bois, they exiled Marcus Garvey, they compromised Booker T. Washington, they excoriated Malcolm X, they murdered Medgar Evers, they persecuted Paul Robeson, they expelled Adam Clayton Powell Jr., they slandered Harold Washington, they smeared George Crockett, they slew Martin Luther King Jr., they excommunicated Father Stallings, they discredited Marion Barry, they incarcerated Nelson Mandela, they killed Steve Biko, they bludgeoned Rodney King, and they killed Malice Green.[22]

After the funeral, the community all but ignored Green's grave, located in the town of Mt. Clemens about twenty miles away—a short pilgrimage even by medieval standards. The site of his murder, however, continued to resonate with significance. After the initial grief passed, it was not so much Green as an individual but his perceived martyrdom, and hence the site of his fatal beating which remained important. The shrine continued to serve as a rallying point for anxious Detroiters waiting to see if the justice system would rub salt in their wounds by going easy on the police officers as it originally had in Los Angeles.

The shrine served as the focal point for rallies during uncertain moments in the justice process, for example, when the trial venue was being decided, and during the jury deliberation and sentencing. These vigils at the shrine allowed people to express their emotions in a way that was not destructive. Violence erupted only once when a group of mostly white outsiders from a local communist group appeared on the scene in the tense hours before the guilty verdict was handed down on August 23, 1993. They tried to stir up trouble by chanting, "No justice. No peace"; and a few punches were thrown before they were chased from the scene by locals.[23]

People were drawn to the shrine after the guilty verdict was delivered. Detroiters seemed to want to observe the scene of Green's death with their own eyes again, now that justice had been served. Perhaps, their visits gave a greater tangibility to the guilty verdict which almost seemed too good to be true in light of the acquittal of the officers involved in the Rodney King beating.

New words and images that expressed satisfaction with the verdict and sentencing were added to the shrine. For instance, on August 31, 1993

someone, whose signature is now illegible, added the phrase, "Increase the peace! Keep hope alive." Charles Allen added a drawing in black paint of the officers; one holds his head in despair, the other looks straight ahead in disbelief. The captions, "Guilty Aug. 23, 1993" and "Give them life in prison. Oct. 12, 1993" leave no doubt about the sentiments of the artist.

I do not think that the importance of Malice Green's death rests in its capacity to mirror medieval sainthood. His shrine, although it still attracts some visitors, will probably never find a place among the canonical pilgrimage monuments such as Saint Peter's, Rome, or Santiago in Compostela. It was not built, after all, by the empowered with immutable materials and the fulsome approbation of the church and state. Already the shrine is beginning to fall into decay. But its power, however ephemeral, was awesome. For one brief moment it was the locus of the miraculous: it served as a crucible where red hot anger, fear, and hatred were transformed into a courageous resistance to the primal human urge to answer one violent act with another. The words and images of the shrine helped to construct and further the belief that Green was a martyr and a redeemer, not just another ordinary victim. A woman known as Paradise expressed the sentiments of the whole community when she told reporters:

> It angered me that he had to die, but I knew it would bring about some change. . . . It's like he was a sacrifice. There's still hope, and this doesn't have to go on forever. It's going to get better. It has to get better. It's been promised by God.[24]

With this expression of optimism, my story of Malice Green is finished, and I leave you with the sentiments written by my medieval counterpart, Bernard, about a thousand years ago:

> Because there is nothing truer, I implore you to bring faith wholeheartedly to my narration so that later you will not regret that you disparaged a holy martyr. Better yet, if the unusual novelty of the miraculous content disturbs you, I prostrate myself on the ground to beg this . . . that . . . you also come here, not so much to pray as to gain knowledge through experience. For through lack of experience you might prematurely judge something false whose truth, once you have seen it for yourselves, you will proclaim thereafter.[25]

Notes

The first version of this paper was delivered in a session entitled *From the Holy Land to Graceland: 20th-century Pilgrimage Sites, Rituals, and Relics* at the

College Art Association annual meeting in San Antonio, Texas, 1995. I would like to thank the cochairs of this session, Annie Shaver-Crandell and Harriet Senie for having allowed me this opportunity to present my work. A second version of this paper was presented in *Murders, Medieval and Modern* at a conference entitled *The Cultural Work of Ritual, Symbol, and the Other* held at the University of Western Ontario, February 10–11, 1995.

1. See Pamela Sheingorn, introduction to *The Book of Sainte Foy*, trans. Pamela Sheingorn (Philadelphia: University of Pennsylvania Press, 1995) 24–25.

2. Sheingorn 38.

3. Sheingorn 38.

4. Kathleen Ashley, in a paper entitled "Theorizing the Other in Medieval Studies and Cultural Studies," delivered at *The Cultural Work of Ritual, Symbol, and the Other* (The University of Western Ontario, February 10–11, 1995), discusses how the early portions of Bernard's text present the monks of Conques and the cult of Sainte Foy as inferior and provincial so that Bernard can better aggrandize his own intellectual prowess and sophistication. Ashley points out that Bernard, nevertheless, was gradually converted, and that his perception of his own superiority was dissolved by faith and experience.

5. The *Detroit Free Press* reported the following chain of events compiled from witnesses and police officials:

1. Green sees his friend, Ralph Fletcher, leave a party store at Warren and Tillman about 10:30 P.M. Green offers him a ride home, about one block west.
2. Green drops Fletcher off.
3. Two plain clothes officers in an unmarked car flash their lights, pass, then back up in front of Green's car. Green gets out.
4. Officers Larry Nevers and Walter Budzyn ask Green about his driver's license. Green opens his door and his glove box. One officer asks Green what's in his hand, and tells him to let go. Then: The officer jumps into the car and starts beating Green's hands with his flashlight. The other officer jumps in on the other side. Green, half out of the car, drops a piece of paper. He is struck in the chest, and appears dazed.

> Two EMS units arrive, flagged down by police.
>
> Other police arrive in marked cars, including Sgt. Freddie Douglas. One of the arrivals, a white male officer, pulls Green off his seat and beats him with his fist in the face, chest and stomach. Another officer stands on Green's neck as handcuffs are put on. At least two other uniformed officers reportedly hit Green, who drops some keys.
>
> An EMS technician messages a supervisor: "What should I do if I witness police brutality/murder?"
>
> Green goes into a seizure. Police find a closed knife in his pocket.
>
> An EMS unit takes Green to Detroit Receiving Hospital, where he is pronounced dead on arrival at 11:06 P.M.

(Jim Schaefer and Roger Chesley, "Fatal Beating by Police Outrages City Leaders. Chief to Seek Charges for the 7 Cops Involved," *Detroit Free Press*, 7 November 1992, sec. NWS, p. 1A)

6. The following were comments made to a reporter by people who live in Green's neighborhood:

> "The neighborhood is nice," says Troy Colvin, 28. "There are some real beautiful people. But," he adds, "it's not safe on the streets at night."
> "You won't catch me out walking after 9 P.M. unless I've got my gun," says Colvin. "Bullets ain't got no names."

(L. A. Johnson, "In Troubled Neighborhood There's Talk About Revival," *Detroit Free Press*, 29 November 1992, sec. COM, p. 1F)

7. Susan Watson, "Young Sees Achievement of Justice Tarnished," *Detroit Free Press*, 7 November 1992, sec. NWS, p. 1A. Of the 3,851 sworn Detroit police officers, 2,167 are black, 1,615 are white, 59 are Hispanic, 5 are Native American, and 5 are Asian. See Roger Chesley and Jack Kresnak, "Officers See No Setback to Race Relations. Police Pull Together in Face of Verdicts, Cite Detroit Progress," *Detroit Free Press*, 25 August, 1993, sec. NWS, p. 8A.

8. For a full biography see Brenda J. Gilchrist and David Zeman, "Green's Fatal Path Is Well-worn. His Defiance Grew along with Troubles," *Detroit Free Press*, 26 November 1992, sec. NWS, p. 1A.

9. That he continued to use drugs and alcohol as a means of dealing with his problems was borne out in his autopsy which revealed he had 0.5 micrograms per milliliters of cocaine in his blood, and a 0.03 level of alcohol in his urine (Michigan sets a blood alcohol level of .10 for intoxication while driving). See Roger Chesley, "Drug's Role in Slaying Unclear. Green Died of Blows to Head Report Says," *Detroit Free Press*, 19 November 1992, sec. NWS, p. 1B.

10. Janet Wilson, "Cops Sought Charge on Green. Computer Specialist Says Car was Clear," *Detroit Free Press*, 7 July 1993, sec. NWS, p. 1B.

11. *Detroit Free Press* reported the following comments by people from Green's neighborhood:

> "Everybody knows them as Starsky and Hutch," Fletcher said. "They harass people. I mean this is the first time I seen them do anything like that. That was a shock."
> Beverly Gilbert, 31, lives nearby. "They were hard on a lot of people, real hard," she said of officers who patrol the area as partners.

(Jim Schaefer and Roger Chesley, "Fatal Beating by Police Outrages City Leaders. Chief to Seek Charges for Some of the 7 Cops Involved," *Detroit Free Press*, 7 November 1992, sec. NWS, p. 1)

12. Jim Schaefer and Roger Chesley, "Sargeant Denies Beating Role. Witnesses Say He Watched Detroit Cops Pummel Man," *Detroit Free Press*, 9 November 1992, sec. NWS, p. 1A.

13. Schaefer and Chesley, "Fatal Beating."

14. Dawn Terry, "Death after Police Beating Inspires Fear in Detroit," *New York Times*, 8 November 1992, sec. 1, p. 24.

15. *New York Times* 24.

16. *New York Times* 24.

17. Jeffrey S. Ghannam, Roger Chesley, and Jim Schaefer, "Family Friends and Strangers Gather for Vigil. 300 Mourn Green as Prosecutors Get Case," *Detroit Free Press*, 11 November 1992, sec. NWS, p. 1A.

18. Corey Williams, "Emotion Colors His Portrait of Green," *Detroit News*, 29 November 1992, sec. C, p. 1. He related the same opinion to me in conversation, April 6, 1995.

19. An article in the *Los Angeles Times* said that they were Green's favorite shoes. Pamela Warrick, "What Next for Detroit? With Rodney King in Mind, Officials have Reacted Quickly to the Beating Death of a Black Motorist. Residents Watch, Wait," *Los Angeles Times*, 25 November 1992, sec. View, pt., E, p. 1.

20. Ghannam, Chesley, and Schaefer, "Family Friends and Strangers Gather."

21. Robert Farris Thompson, *Dancing Between Two Worlds: Kongo-Angola Culture and the Americas* (New York: Random House, 1991) 1.

22. Roger Chesley "Racism Killed . . . Green. If It's Not Destroyed, No One is Safe, Pastor Tells Mourners," *Detroit Free Press*, 13 November 1992, sec. NWS, p. 1A.

23. "On the Streets, A Sense of Calm, Relief Prevails. Knox Thanks Crowd for Staying Peaceful," *Detroit Free Press*, 24 August 1993, sec. NWS, p. 8A.

24. Johnson, "In Troubled Neighborhood."

25. Sheingorn 4.

10

POSTMODERN IDOLATRY

THE MEDIA AND VIOLENT
ACTS OF PARTICIPATION

DAWN PERLMUTTER

Discussions on the subjugation of the spiritual in contemporary art would be deficient without considering the issue of violence. The subject of violence has become one of the most truculent points of debate in American media and art. Politicians, parents, educators, critics, the press, and the general public argue over issues such as what is considered violent, what degree of representing violence is acceptable, and what should children and young adults be exposed to. However, the most controversial debate centers around this question: Does violence in the media inspire violent acts in real life, or is media violence a reflection of the prevalent chaos in our society? Does art imitate life or does life imitate art? Television, film, and art critics always knowingly or unknowingly take one view or the other as the basis for their reviews.

Building on the theories of Aristotle, René Girard, Edward Whitmont, and Konrad Lorenz, it will be demonstrated that historically there has been a direct correlation between violence and the sacred, that participation in either actual or signified acts of violence are a significant part of religious ritual, that humans are by nature aggressive, that violence in art and the media serves as a catharsis for human aggressive drives, and that religious ritual used to realize this function. Hence, the paradoxical

question of whether art-violence imitates life or life-violence imitates art becomes moot in terms of art criticism, because the question is demonstrated to be based on a false premise.

It will be argued that the issue of violence in the media is a theological problem of idolatry, and that censoring representations of violence is actually serving to perpetuate rather than diminish crime in our society. The 1994 films *Pulp Fiction* by filmmaker Quentin Tarantino and *Natural Born Killers* by director Oliver Stone will be used to help demonstrate these arguments.

Contemporary views on violence are a reflection of an "aesthetics of denial" that originated in theological literature, and which was solidified in the emphasis on rationality in the Western philosophic tradition. The denial in Judaic-Christian theology of the body and its physical urges and biological needs, such as sexuality and aggression, directly corresponds to the theological prohibition of images, which forbids the representation of God in any form—god in whose image man is made. Fertility goddesses that emphasized large hips and breasts, fertility gods with large penises, and warrior gods and goddesses were sacred representations of non-Judaic-Christian peoples that incarnated human desires. An invisible god does not have any sexual organs, does not carry any weapons, and does not in any way, shape, or form symbolize human urges. Hence, if it is not represented then it must either not exist, or it must not be religiously acceptable. Judaic-Christian ideology with its emphasis on the cerebral, rational, and intellectual worship of an abstract god intentionally caused humans to sublimate all physical urges, which is probably why both religions met with such strong resistance for such long periods of time.

Culturally we only need to look at the correlation of strict religious movements in history, and the corresponding degrees of violence, such as the Crusades, the Spanish Inquisition, and the seven hundred years of witch hunts, to verify the point. Religious prohibitions that sublimated sexual and aggressive desires erupted into sadistic, tortuous acts of violence, in the name of God. Ironically these religious acts of violence exemplify a form of ritual participation that integrated violence and the sacred under the auspices of religious doctrine.

In part 1 of *Return of the Goddess*, psychiatrist and scholar Edward Whitmont describes the modern dilemma as a collective cultural repression of basic antisocial, instinctual urges that comes from a one-sided image of human nature as basically good. He claims that our cultural codes are based on traditional patriarchal religions which make us view anger, hostility, aggression, and desire as evil. Whitmont argues that there is no more violence or brutal oppression in the present than in the past, but

rather that we no longer have religious-cultural systems capable of defusing aggression, anger, and violence, which would direct them into constructive channels. Whitmont goes on to say that as long as aggression and violence were considered an expression of the power of a deity (such as Dionysus, Ares, Shiva, Thyr, Sekhment, and the Morrigan), or served the glory of emperor, church, or fatherland, they were integrated into a morally and ethically functioning system. Aggression can not be gotten rid of, rather it is absolutely necessary for survival.[1]

Obviously the core of Whitmont's hypothesis rests on the philosophical problem of nature versus nurture. Are humans biologically aggressive or is human violence just a response to cultural and social circumstances? In his book *On Aggression*, Konrad Lorenz argues "that human behavior, and particularly human social behavior, far from being determined by reason and cultural traditions alone, is still subject to all the laws prevailing in all phylogenetically adapted instinctive behavior."[2] Lorenz goes on to state that the rapid changes that came about through human ecology and cultural development have thrown out of balance phylogenetically adapted behavior mechanisms such as aggressive behavior and killing inhibitions.[3] By applying animal behavior to human behavior, Lorenz demonstrates that "it is particularly the drives that have arisen by ritualization which are so often called upon to oppose aggression, to divert it into harmless channels, and to inhibit those of its actions that are injurious to the survival of the species."[4] His use of the term ritualization refers to a diverse range of human activities including religion, magic, daily habits, and manners. According to Lorenz, the original function of ritual is communication, which can prevent the harmful effects of aggression by inducing mutual understanding between members of a species,[5] and the secondary task is to create a bond between certain individuals, which can be achieved through various ceremonies, again controlling aggression. Although Lorenz's theory is controversial and not accepted as fact by many scholars, he presents a compelling argument that humans are aggressive by nature.

Lorenz's theories are relevant to the question of violence in the media for several reasons. First of all, he proposes that humans are biologically aggressive. Secondly, he acknowledges that ritual and ceremony are important methods of controlling violence. Thirdly, he recognizes that catharsis will relieve undischarged aggression. The initial premise, that humans are biologically violent, leads one to conclude that media violence reflects real life. However, it is quite obvious that violence is not depicted very accurately on television and in film; in fact, if anything it is deliberately glorified. If art were simply reflecting violence in real life there would be no need to have fictional, exaggerated accounts; rather all expressions

of violence would actually be a form of news reporting. The glorification of violence in nondocumentary film is a method of making violence socially and ethically acceptable by suspending our traditional belief system, at least until the film is over. This temporary suspension of our moral rules allows us to emotionally and ethically enjoy the violent acts on film, generating a cathartic discharge of our aggressive drive. Depictions of violence in film and television are contemporary outlets for aggression because they act as vehicles for catharsis. Violence in media does not reflect violence in real life, rather it cathects it.[6] As Whitmont states:

> Television and the movies glorify violence, horror and explicit sex to the point where these performances are almost ritualistic. Their appeal seems to rest upon the cathartic effect of drama. These violent contemporary dramatics are secularized, indeed decadent, caricatures of the solemn presentation of ancient tragedy.[7]

The *Oxford English Dictionary* defines the words catharsis and cathartic as medical terms which signify "cleansing and purging, 1) purgation of the excrements of the body, evacuation of the bowels and generally it can be defined as including cleansing, purifying and purging of the Spirit."[8] *Webster's New World Dictionary* defines catharsis as "1. a purging, esp. of the bowels and 2. a relieving of the emotions, as through the arts or psychotherapy."[9] The concept of art as catharsis is not a new one; Aristotle proposed a theory of art in which art purges the passions. Aristotle states:

> An emotion which strongly affects some souls is present in all to a varying degree, for example pity and fear, and also ecstasy. To this last some people are particularly liable, and we see that under the influence of religious music and songs which drive the soul to frenzy, they calm down as if they had been medically treated and purged. People who are given to pity or fear, and emotional people generally, and others to the extent that they have similar emotions, must be affected in the same way; for all of them must experience a kind of purgation and pleasurable relief. In the same way, cathartic (songs and) music give men harmless delight. We must therefore make those who practice mousike [poetry and music] in the theater perform these kinds of tunes and songs.[10]

Aristotle's theory of catharsis answered Plato's moral objection to art.

> While Plato insists that artistic imitation, especially tragedy, feeds the passions and misleads the seeker after truth, Aristotle answers that the arts in general are valuable because

they repair the deficiencies in nature, and that tragic drama in
particular is justifiable because of the moral contribution it
makes. . . .[11]

Although both philosophers put forth a mimetic theory of art, Aristotle's
theory is a defense against all three of Plato's objections to art which in-
cluded the ontological, epistemological, and moral. Plato argued that art
appeals to our irrational side and encourages irrational beliefs and ten-
dencies, hence it should be censored because it is potentially harmful.
Anyone who maintains that violence in the media will inspire violence in
real life holds a Platonic moral view of art. According to Aristotle it is not
only natural but ethical to cathect violent, tragic images in film. From an
Aristotelian perspective the question of the media either inspiring or re-
flecting violence in real life becomes logically invalid.

To demonstrate the correlation of violence and the sacred, the ag-
gressive nature of human behavior, and art as catharsis, I propose to ex-
amine two contemporary films. In 1994 two major films, *Natural Born
Killers* by Oliver Stone, and *Pulp Fiction* by Quentin Tarantino, received
a multitude of criticism because of the amount and type of violence they
portrayed. They were described in various reviews as being the epitome
of senseless violence, surreal, expressionistic, nihilistic, and raw.

Natural Born Killers explores the relationship between violence and
the media, and was the subject of an abundance of reviews ranging from
basic film criticism to social commentary. Two young lovers, Mickey and
Mallory, embark on a murder spree across the American West that makes
them worldwide stars and leaves fifty-two dead in three weeks. Through-
out the film, there are references to various forms of media and media
hype by use of television clips, cartoons, television style reenactments,
and black-and-white scenes. The couple is featured on the news, maga-
zine covers, mock documentary reportage, and in newspapers. One
teenage fan stated in a television interview that "Mickey and Mallory
were totally hot and the best thing to happen to mass murder since Man-
son."[12] Representing the pinnacle of media hype is Wayne Gale, the host
of a TV program called *American Maniacs*, who manages to get an ex-
clusive interview with Mickey in prison, scheduled for Superbowl Sunday,
which subsequently causes a jail break and riot. Interestingly, Wayne Gale
is perceived as having less moral value and personal integrity than the
two killers. The obvious evil portrayed in this film is not so much the se-
rial killers as the media in general, specifically television. The film leaves
you wondering whether murderers are natural born killers or a product
of their environment. If they are a product of their environment, is it all
the violent media images and celebrity attention that creates them?

During his prison interview, we are presented with Mickey's philosophy of life, which is a combination of a strong belief in Fate, Christian concepts of God, and survival of the fittest.

W: So tell me Mickey, how can you look at an ordinary person, an innocent guy with kids, and then shoot him to death? I mean, how can you bring yourself to do that?

M: Innocent, who's innocent Wayne? Are you innocent?

W: I'm innocent, yes I am, of murder definitely.

M: It's just murder man. All of God's creatures do it in some form or another. I mean you look in the forest, you got species killing other species, our species killing all the species, including the forest, we just call it industry, not murder. . . .

W: Please explain to me, where's the purity that you couldn't live without in the fifty-two people who are no longer on this planet because they met you and Mallory? What's so _____ pure about that? How do you do it?

M: You're not ever gonna understand, Wayne. You and me we aren't even the same species. I used to be you and then I evolved. From where you are standing you are a man, from where I am standing you're an ape. You're not even an ape you're a media person. Media's like the weather, only it's manmade weather. Murder, it's pure. You're the one who made it impure, you're buying and selling fear. You say why, I say why bother?

W: Are you done? Great. Now let's cut the B.S. and get real—why this purity that you feel about killing?

M: I guess Wayne, you just got to hold that old shotgun in your hand and it becomes clear like it did to me for the first time. That's when I realized my one true calling in life.

W: And what's that Mickey?

M: Shit man, I'm a natural born killer.[13]

Mickey is the perfect example of Lorenz's maladapted twentieth-century man living in a media-crazed society, whose only outlet for his aggressive drive is to kill. By depicting Mallory's childhood as a television sitcom showing her as a victim of psychological and sexual abuse at the hands of her father, and by alluding to Mickey's home life as being abusive, with a father who committed suicide, Oliver Stone provided an environmental rationale for Mickey and Mallory's behavior which contradicted the title, *Natural Born Killers*, and theme of the film. Stone depicts them as the ultimate survivors of dysfunctional childhoods and a

media-crazed world, which provides the audience with a bit of a psychological cushion at the expense of the integrity of the film.

The perhaps not immediately obvious religious elements in this film are multiple; these include a Christian concept of God via references in images and dialogue to demons, the concept of the Garden of Eden, the concept of being born bad (into original sin), and a mystical form of nature worship expressed via images of animals, rattlesnakes, a tornado, and talk of Fatalism throughout the film. A significant scene occurs in the desert where the couple come across a Navajo Indian, who surrounded by rattlesnakes is the natural healer capable of exorcising their demons. During a nightmare Mickey shoots him, causing a bad omen that leads to their capture, and the only remorse for a killing that the couple express. Meeting with this holy man eventually is the reason they decide to not kill anymore. His death leads to their redemption. Does this sound familiar? Although Oliver Stone presents what appears to be a form of nature religion, he mixes it up with the traditional Christian concept of redemption via a holy man dying for the sins of the world. The natural symbolism of the rattlesnakes is also tainted with Christian symbolism when Mallory steps into a snakepit, causing first herself and then Mickey to be bitten, leading directly to their capture. This is a repetition of the story of Eve and the serpent causing Adam and the future of mankind to get thrown out of the garden; in this case they are thrown out of the desert and into jail.

This film, which supposedly portrays a distorted depiction of ethics and morals, allowing two serial murderers to be respected and glorified by the public through mass media, is really just another postmodern version of the Judaic-Christian patriarchal ideology confronting and distorting pagan nature religions. The death of the holy man which leads to redemption, Mickey and Mallory's expulsion from the desert after her reckless interaction with the snakes, and the loss of their natural born killer state—all lead towards the film's end. At this point Mickey is seen driving a van, surrounded by small children, along with pregnant Mallory, now appropriately civilized and socially adapted in the world.

The patriarchal Christian ethic is also apparent in the sexual conventions and misogynist attitudes in this film. Amidst their violent rampage, they find it necessary to perform their own marriage ceremony, involving a blood ritual and wedding bands in the form of two coiled snakes. Mallory, who has no problem killing, gets jealous when Mickey wants to include an attractive female victim in their lovemaking, perpetuating the biblical ideal of the sanctity of marriage and the commandment against adultery, even in this bizarre circumstance. It is also

significant to mention the character of Detective Jack Scagnetti. Envying their ability to kill, he enthusiastically strangles a young female prostitute only after he allays her fears of being hurt by telling her "I'm the law your protector," and he avidly looks forward to raping Mallory. The scene from Mallory's childhood portrayed in a sitcom has canned laughter when the father talks about beating his wife and sexually abusing his daughter while winking at his son. Interestingly enough, in all of the reviews the misogyny manages to get lost behind the issues of violence.

For all of its supposedly random acts of violence, bloodshed, and gore, this film is really about the subjugation of the spirit and the spiritual, not directly through mass media but through the conflict of nature-environmental-pagan ideologies and Judaic-Christian doctrines. Mass media is depicted as a specific form of evil which is antinature; this is accomplished by the constant contrast of media images with natural images. Judaism and Christianity were founded on doctrines against nature in order to reinforce the cerebral, abstract concept of God, and to subjugate pagan nature religions. Mickey and Mallory's characters exemplify the spiritual confusion which ensues when one tries to reconcile Christianity, nature, and survival in the postmodern age of mass media.

Pulp Fiction won the Palme d'Or as the best film at the 1994 Cannes International Film Festival. The film contains three separate stories out of chronological order in which the characters from one story interact with those of the next. The violent scenes are offset by dialogue and situations that can only be found humorous. The opening and closing scenes occur at the same time in a coffee shop but from different characters' points of view. The film opens up in the coffee shop where we see two characters named Pumpkin and Honey Bunny planning to rob the restaurant. The scene closes with them pulling out their guns. The film then moves to the first story "Vincent Vega and Marsellus Wallace's Wife," which portrays Vincent and his partner Jules driving to work making casual conversation about various issues. They are professional killers. They continue their casual conversation before, during, and after killing three men. Before Jules shoots one, he recites Ezekiel's prophecy against the Philistines. They discuss how Vincent was recruited to take out Mia Wallace while her husband, Marsellus their boss, is out of town. Next we view Butch and Vincent crossing paths at a bar while reporting to Marsellus. Vincent is then seen buying and using heroin on his way to pick up Mia. Their evening out in a fifties diner involves a dance contest and a drug-related accident.

The second story "The Gold Watch" is introduced when a military officer explains how he came to have a gold watch that he is presenting to a little boy named Butch and then moves onto the story of the adult Butch

who is now a prizefighter. Butch is supposed to throw the prizefight but instead wins and happens to kill his opponent during the match. Now on the run, he meets his girlfriend who is waiting at a predesignated hotel only to find out the next morning that she didn't pack his father's gold watch. Butch goes back to his apartment, finds the watch, and in the process accidentally kills Vincent who was there. After leaving the apartment and feeling relieved, he stops at a red light just when Marsellus happens to be crossing the street. As soon as Butch realizes that Marsellus recognizes him, he runs him over, crashes the car trying to escape, ends up getting shot at by Marsellus, and a chase ensues. They both end up fighting in a pawn shop until the owner Maynard holds a rifle to their heads. The next scene depicts Butch and Marsellus tied up in the basement of the pawn shop, which was converted into a sadomasochistic dungeon. Maynard and his friend Zed choose Marsellus first and take him into a back room to be raped. Butch manages to escape and then decides to save Marsellus. Another bloody scene is depicted when Butch uses a sword to save Marsellus. Butch, after reconciling with Marsellus, leaves on a motorcycle.

The third story "Jules, Vincent, Jimmie & The Wolf" returns us to the first vignette just at the point where Jules is about to recite the biblical verse before he shoots Brett. This time the point of view is from a fourth man who is hiding in the bathroom. The fourth man comes out shooting directly at Jules and Vincent but confusingly none of the bullets hit them. Then the fourth man is killed by them. Jules attributes the fact that they weren't killed to divine intervention and considers it a miracle. The next scene shows them in their car with Jules driving, Vincent next to him, and Marvin, the only survivor from the apartment, in the back seat. Jules is telling Vincent that he is going to retire because of the miracle. Vincent who has his .45 casually in his grip pointed at Marvin proceeds to ask Marvin what he thinks of the miracle when the gun accidentally fires and hits Marvin in the throat. They agree to put Marvin out of his misery by shooting him in the forehead, leaving both them and the car completely covered in blood. To get off the streets in broad daylight they drive over to Jimmie's (a friend of Jules) place, call Marsellus, who calls in a clean up man referred to as "The Wolf." The Wolf in a very efficient manner handles the situation so that both the car and both of them are cleaned. The final scene is the same coffee shop depicted in the first scene about to be robbed by Pumpkin and Honey Bunny. They confront Jules who takes control but in keeping with his resolution does not kill them and in a conversation with Pumpkin presents his interpretation of the biblical phrase from Ezekiel recited before each killing.

Unlike *Natural Born Killers*, *Pulp Fiction* is not concerned with issues of the media. The disturbing scenes in this film are not the actual

violent acts, as much as the nonchalant attitude towards killing inter-
spersed with humor, which forces the audience to participate in some-
thing that feels unethical. It is the equivalent of finding yourself laughing
at a very funny joke, but knowing it is at someone else's expense. The im-
ages of drug dealers, sadomasochistic rednecks, and professional killers
contrasted with unexpected humor plays havoc with the viewers' moral
judgments. Combined with the shifts in chronology, the film is truly un-
predictable. This film does not present random acts of violence; rather the
viewer is so disoriented ethically that it just appears that way. They aren't
random acts because violence is depicted as a method to make money, a
way to achieve sexual pleasure, self-defense, or simply accidental.

The religious aspect to this film is significant. Jules's habit of stating
Ezekiel's passage before each killing is an excellent example of the con-
nection of violence and the sacred. Jules instinctively feels a need to ritu-
alize his killing. According to René Girard, violence is endemic to society,
and the solution to this problem is given in rituals of killing and their ra-
tionalizations as "sacrifice."[14] Jules may be a professional killer, but at
some level he has the need to rationalize his murders as being other than
simply for money. Ritual involves a repetitive process such as reciting the
same passage in prayer. Whitmont states, "Any affect or emotion which
in its raw and unaltered form is too intense to be controlled by will alone
may need its ritual. . . . Ritual brings about containment and acceptance,
control of intensity, and dosage."[15] The fact that Jules decides to quote a
biblical passage also adds to the correlation of violence and the sacred.
He paraphrases and expands upon Ezekiel 25:17:

> The path of the righteous man is beset on all sides by the
> iniquities of the selfish and the tyranny of evil men. Blessed is he
> who, in the name of charity and good will, shepherds the weak
> through the valley of the darkness, for he is truly his brother's
> keeper and the finder of lost children. And I will strike down
> upon thee with great vengeance and furious anger those who
> attempt to poison and destroy my brothers. And you will know
> my name is the Lord when I lay my vengeance upon you.[16]

The passage itself is violent, a wrath of God verse which concerns
the damnation of good people who falter and the salvation of sinners.
Once Jules takes the time to consider what he is actually spouting, he de-
cides to give up killing so the recitation itself inadvertently leads to his re-
demption.[17] At the end of the film he states:

> I been sayin' that shit for years. And if you ever heard it, it
> meant your ass. I never really questioned what it meant. I
> thought it was just a cold-blooded thing to say to a mother-
> fucker 'fore you popped a cap in his ass. But I saw some shit

this mornin' made me think twice. Now I'm thinkin', it could mean you're the evil man. And I'm the righteous man. And Mr. .45 here, he's the shepherd protecting my righteous ass in the valley of darkness. Or it could be you're the righteous man and I'm the shepherd and it's the world that's evil and selfish. I'd like that. But that shit ain't the truth. The truth is you're the weak. And I'm the tyranny of evil men. But I'm tryin', I'm tryin' real hard to be a shepherd.[18]

The theme of redemption is at the heart of this film. It may seem inconceivable that murder can lead to spiritual redemption, but that is exactly what human sacrifice achieved throughout history. Blood sacrifice inclusive of animals, and human animals dates back at least twenty thousand years.[19] If there are still doubts about the correlation of violence and the sacred consider this passage by Walter Burkert:

> Aggression and human violence have marked the progress of our civilization and appear, indeed, to have grown so during its course that they have become a central problem of the present. . . . Those, however, who turn to religion for salvation from this so-called evil of aggression are confronted with murder at the very core of Christianity—the death of God's innocent son; still earlier, the Old Testament covenant could come about only after Abraham had decided to sacrifice his child. Thus blood and violence lurk fascinatingly at the very heart of religion.[20]

Blood and violence also lurk fascinatingly at the heart of the film *Pulp Fiction*, and when viewed in the redemptive light of blood sacrifice, it could almost be argued that this is a religious film. Each vignette posits a form of redemption, and each entails bloodshed. Consider the scene in which Jules and Vincent had to clean up the car after shooting Marvin in the head. They get covered in blood, brains, and bone while the body is in the trunk until The Wolf literally hoses them down while they stand naked. This is reminiscent of sacrificial and baptismal rites. The first image of Mia, after she accidentally snorts heroin mistaking it for cocaine, shows blood slowly dripping out of her nose. After what obviously appears to be death by overdose, Mia is miraculously saved by having a needle full of adrenaline stabbed into her heart. This scene suggests a postmodern version of a resurrection. Butch is involved in blood throughout his narrative, from the time we hear about the bloodiest boxing match, to accidentally pumping twenty bullets into Vincent, to his fight with Marsellus, and finally to his killing Maynard with the sword. Saving Marsellus earned him his freedom, and the theme of redemption is epitomized when Butch leaves on a motorcycle named Grace.

Pulp Fiction and *Natural Born Killers* both portray a survival of the fittest attitude in a postmodern world. They are genuinely disturbing because of their depiction of primal survival instincts. These films exemplify the moral ambiguity our culture holds towards violence. Traditionally the viewer of horror and violence is somehow made to identify or sympathize with the main characters. No matter how violent the actions, circumstantial evidence is provided to allow the viewer to stay in the realm of his ethical conscious and not feel guilty about enjoying violent images.

However, these two films do not provide the usual psychological cushion that allows the viewer to accept and cathect the violence. According to Aristotle, "Tragedy must imitate actions arousing fear or pity."[21] The films aren't offensive because they are violent, they are offensive because they represent the Judaic-Christian concept of evil. Killing is morally and ethically acceptable in the hundreds of films that have glorified war and encouraged men and women to join the armed forces. Random killing is unacceptable and threatening when seen in it's raw condition without the security of moral justification and social validation. In fact, when killing is not politically or religiously motivated, it is classified under the biblical concept of evil. These films no longer serve to perpetuate the pervasive denial of natural sexual and aggressive desires by sugarcoating them with acceptable moral situations such as love and war. In an ironic sense, portrayals of unjustified random acts of violence are more honest and easier to accept than to be constantly disillusioned by media hype and politics. According to Girard, "demystification (of the judicial system) leads to constantly increasing violence perhaps less 'hypocritical' than the violence it seeks to expose, but more energetic, more virulent, and the harbinger of something far worse—a violence that knows no bounds."[22] These films expose the myth that our so-called rational society is either just or sane.

It has been argued throughout this chapter that violence in the media does not reflect or inspire violence in real life. The depiction of violence in film is a theological form of idolatry that invokes a cathartic form of ritual participation in its viewers. However, since there is documented evidence of incidents where violence in the media inspired violence in real life, how do we explain these events? Just as I argued that violence in the media is a form of idolatry (image worship), acts of violence that are directly influenced by media will be argued to be a form of iconoclasm (image desecration). Art historian David Freedberg examines the theory of response to images from a behavioral and psychological perspective in two books: *Iconoclasts and Their Motives* and *The Power of Images: Studies in the History and Theory of Response*. Although he is discussing iconoclasm in terms of art works and not film, his basic thesis is still ap-

plicable. In *Iconoclasts and Their Motives*, Freedberg focuses on the most striking assaults on well-known, publicly displayed objects in our century; he determined that unrelated individual acts of iconoclasm were more revealing about the interaction between people and images rather than when people act in groups with evident joint political and social resentments. After submitting examples of individual attacks on paintings, Freedberg proposed different motivations implicated in the destruction of images.[23]

The first class of iconoclasm is referred to as the attention-seeking act which is obviously successful in its aim.

> The other is much more difficult to define but it evidently has to do with the hold a particular image or part of an image has on the individual imagination; and the iconoclastic act represents an attempt to break that hold, to deprive the image of its power. A third motivation characterizes iconoclastic movements, such as that of the sixteenth century, where it is felt, often on the broadest social level, that by damaging the symbols of a power—the Spanish regime or the Catholic Church—one somehow diminishes that power itself. . . . While there is plenty of evidence for the calculated orchestration of iconoclasm in the sixteenth century, we often find instances of the more basic and individualized levels of response, of the unleashing of what might loosely be termed "primitive" feelings and behavior, of the kind of wild abdication of self-control that we described in some of the isolated acts of the present century. . . . On such occasions a wild delight seems to take over in breaking those images and objects which we normally protect and cherish, a delight in and a relishing of the sudden loosening of normal social and psychological restraints.[25]

Freedberg's premise is that there is a tendency for the iconoclast to conflate image and prototype, and

> when critical pressures are brought to bear on this tension, men and women break images, as if to make it clear that the image is none other than just that; it is not living, no supernatural embodiment of something that is alive. We fear the image which appears to be alive, because it cannot be so; and so people may evince their fear, or demonstrate mastery over the consequences of elision, by breaking or mutilating the image; they disrupt the apparent unity of sign and signified by making plain the ordinary materiality of the sign.[25]

If an appropriate response to the viewing of violence in film is to have a catharsis, as proposed in this chapter, then an inappropriate response would be the opposite, which would be further repression. Idolatry

and iconoclasm are opposite concepts although phenomenologically they are similar. For example on November 3, 1994 a *New York Times* headline read "Police Seize Suspect Obsessed By A Movie" and the text read "police officers in Nebraska captured a Utah teenager accused of murdering his stepmother and half-sister after becoming obsessed with the movie 'Natural Born Killers.'"[26] This incident made national news and obviously helped to contribute to the argument for censoring violent films. This was an example of an extreme form of iconoclasm where, due to the fact that the teenager was severely repressed, he psychologically conflated image with prototype and could not distinguish between sign and signified. In simple terms, the distinction between film and reality had dissolved. According to Whitmont, "The urge to violence, when lost sight of by consciousness through repression, is as dangerous, perhaps even more so, than violence overtly expressed."[27] To censor film because of isolated incidents such as this one is truly attributing power to images, but only negative power. If these images can inspire that kind of response negatively, then it can be argued that the positive responses are just as strong, obviously more commonplace, and important to society as a whole.

Violence in film is being censored for the exact same reasons that other forms of art are being subjugated—because violence in film is a manifestation of a struggle between those who would retain the ethics and morality of a monotheistic patriarchal society, and those who believe in ideologies that conflict with the Judaic-Christian view. The biblical prohibition of images censored Dionysian rites and fertility goddesses for the same reasons that contemporary violence in the media is being censored—to repress and deny all sensual urges. The glorification of violence in film transforms the film into an idol worthy of ritual participation in a cathartic experience. Twentieth-century censorship is a revival of the biblical prohibition of images, and denying violence is another manifestation of this prohibition.

Censoring images of violence will only serve to perpetuate rather than diminish crime in our society. According to Whitmont:

> Every culture of the past has taken into account the fact that aggression cannot be aborted but must be respected and given space in such a way that its blind violence is restricted and redirected into positive channels. The ancient propitiatory rites and mystery celebrations offered channels of substitution and sublimation for the archetypal force of Dionysus and Azazel, the Middle Eastern goat god, the scapegoat. When denied or repressed, what belongs to the god is appropriated by the devil, who acts out the demonic urge in such activities as the Black mass and witch burning, bloody inquisitions, and crusades.[28]

Just as the iconoclastic movements were an attempt to reinforce church doctrine by sublimating images of desire to preserve an abstract ideal, they only perpetuated more violence. The films *Natural Born Killers* and *Pulp Fiction* give us a glimpse of the modern-day outcome of sublimated aggression. Random and nonchalant attitudes about killing are the result of severe disillusionment with religious and political structures. "As soon as the essential quality of transcendence—religious, humanistic, or whatever—is lost, there are no longer any terms in which to define the legitimate form of violence and to recognize it among the multitude of illicit forms."[29] Violence is a theological problem because without belief or faith in some concept such as justice, God, or nature, there is no meaning, structure, or value to life, and aggression will manifest itself in uncontrolled acts of violence as exemplified by the characters of Mickey and Mallory in *Natural Born Killers*. Violence and the media is a theological problem of idolatry because media images are twentieth-century idols that have the ability to inspire awe. "Violence is not to be denied, but it can be diverted to another object, something it can sink its teeth into."[30] Violent films and images are objects of catharsis for repressed aggression, and to censor them will only serve to support rather than diminish violence in our society. Censoring representations of violence is the most explicit example of the subjugation of the spiritual in art in contemporary society and can only serve to perpetuate an aesthetics of denial.

NOTES

A version of this chapter was presented at the School of Visual Arts Ninth National Conference on Liberal Arts and the Education of Artists in 1995 and published in their journal, *Art & Academe, A Journal for the Humanities and Sciences in the Education of Artists*, 8.1 (1995).

1. Edward C. Whitmont, *Return of the Goddess* (New York: Crossroad, 1990) 1–27.

2. Konrad Lorenz, *On Aggression* (New York: Harcourt Brace & Company, 1963) 237.

3. Lorenz 246.

4. Lorenz 67.

5. Lorenz 85.

6. Since there is no adequate verb to describe catharsis, the term cathect will be used for this purpose.

7. Whitmont 13.

8. The Philological Society, *The Oxford English Dictionary*, vol. 2 (Oxford: Clarendon Press, 1970) 184.

9. David B. Guralnik, ed., *Webster's New World Dictionary of the American Language* (New York: Warner Books, 1987) 98.

10. Donald Palmer, *Does the Center Hold? An Introduction to Western Philosophy* (Mountain View, CA: Mayfield Publishing, 1991) 450–51.

11. Albert Hofstadter and Richard Kuhns, eds., *Philosophies of Art and Beauty* (Chicago: University of Chicago Press, 1964) 79.

12. *Natural Born Killers*, screenplay, Oliver Stone, David Veloz, and Richard Rutowski, Warner Brothers Film, 1994.

13. Stone film.

14. Robert G. Hamerton-Kelly, ed., *Violent Origins, Ritual Killing and Cultural Formation* (Stanford, CA: Stanford University Press, 1987) 6.

15. Whitmont 235.

16. *Pulp Fiction*, screenplay, Quentin Tarantino, Miramax, 1993.

17. Beverly Lowry, "The New Season/Film; Criminals Rendered in 3 Parts, Poetically," *New York Times*, 11 September 1994, sec. 2, 27.

18. Tarantino film.

19. Patrick Tierney, *The Highest Altar, Unveiling the Mystery of Human Sacrifice* (New York: Penguin Books, 1989) 10.

20. Walter Burkert, *Homo Necans: The Anthropology of Ancient Greek Sacrificial Ritual and Myth* (Berkeley: University of California Press, 1983).

21. Hofstadter and Kuhns 109.

22. René Girard, *Violence and the Sacred*, trans. Patrick Gregory (Baltimore: Johns Hopkins University Press, 1989) 24–25.

23. Dawn Perlmutter, *Graven Images: Creative Acts of Idolatry* (Ann Arbor, MI: UMI Dissertation Services, 1993) 194.

24. David Freedberg, "Iconoclasts and Their Motives," The Second Gerson Lecture, Montclair, New Jersey.

25. Freedberg.

26. Associated Press, "Police Seize Suspect Obsessed by a Movie," *New York Times*, 4 November 1994, sec. A, 23.

27. Whitmont 20.

28. Whitmont 21.

29. Girard 24.

30. Girard 4.

Thou Art

The Continuity of Religious Ideology in Modern and Postmodern Theory and Practice

DEBRA KOPPMAN

Although American political and social institutions are founded on the separation of church and state, and in spite of the consciously held belief that we live primarily in a secular society, underlying assumptions found in Western religious thought, philosophy, and mythology have in great measure formed the bases for the construction of a not-specifically-acknowledged national identity. We proclaim our trust in God on our national currency, we swear on a Holy Bible in our courts of law, we listen to politicians refer to us as a god-fearing people, we close our public schools on the most important of Christian holidays.

The truth that American culture in fact consists of a wildly heterogeneous medley of peoples, possessed of varied beliefs and religious backgrounds, has not yet substantially altered the essentially Christian backdrop of our society. The often unspoken assumptions about religious beliefs and the meaning of symbols profoundly inform the development of theory, criticism, and interpretation of art. The nature of art and the nature of the spirit remain integrally intertwined in contemporary critical theory and interpretation.

Critical omissions regarding contemporary manifestations of the sacred in art are ironically located in the recognition and rejection of the religious undercurrents of modernism. The Renaissance glorification of man, the weakening of creeds caused by the Protestant Reformation, and the loss of an overarching belief in god caused by rapid scientific developments were responsible for the shift in the function of art in the nineteenth century; art, which was previously tied to religion, was replaced with art as religion.[1] This elevated conceptual status of art, responsible for the development of the myths of modernism, replaced a patriarchal faith in god with a patriarchal faith in man-as-genius and created a situation in which it was possible for the artist to see himself as godlike; the role of shaman, seer, prophet, visionary, became attached to the artist by a populace searching for truth.[2]

The "myths of modernism" arising out of Enlightenment beliefs in the integrity of the individual soul and the possibilities of ever greater, upward reaching social progress have been attacked and systematically deconstructed in our present period of postmodernism. Not only is modernist philosophy seen as naively hopeful, it is also shown to be the pillar of a structure which upholds the value system of a specific culture which is Western, white, Christian, and male while presuming to be universally true. Contributing to this pillar is the modernist glorification of the artist as the solitary and uniquely perceptive genius, along with the modernist tendency toward a "disinterested" aestheticization of form.[3] In spite of the fact that the myths of modernism arose out of the loss of faith in god, they remained religious in origin; a belief in man-as-genius was substituted for a belief in one absolute god, leaving the underlying pattern of thinking the same.

The postmodern attacks on the myths of modernism have correctly associated those myths with a Western religious tradition. The myth of the hero/genius which has its antecedents in the man-as-savior stories of the Old and New Testaments and in Greek and Roman mythology, was declared defunct by Roland Barthes's proclamation announcing "the death of the Author." He says, "it is not an individual who speaks . . . but Language that speaks through the individual."[4] Barthes's premise is essentially that texts exist independently of authors, and that any supposed inherent connection is illusory. The traditional Western idea of self as an unchanging essence, an inheritance of the monotheistic conception of a fixed universe, has been associated in postmodern theory with autocratic maintenance of the social order, class structure, and central authority.[5] Modernism comes to be seen as "yet another disguised form of the Christian prophecy of the End of History (which is striving), and the attainment of the ahistorical Edenic paradise again (as reward for that striving)."[6]

The fact that in many ways the powers of the artworld—museums, galleries, institutions, and critics—have functioned as a secularized church, conferring status, enshrining objects, codifying belief and behavior, has given "the sacred" a bad name. Criticizing the deluded, religious character of modern philosophy for its hierarchical and evangelical overtones, postmodern sensibility rejects the conflation of the sacred with art.

To talk in the present of reinvesting art with a sense of the sacred causes discomfort and suspicion. However, the deconstruction of modernism's spiritual undertones creates several problems. The dogmatic and absolutist tone often employed by postmodern theorists curiously mimics traditional religious dogma. Seemingly unaware of this irony, postmodern theorists have not actually strayed so far from the flock.

Recurring patterns of religious behavior are exemplified in essentially Christian myths which survive in postmodern thought. Among these myths are Intelligent Life, The Protestant Work Ethic, The Death of the Author, The Appropriation Strategy, and The Myth of the Apocalypse.

Intelligent Life

The contemporary fascination with unreadable theory, and the often incomprehensible art it spawns, would seem to indicate a continued denial of the value of material in art. The prevalence of the incorporation of text into obscure visual images which require deciphering on the part of viewers suggests a continued valorization of verbal over visual modes of expression. The scorning of beauty as a value in art and the continued equation of beauty with seduction indicate that postmodernism represents a perfection rather than a negation of a long standing Judeo-Christian religious proscription of the physical and sensual world.

By removing art from an experiential, sensuous base to a place which resides principally in one's head, artists may have inadvertently made an art that fits the patriarchal religious paradigm perfectly. In a total renunciation of the physical, tactile, experienced world, conceptual art, which requires knowledge of highly intellectual theory, exists essentially as an abstract concept, paralleling a god which exists exclusively as an abstract concept.

The Protestant Work Ethic

Postmodern theorizing, which rejects the notion of the artist as hero and as uniquely perceptive, would seem to reject simultaneously the designation of artist as social critic, a role which arose in relationship to the rise of art as religion.[7] However, contemporary art practice, replete as it is

with art of explicit social and political content, would seem to be based on the continued valuation of this role.

From a feminist perspective, several contradictions exist. On the one hand, a postmodern rejection of the Enlightenment ideal of the possibility of social progress means that

> the very notion of a feminist art is represented as out of step with the times. To dream of changing society via the arts is an anachronism; even an awareness of a "project of emancipation" jars with the mood of a male-dominated elite.[8]

However, a Protestant work ethic remains a powerful influence in contemporary art/theory. The relationship of art to life must be blatant and explicit, so that what is defined as "in" must be morally or politically topical, and therefore socially "useful". At the same time art which is deemed frivolous or decorative by its nonutilitarian status as merely art is also critically placed as out of step with the times.

The issue of art's utilitarian status is simultaneously convoluted and narrow. The embodiment of complex ideas which we call art is valued over "merely" utilitarian, decorative, or beautiful objects we call craft. In a familiar pattern reminiscent of monotheistic thought, intellectual ideas are valued over sensual materials in a system which often and ironically results in narrowly didactic preacher-art intended to be useful. At the same time, the notion of beauty as a value in art is attacked as elitist, while the same criteria results in an equally elitist rejection of the craft and folk art which makes up the majority of the world's art and artlike activity and production.

THE DEATH OF THE AUTHOR

The postmodern proclamations announcing the "Death of the Author" chimed the death tolls of one of the now scorned myths of modernism; a rejection of the godlike hero/genius. This hero/genius is replaced by a postmodern autocratic no-man, presented as a revolutionary soulless nonentity.

The irony of this supposed deconstruction of authority seems to have been lost on its white male theoreticians. The "death of the author" is based on a false notion of a gender-free and culturally inclusive society of makers and viewers of art. For those who have participated in the world of art and artlike activities outside of Western art history, the death of the hero is not so noteworthy as the negation of the heroine and the not-white genius.

The notion of the possibility of divorcing a text from its author, or the idea that the belief in their inherent connection is illusory, conveniently ignores the history and effects of cultural imperialism and supposes by implication the existence of a value-free playing field. The evidence in galleries and arts publications shows issues of cultural and personal identity based on the position and experiences of those who are not white, not male, not Christian, and not Western to be a prevalent contemporary concern which is made light of by the timely postmodern discovery of the dangers of overweening pride.

Theory which deconstructs past tradition and past continuity remains based on the established authors and texts of the Western canon. Theory that denies the existence of the author or the continuity of tradition offers little to those who are already quite familiar with silence, self-negation, and the disappearance of culture. The fracturing of traditions already dismembered and decentered by the effects of colonialism can hardly be liberating.

THE APPROPRIATION STRATEGY

Much has been made of the tendency in contemporary art toward the use of historical references and the overlaying of multiple styles. This is generally interpreted in one of two related ways. Modernism and postmodernism are seen as nonunique cycles of history, the patterns of which can be found as far back as early Greece:

> Then, as now, Modernism arose in the context of a positivistic democracy carried away by emerging international hegemony to an almost giddy sense of its ability to solve social and cultural problems. Thus, certain of its future, a culture gives away its past. Traditions that developed over centuries or millennia are discarded almost casually on the historicist assumption that something better will inevitably replace them. . . . A period in which traditions are destroyed is apt to be followed by a period of nostalgic longing for them and attempts to reconstruct them.[9]

Returns to art styles of the past and historical references are seen from one point of view as arising out of nostalgia based on guilt, with an attempt to recreate lost traditions in the present. More cynically, postmodern appropriation art is seen as courageously illuminating the absurdity of the delusions of modernism; creation and originality are clearly impossible as all modes of communication are based on quotation and variation.

> Seen in this larger context, Alexandrian or post-Modern quot-
> ing is simply a process of bringing out into the open what all
> modes of expression do all the time anyway, but without both-
> ering to acknowledge (or even realize) it. Quoting is an in-
> evitable component in all acts of communication; it is what
> makes communication possible. . . . Communication not based
> on quoting is a mythic ideal, like the innocent eye; both are
> fragments of the myth of Eden, of an ahistorical condition in
> which, since there is no historical sequence, everything happens,
> as Breton said of the unconscious, "always for the first time."[10]

In this view, "art based on quoting postulates the artist as a channel
as much as a source, and negates or diminishes the idea of Romantic cre-
ativity and the deeper idea on which it is founded, that of the Soul."[11] The
impersonality of communication is ironically reiterated in appropriation
art so that we will have no recourse but to accept the painful truth.

This postmodern strategy of appropriation presents several ironies.
The deconstruction of the genius myth leads to a certain honesty; past
sources are recognized and valorized as art is no longer seen as miracu-
lously arising, out of nothing, from the hand of the genius. The Platonic-
Christian conception of linear time is also deconstructed, as the cyclical
nature of creation is exposed.

However, postmodern theorizing leads to its own deadend; the sin-
gle-path modernist straight line is replaced with a unidimensional circu-
lar line to which nothing is ever added, invented, changed, improved
upon. The idea that everything is simply quotation substitutes the genius
myth and the possibility for human progress with its polar opposite; we
are doomed to endless repetitions of exactly the same history, images, and
expressions. Our creative potential as humans is seen as illusory, as our
activities are likened to the mindless repetition of preprogrammed au-
tomatons. Those who believe in this view of human noncreativity are
considered "enlightened" and are rewarded for their cynical exhibition of
the undeniable "truth."

The very notion of appropriation is also symptomatic of a domi-
neering worldview which has its parallel in Western religion. The ten-
dency toward appropriation is not merely a humble acceptance of the
limitations of human creativity; it is rather the result of a frustrated de-
sire for mastery over the truth. Appropriation is equivalent to objectifi-
cation and to possession.[12] What is appropriated is stripped of any
power or mystery, and reduced to a rationalized, sterilized series of facts
or images.

The postmodern myth of appropriation is a less clever and less log-
ically substantiated variation of an ancient "myth of eternal return"; by

faithful repetition of paradigmatic divine models, humankind remains in reality and the world remains sanctified.[13] In both cases the possibility for human creativity is disavowed while the locus of creativity is placed outside and above the human realm. However, the myth of the eternal return posits the endless repetition of patterns played out by the gods at the beginning of time; the attached recreation myth at least allows for the renewal, re-energizing, and regeneration of the world.

In contrast, the secularized postmodern myth of appropriation does not specify any particular point of origin, any particular locus of creativity, or any potential for earthly renewal. How far back do we need to go in order to discover an original creation? If we all are merely playing out a never-ending repetition, where is the origin of our actions located?

Postmodern theory claims to deconstruct the author-ity of the author and expose the prideful nature of enlightenment striving. However, in practice postmodern theory seems to cut off the progression of time and thought exactly at the point of its own self-realization. In disavowing the possibility for further creativity, the myth of appropriation nevertheless looks back to an image bank and a history created and defined largely by men, ironically serving to reinforce rather than challenge that authority. To accept the impossibility of originality and the prognosis of endless repetition would also be to acquiesce in a biblical and changeless interpretation of the god-given state of the world, the relationship of men to women, of humans to the cosmos.

An acceptance that art in some sense comes from art, that culture generates culture, that communication owes itself to previous communication, is not the same as simplistically and cynically denying the possibility for creativity. To agree with the postmodern assertion that life, art, and society do not move in an ever-progressing linear direction but go through cyclical stages does not mean we are doomed to literal repetitions without variation.

Art based in a multicultural view of aesthetics does not seek to claim, hero-fashion, that art originates in the godlike psyche of the individual artist. However, the notion of endless recycling through language is based on a faulty linguistic theory. While it is true that children must hear language in order to learn to speak, a behaviorist understanding is inadequate for explaining the complexity of language acquisition. If we truly learned language merely by quoting, we would learn to speak like parrots. We would never utter a sentence which we had not heard, never formulate new ideas or theories. To merely appropriate existing images in the present in order to save us from the delusion of creativity is to reduce the richness of human experience and possibility. To accept the reality of the influence of pre-existing forms of communication on our thoughts

and behaviors does not necessitate total denial of originality. What is transmitted during language acquisition are structures.[14] Just as a child who cannot hear is denied access to those structures, the negation of cultural tradition denies access to structures of meaning and ways of living. References made in art to past and present cultural traditions do not necessarily involve either nostalgia or ironic quotation, but may involve a complex web of association which demands an entirely different interpretative strategy.

THE MYTH OF THE APOCALYPSE

The favoring of the verbal and the conceptual over the material and the sensual has continually narrowed the gap between art and philosophy; from this stems the notion that art has ended.[15] In order to perceive the end of art, one must first conceive of art within the conceptual framework of traditional art history. In spite of postmodern attempts to deconstruct the notion of linear progression, the history of art is studied as a series of stylistic changes which move in an ever improving, single direction; when accurate visual correspondence was achieved or perceived as no longer necessary, artists occupied themselves with conceptual problems which more and more closely approximated those of philosophy, causing the eventual collapse of art into philosophy. This time line approach to the history of art finds its parallel in a religious paradigm; as the important qualities of art are transferred from the material and sensual to the conceptual, both art and god become more and more an abstract concept, divorced from physical connections and located in the realm of the rational.

The belief in the end of art, as well as the decentering and appropriation strategies of deconstruction, are elements in the myth of the apocalypse. One must have faith in the linear notion of time in order to fear or herald its end. Deconstructionist artmakers function as the last riders of the apocalypse, announcing only the futility of originality and the uselessness of action. Believing themselves to be above and removed from the self-deluding myths of modernism, they are ideal members of an unordained priesthood which serves to maintain the status quo as effectively as any religious hierarchy. Just as Judeo-Christian ideology promotes a kind of fatalistic passivity exemplified by the expulsion of Adam and Eve from the Garden of Eden, postmodern theorists and deconstructionist artists promote passivity. In proclaiming the nonexistence of meaning, responsibility and action become not only unnecessary, but cynically perceived as absurd.

The Decline of PatriArt

In noting the collapse of art into philosophy, only art which has been consecrated as serious has been taken into account. All other art is trivialized as being outside the realm of history. As this history of canonical art most closely parallels the history of Western religions and potentially serves similar ends, the term "PatriArt" will be coined to emphasize its elevated importance in history and to distinguish it from its less revered sisters and cousins.

The stance taken by the most extreme of the deconstructionist theorists is to replace one dogma for another, to replace the surety and simplicity of one absolutist worldview with what turns out to merely be its mirror image. Forced by logical reason to see that one's faith has been placed in something which contradicts one's experience of the world, the disillusioned rush to fill the gap with another set of false premises—to believe in nothing is less discomforting than to live with uncertainty and indeterminacy.

The flip side of complete belief in absolute truth and god is the absolute belief that there is no meaning. The response of alienation, hopelessness, and the extremes of deconstruction perfectly serve to maintain things exactly as they are, due to apathy and the belief that nothing can be done, that there is no meaning, that we share no common ground and no common experience. The decentering and the deconstruction of meaning of postmodernism has resulted in the preaching of correct standards and paradigms which are secular in content, yet religious in tone.

The art of the present and recent past, which depends so heavily on theory for its existence as art, may indeed signal the end of PatriArt; however, an alternative interpretative framework based on feminist redefinitions of the sacred and on multicultural theoretical approaches to art may indicate the spiraling back rather than the end of art.

Institutional Theory of Profanation of Art

The separation of categories into sacred and profane is a relatively recent phenomenon in the history of humanity, as is the exclusion of the sacred from art. The difficulty of discussing the sacred in art arises in our culture because of our perception of these categories as immutable and distinct. We have effectively rooted out the sacred from every aspect of our lives, reducing the realm of the spiritual to what is perceived as archaic and delusionary. Art, originally part of this sacred world, becomes as profane

as everything else; however, as it is stripped of its original "usefulness," it now needs theory to make it what we call art.

Our definitions set boundaries, creating a class of objects and practices which we perceive as separate from life and from similar objects and practices of other, preindustrial cultures. How we define art and how we perceive art to function in our society is in itself a convoluted and theoretically dense debate among aestheticians.

Although the attempts by Western aestheticians to define "art" has proven largely elusive, it has been posited that what we in our culture call art only exists within the institution of the artworld. The artworld in our culture exists as a system of established practice within which works of art are understood as "art"—validated, appreciated, rejected, discussed.

The artworld as institution seems to be a quite accurate description of the relationship our culture has with art. Interesting questions arise when we try to understand something about the distinctions between what we call art and what we see as the related activities of other cultures. The inappropriateness of applying our conceptual categories of art outside of our own culture has been effectively argued.[16] The lack in many languages for a word which corresponds to "art" presents convincing evidence that while artlike or artistic activities are prevalent cross-culturally, the meaning of those activities and the experiences that makers and viewers have are not universally shared. What seems to differentiate our art from the artmaking activities of non-Western, nonindustrial cultures is precisely the lack in our own artworld of the original integration of art and life and art and the sacred.

In our world, art loses what it may have in common with non-Western art exactly when it enters the institution of the artworld; it is at this point that it becomes profane. In spite of the existence of residual elements of the sacred in the form of modern and postmodern behaviors and philosophy, any potential powers to embody the sacred are effectively relinquished as art enters the world of commodities and status.

To talk about the spiritual in this context becomes absurd, in spite of the fact that the system still retains elements of religious behavior. Attempts at deconstruction notwithstanding, the "successful" artist is still surrounded by a sacredlike aura; those collectors who are not merely involved with buying art-as-investment still hope for the possiblity to capture or possess something of that aura embodied in the work. The institutional profanation of art and the subsequent distortion of the sacred explain in part the limited critical attention given to manifestations of sacredness in art in contemporary practice.

GOOD/GOD ENMESHED IN HOLY WAR

Images are powerful, going beyond what is allowed inanimate matter; such power must be controlled, eliminated, or denied.[17] Prohibitions against images arise precisely out of the fear of acknowledging their potential power; this fear is closely tied to a fear of the sensual and a fear of women.[18] Christian philosophy presents a view of fallen man; the body is discovered to be shameful at the very beginning of human existence in the Garden of Eden. Mankind becomes simultaneously aware of his sexual desire and of his separate existence and distance from god. A contradiction therefore arises between man's physical and religious aspirations. His relationship with the physical world, as embodied in his own flesh, in nature, and in women, becomes ambivalent and disturbed.[19]

The idealization of the spirit finds a counterpart in the demonization of the sensuous, and by association, of women.[20] The desire for woman's body makes men aware of their own bodies, and (almost) against men's will causes men to identify with the flesh.[21] This puts men in an uncomfortable relationship with the ideal of man as pure spirit, causing each man to "resent his own weakness and woman's power to seduce man into a betrayal of himself."[22]

Modern art was divorced from art's original marriage with the sacred; ironically, however, many tendencies explored in modern art were derived from religious conceptions which influence the way men see themselves in the world. Woman portrayed as vampire, witch, temptress illustrates her destructive power over men.[23] Instead of functioning as a site of veneration, art became a focus of warning and purgation.

In creating an impossible ideal of an autonomous spirit, men create their own hell,[24] then use art to give expression to these fears, and to create the illusion that this nightmare exists outside of themselves. The images may in fact be profane, but their function remains tied to a worldview which is religious in its foundations.

Art functions not merely as a mirror of a particular age, but also as a creator and reinforcer of values. Pluralism implies a necessity to live with the contradictions, the richness, and diversity which a multicultural community demands. Pluralism threatens the notion that the United States is one nation, indivisible, under god. At the present juncture, however, it is obvious that the separations between church and state remain fuzzy.

Censorship in the 1990s in the United States is a clash between opposing worldviews, based in ways of living and seeing the world which are essentially religious in origin. Western society is fundamentally Chris-

tian; dominant, aggressive, colonizing, it is fearful of the signs of loss of empire. The religious fervor of the New Right in defending "family values" can be seen as the last desperate impulses of a vanishing system:

> we know from studies of cultural history that when a way of life is vanishing, people hold on to it and try to give it a more intense expression. When knighthood is about to disappear from the waning Middle Ages, armor becomes extremely elaborate; the celebration of the armored knight mounted on his horse becomes an unconscious farewell. Whether it is the Ghost Dance of the American Indians or the return to nature in the romanticism of industrial Europe . . . it is the supernova of a star in its death.[25]

The vehemence with which "pornography" has been attacked, the association of pornography with art, the determination to classify art and control artists can be taken perversely as signs of affirmation of the continuing power of images. A consciousness of the religious origins of language and art leads to the conclusion that current censorship debates are profoundly religious in nature. We are clearly enmeshed in a Holy War.

MUTATING TO SURVIVE

Although to suggest the possibility of a reintegration of the spiritual in art is not the direction of mainstream criticism and practice, there is ample evidence in the work of artists of diverse ethnicities to show this to be a significant trend in this pluralistic era. Multivocal, multicultural, and feminist models of spirit can be used to deconstruct the traditional interpretations of the manifestations of the spiritual in art, while showing how criticism based on deconstructionist theory works to perpetuate rather than eradicate patriarchal myths of religious origin in the postmodern era.

These multivocal models can also be used to offer alternative interpretations of contemporary art and may shed light on the seeming incoherence of pluralism. In attempting to make connections between seemingly static dualities, art in the present moment may be spiraling back to repeat an essentially religious act of binding up. The present manifestation of the spiritual contradicts the beliefs of the Platonic-Christian tradition.

Seen in the light of feminist and multicultural approaches to the sacred, contemporary art is neither in search of an absolute ideal nor obsessed with frustration over the temporality of human existence. Beauty, completeness, and a sense of the sacred are not limited to a realm of being which can only be found in a conception of infinity outside of time; rather, art, life, and the sacred are understood to be processes of becoming.

It is possible that contemporary forms of art are manifestations of a pantheistic worldview; rather than setting oneself godlike above a strange and hostile world, a perception of belonging to the world leads the artist to experience all manifestations of the world as equally real. A shift in emphasis therefore comes about as the search for purity and an ultimate, unifying, and universal form of expression is abandoned. There is no escape from the immanence of material form; all of human experience, including "abstract" images, are real.

Insofar as art manifests the invisible in the visible, suggests the possible by confronting the impossible, opens unforseen realms, can it not be seen as sacred? Could it be that we are not only witnessing the deconstruction of the false categories of the past, but the reconstruction of new perspectives on the future? The desire, or perhaps more urgently, the need to reintegrate art and life, to reaffirm and reidentify with one's cultural roots, to reclaim lost or denigrated sources of knowledge, to reassert the primacy of material reality and experience, to valorize the visual as opposed to the verbal in art, to emphasize the importance of material and craft, to de-emphasize the importance of classifications such as painting or sculpture, art or craft, may be seen as unified under a theme of connection. In criticizing the privilege and insularity of the artworld, in reconstructing the meaning of gender, art, and the sacred, in rejecting duality, in preferring chaos to compartmentalizing, artists appear to be challenging the religious foundations of our society in a plethora of activities which can themselves be interpreted as spiritual in nature.

The traditional Western view of spirituality, tied to religious dogma, allows room for neither multiple possibilities nor bothersome contradictions. The most influential of postmodern theorists preach secularized versions of an apocalypse without possibility of redemption. However, both the realm of spirit as well as the postmodern era may be interpreted from multiple viewpoints. A necessary coexistence of disturbing contradictions through which a fecundity of possibilities emerge may ironically characterize both the realm of spirit as well as the postmodern era.

NOTES

A version of this chapter was presented as a paper at the 1995 annual meeting of the College Art Association, on the panel entitled *The Subjugation of the Spiritual in Art*, cochaired by myself and Dr. Dawn Perlmutter.

1. Jacques Barzun, *The Use and Abuse of Art* (Princeton: Princeton University Press, 1973) 24–46.

2. Barzun; this is the premise of his entire book.

3. This idea takes its inspiration from the influential German philosopher, Immanuel Kant, *Critique of Judgment*, (trans. J. H. Bernard (New York: Macmillan Publishing, 1951). For Kant, beauty exists as an absolute; through "disinterested" contemplation, one can apprehend that beauty. In order to satisfy the condition of "disinterestedness," an object may not serve any other purpose than to exist. "The Beautiful is That Which Apart from Concepts is Represented as the Object of Universal Satisfaction."

4. Quoted in Thomas McEvilley, *Art and Discontent: Theory at the Millennium* (Kingston, NY: McPherson and Co., 1991) 101.

5. McEvilley 128.

6. McEvilley 99.

7. Barzun 47.

8. Christine Battersby, *Gender and Genius: Towards a Feminist Aesthetics* (London: The Women's Press, 1989) 146–47.

9. McEvilley 96–98.

10. McEvilley 99–100.

11. McEvilley 101.

12. Karsten Harries, *The Meaning of Modern Art* (Evanston: Northwestern University Press, 1968) 50.

13. Mircea Eliade *The Myth of the Eternal Return* (Princeton: Princeton University Press, 1991).

14. Noam Chomsky, "On Cognitive Structures and Their Development: a Reply to Piaget," *Language and Learning: The Debate between Jean Piaget and Noam Chomsky*, ed. Massimo Piattelli-Palmarini (Cambridge, MA: Harvard University Press, 1980) 35. Chomsky refers to language faculties as "humanly accessible grammars."

15. Arthur C. Danto, *The Philosophical Disenfranchisement of Art* (New York: Columbia University Press, 1986) 81–115.

16. This has been a major thrust of the work of Dr. David W. Ecker. He has effectively conveyed this point in his lively seminars "Aesthetic Inquiry," "Aesthetic Foundations of the Arts," and "Phenomenology in the Arts," in the doctoral programs at New York University.

17. David Freedberg, *The Power of Images* (Chicago: University of Chicago Press, 1989) xxiv.

18. Freedberg 65.

19. Harries 86.

20. Harries 87.

21. Harries 86.

22. Harries 86.

23. Harries 87.

24. Harries 89

25. William Irwin Thompson, *The Time Falling Bodies Take to Light: Mythology, Sexuality and Origins of Culture* (New York: St. Martin's Press, 1981) 123.

CONTRIBUTORS

ANDREW DOERR is currently completing a Doctor of Philosophy in the Department of the History of Art and Architecture at the University of California, Santa Barbara. His dissertation is entitled *Jean Tinguely: Technology and Identity in Postwar Switzerland, France and the United States, 1953–1970*. In addition to his work on the art of postwar Europe, he has written on fin de siècle Scandinavian art focusing on the work of Edvard Munch. His present research interests include the intersection of art, medicine, and technology as means of defining and mapping the body. He is an independent scholar and teaches art history at Cuesta College in San Luis Obispo, California.

MELISSA E. FELDMAN is an independent curator and critic based in London, where she is a regular correspondent for *Art in America* and *Art Monthly*. She was formerly Associate Curator at the Institute of Contemporary Art, University of Pennsylvania and holds a Master of Art degree from the Institute of Fine Arts, New York University. Her diversified curatorial work and writing focus on both emerging international artists—Karen Kilimnik, Mariko Mori, Hiroshi Sugimoto—and on identifying significant or neglected themes in contemporary art. Among Feldman's current curatorial projects is an exhibition examining a Victorian sensibility among contemporary British and American artists that will tour binationally.

DEBRA KOPPMAN is a painter, sculptor, printmaker, writer, professor, and researcher with a Doctor of Arts from New York University. In addition to participating in group and solo exhibitions nationally and internationally, she has taught art studio and art theory to university students in the United States, Mexico, Nicaragua, and Peru. Her research interests revolve around three interrelated and interdisciplinary themes—multicultural aesthetics, feminist criticism, and the continuing contemporary connections between art and the sacred. Dr. Koppman is a 1995 recipient of

a Fulbright Scholar Lecturing Award in Peru. She currently teaches in the Department of Arts and Consciousness in the Graduate School of Holistic Studies at John F. Kennedy University in Orinda, California, and is a regular contributor to *Artweek* magazine.

CHER KRAUSE KNIGHT is Instructor of Art History at West Texas A&M University. She is currently completing her doctorate on Disney World in the Department of Art History at Temple University. She holds a joint Master of Art degree in Art History and Museum Studies from City College, City University of New York. Her areas of specialization include postmodern architecture, popular and material culture, and the usage of simulacra, all of which have contributed to her examination of "Disneyism." The chapter included in this anthology is the result of years of research on the topic, as well as over twenty visits to the Florida, California, and French Disney theme parks.

JANICE MANN is Assistant Professor of Art History at Bucknell University, Lewisburg, Pennsylvania. She holds a Doctor of Philosophy, Master of Philosophy, and Master of Art from Columbia University. Her area of expertise is the art and architecture of medieval Christian Spain. Her research focuses on the way visual culture and cultural identity mesh to form the fabric of a society. Dr. Mann is currently working on a book entitled *Frontiers and Identities: The History and Historiography of Romanesque Art in Eleventh-Century Christian Spain*, which explores through modern art historical scholarship how notions of the frontier act as both the backdrop and driving force in the formation of Spanish Romanesque Art.

DAWN PERLMUTTER is Assistant Professor of Art and Philosophy at Cheyney University of Pennsylvania, Cheyney, Pennsylvania. She holds a Doctor of Philosophy from New York University and a Master of Fine Arts from The American University, Washington, D.C. Dr. Perlmutter's research, which has been presented at numerous conferences, focuses on the application of ritual theory to ethical issues in aesthetics. Lectures consider prevailing issues such as the psychology of image worship, censorship in film and art, violence and the media, beauty pageant values, the ritual use of blood in contemporary art, and the application of aesthetics to ritual homicide. Dr. Perlmutter is currently working on an interpretative research project, resulting in a publication entitled *Postmodern Idolatry, Ritual Uses of Blood in American Culture*.

CRISPIN SARTWELL is Assistant Professor of Philosophy at Penn State, Harrisburg. He is the author of *The Art of Living, Aesthetics of the Ordinary in World Spiritual Traditions*, which posits a multicultural aes-

thetics and a theory of art on living more artfully, and *Obscenity, Anarchy, Reality*, which explores the prospects for a metaphysics and an ethics (or an antimetaphysics and an antiethics) of world affirmation. Dr. Sartwell is the recipient of a postdoctoral fellowship at the University of Pennsylvania and an Andrew W. Mellon postdoctoral fellowship at Vanderbilt University. He is also the author of numerous articles and reviews in the areas of aesthetics and epistemology.

SUSAN SHANTZ is Associate Professor of Art in the Department of Art and Art History, University of Saskatchewan, Saskatoon, Canada. She holds graduate degrees in Religion and Culture (Wilfrid Laurier University, Waterloo, Ontario, 1985) and Visual Art (York University, Toronto, 1989). She has exhibited her art in public and private galleries across Canada and the United States, and her work is represented in numerous collections. Her previous publication on religion and art is *The Stations of the Cross: A Calculated Trap?*

INDEX

Abhinavagupta, 94–95
aesthetics
 and separation from spiritual, 7
 as prayer, 3
 feminist, 47–51
 minimalist and Zen, 91
 non-western, 4, 89–101, 106–115
 African, 91, 92, 96–97,
 106–109, 113–115, 120,
 122, 123
 African-American, 96–97,
 98–99
 Australian Aboriginal, 93
 Aztec, 92
 Eskimo, 94
 Huichol, 92–93
 Indian, 94–95
 Latin American, 4, 93, 95
 Native American, 13, 91, 92,
 95, 97, 99–100, 107, 108,
 109, 111, 115
 Navajo, 95
 Tibetan, 95
 Zen Buddhist, 95
 of denial, 130
altars
 contemporary
 Bedia, José, 107
 de Saint Phalle, Niki, 3, 73–85
 Mesa-Bains, Amalia, 73
 Saar, Betye, 73
 Stout, Renée, 73
 Tinguely, Jean, 3, 73–85
 Tracy, Michael, 73

 traditional
 Isenheim Altarpiece, 3, 20–21,
 23, 28, 30, 73
 meanings, 74–75
Aristotle, 1, 129, 132

Barthes, Roland, 76, 146
Beardsley, John, 14
Beck, Larry, 99–100
Bedia, José, 4, 106–109, 110, 111
Beuys, Joseph, 4, 63, 106, 109–111
biblical prohibition of images, 7–9,
 16, 17, 130, 142, 155
body art, 10, 16, 28–30
Botticelli, 21, 23, 25, 27
Burden, Chris, 3, 24

censorship, 2, 5, 7, 8, 142, 143,
 155–156
 and pornography, 16, 156
 and relationship to power, 17
 National Endowment for the Arts,
 15
Chinen, Sharon, 100–101
conceptual art, 105
 Beuys, Joseph, 4, 63, 106, 109–111
creativity, concepts of, 17, 151–152
cults, 8

Dada, 105
Damon, Betsy, 49
DeMaria, Walter, 14
Duchamp, 105